Isaacs Seen

Greenwich Art Shop 1950-1955

Greenwich Art Gallery 1956-1957

The Isaacs Gallery 1958-1991

The Innuit Gallery 1970-1991

The Isaacs/Innuit Gallery 1991-2001

50 years on the art front

a gallery scrapbook compiled by

Donnalu Wigmore

The Justina M. Barnicke Gallery, Hart House
University of Toronto Art Centre
Textile Museum of Canada
Art Gallery of Ontario

Curated by Megan Bice:

Gallery ReView

May 10 to August 5, 2005
University of Toronto Art Centre

Regarding Av

May 19 to August 18, 2005
The Justina M. Barnicke Gallery, Hart House

Closet Collector

May 19 to September 25, 2005
Textile Museum of Canada

Curated by Georgiana Uhlyarik
(in collaboration with Maia Sutnik and Dennis Reid):

Two on the Scene

Photographs by Michel Lambeth & Tess Taconis
June 1 to September 4, 2005
Esther and Arthur Gelber Treasury
Art Gallery of Ontario

Text copyright © 2005 the authors

Artworks copyright © the artists unless otherwise stated,
see page 167.

Photography copyright © the photographers,
unless otherwise stated

Copy editor, John Parry

Photography, Dave Kemp

Design, Stan Bevington with Rick/Simon

Printed at the Coach House Press on bpNichol lane

Distributed by ABC Art Books Canada Distribution
www.ABCartbookscanada.com

LIBRARY AND ARCHIVES CANADA
CATALOGUING IN PUBLICATION

Isaacs seen / editor: Donnalu Wigmore

Published by Hart House, University of Toronto,
Co-published by the University of Toronto Art Centre, Textile
Museum of Canada and the Art Gallery of Ontario.

Catalogue of an exhibition.
ISBN 0-9694382-6-5
1. Art dealers--Ontario. 2. Isaacs, Avrom, 1926- --Exhibitions. 3.
Isaacs Gallery--History--Exhibitions. 4. Art, Canadian--20th century
-Exhibitions. 5. Art--Ontario--Toronto--History--20th century--
Exhibitions

 I. Parry, John, 1949- II. Hart House III. University of Toronto
Art Centre IV. Textile Museum of Canada V. Art Gallery of
Ontario

N8660.I83I83 2005 709'.2 C2005-901625-6

Acknowledgments

It was a couple of years ago that I ran into Av Isaacs at 401 Richmond Street West (a vibrant arts community building). This was the start of many conversations that led to the exhibition "Isaacs Seen" and the accompanying "scrapbook/catalogue." First and foremost, I thank Av for his inspiration and for his dedication to this project. Along with Av came Donnalu Wigmore, whose hard work as producer of this scrapbook has made the project well worth the effort.

On an ongoing basis, a core crew was responsible for making this book happen. To them we are grateful beyond words. They are Dave Kemp, an unflappable photographer and photo editor; Barbara Sears, an unsinkable organizer and researcher; Bridget Indelicato, our super-organized production assistant; and John Parry, our astonishingly capable copy editor.

Many people, whose names are included in the text, have contributed to this publication, and their efforts are what makes it a good read. I would, however, like to centre out the individuals who have worked diligently behind the scenes. Ronnie Burbank volunteered her time to do research for the project. Suzanne Dubeau at the York University Archives assisted our researchers in the exploration of the extensive archival files that Av Isaacs generously donated there. Lawrence Barichello was our computer wizard who set up the data entry programme. We are indebted to Bill Kirby for helping us navigate the Centre for Contemporary Canadian Art website, for having the foresight to keep the website pertinent, and for making the material available to us. Found on the site is a goldmine of information on The Isaacs Gallery and also on The Isaacs/Innuit Gallery.

Megan Bice, curator for the project, has been immensely helpful in providing expertise and good advice over the better part of a year. I thank her for her unflagging good humour and for her patience.

It has been a great partnership for four galleries to work together on this exhibition. This partnership has increased my appreciation for all those often-unsung people who dedicate their working lives to galleries – in this case, Nataley Nagy, Niamh O'Laoghaire, Sarah Quinton (thanks to her also for her eagle eye in proofreading), Dennis Reid, Maia Sutnik, Georgiana Uhlyarik, and Liz Wylie.

Perhaps the most challenging aspect of doing a book of this nature is copyright clearance. I want to thank the numerous contributors who waived copyright on their art/photographs. The National Gallery of Canada and the Art Gallery of Ontario made their images accessible to us. Janice Seline at CARFAC was most helpful with her advice. Every effort has been made to ascertain the identities of the photographers whose images appear within these pages, but some remain unknown.

The concept of this book started as a suggestion put forth by Stan Bevington of Coach House Press. Without his kindness, expertise, and patience, it would not have happened. Along with Stan came the wonderful designer Rick/Simon. We could not have asked for a better team to design and print *Isaacs Seen*.

Finally, but not least, I would like to express our appreciation of financial support from the following government agencies: City of Toronto, through the Toronto Arts Council; the Ontario Arts Council; and the Canada Council for the Arts. As well, certain foundations, funding groups, galleries, and individuals have also seen the merit of this project and have given generously. They are the Walter and Duncan Gordon Foundation, David Mirvish, Morton and Carol Rapp, Toronto Friends of the Visual Arts, and Morden Yolles.

The University of Toronto Art Centre is grateful for the assistance of David and Vivian Campbell, Paul Perron, and Meredith Saunderson.

Such a project happens once in a lifetime. Thank you, Av, for making it happen in my lifetime.

– Judi Schwartz,
Director/Curator, Art Gallery, Hart House

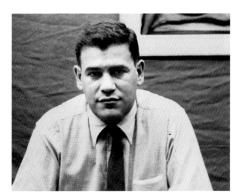 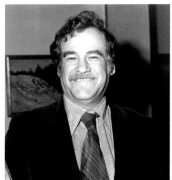 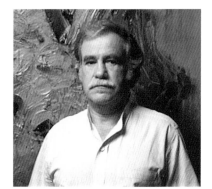

THANKS FOR THE MEMORIES

To all the friends and associates who ransacked their memories and their old photo albums to contribute to this catalogue/scrapbook, many thanks. I enjoyed every word and picture. Also greatly appreciated are the essays from those astute analyst/observers of the Isaacs scene: Dennis Reid, Robert Fulford, Ramsay Cook, Sarah Milroy and my long-time associate Martha Black. And my special thanks to Judi Schwartz for cooking up this bold plan and to my partner Donnalu Wigmore, producer of this catalogue, whose special Saskatchewan " stick-to-it-iveness" pulled it all together.

A. Isaacs

"ART IS THERE WHEN YOU NEED IT!"

That was the message under a picture of a wickedly pointed piece of Inuit sculpture in the Globe & Mail, November 12, 1995. The advertisement was Av Isaacs' waggish reaction to Prime Minister Chrétien's self-defence against an intruder at 24 Sussex Drive – a piece of nearby Inuit sculpture. In fact, The Isaacs Gallery in its various incarnations had been providing the Canadian public with art artillery for decades.

The home base for the "art artillery" was the Isaacs Gallery, a.k.a. the Greenwich Gallery, the Innuit Gallery and the Isaacs/Innuit Gallery, commanded by Av Isaacs, with very able assistance, from 1950 to 2001. In recognition of the Isaacs Gallery's contribution to Canadian life, four public institutions have come together to celebrate the people and the times with the exhibition **Isaacs Seen**.

Why so many venues? Primarily because Isaacs's galleries, in all their manifestations, were an instrumental force in the story of Canadian art throughout the last half of the twentieth century. The personality, enthusiasms, and perseverance of the man created an atmosphere that was inquiring, rebellious, and demanding of excellence. The galleries took risks, standing by the evolution of their core talent while introducing the new and unknown – whether emerging artists east to west, or urban south to Inuit north. An active and challenging program presented artists' events, experimental films, poetry readings, and performances, including the Artists' Jazz Band. Publication initiatives documented

exhibitions and produced artists' prints such as the Toronto 20 portfolio as well as books of art and poetry and records of contemporary music.

Many of the artists championed by Isaacs have become fixtures in Canadian art history, making a lasting impact on both local and national scenes. For many private and public collections, representation of the decades since the Group of Seven and the Second World War would have been incomplete without them. A number have become well known internationally, their works acquired for landmark museums such the Museum of Modern Art and the Guggenheim in New York, the Albright-Knox in Buffalo, and the Centre Georges Pompidou in France.

In company with collecting institutions across the country, each of the four venues for **Isaacs Seen** has had a professional relationship with Av Isaacs. Works acquired and shows mounted represent Isaacs and Innuit Gallery artists. As well, Isaacs himself has given generously from his personal holdings. With limited space, how can the inevitable snapshot of this retrospective do justice to the lengthy, complex, and multi-faceted chronicle of such a career? The answer is by pooling resources, each partner illustrating an aspect of the narrative.

Gallery ReView at the University of Toronto Art Centre exemplifies what the public might have seen at the Isaacs Gallery from the 1950s to 1990. Beginning with the abstract expressionist *Karma*, a 1957 canvas by William Ronald, it includes thirty paintings and sculptures by twenty-four artists long associated with the gallery. While it cannot comprehensively cover four decades of hundreds of shows, the Art Centre displays something of the breadth and depth of Isaacs Gallery offerings, with widely varying approaches expressed through a vast range of media.

While known perhaps principally for its activities in the 1960s and 1970s, the Isaacs did not focus on one time, subject, medium, or style. It showed the painterly abstraction of Ronald, Meredith, Gorman, and Rayner. The intellectual, new media works of Snow and Kubota contrasted with evocative and dream-like, sometimes-whimsical paintings and sculptures by MacGregor, Urquhart, Falk, Pflug, Tinkl and Greer. The cool photorealism of Jack Chambers was distinct from the deeply personal representationalism of Kurelek and

Pflug. Redinger's anthropomorphic forms and the sensuality of the human body as depicted by Coughtry, Markle and Burton differed markedly from the suffering depicted by sculptor Mark Prent. Despite their dissimilar imagery and materials, the installations of Gomes and Cruise called up associations and relationships of the human presence in real or imagined environments.

In **Regarding Av**, the Justina M. Barnicke Gallery at Hart House recreates something of the personal world of the man behind the galleries. Fascinated by people and what they make, whether fine art, craft or manufactured, Av Isaacs has been eclectic in his passions and has shown and collected accordingly. Exhibitions of southern and northern Canadian art were punctuated with shows of objects from around the globe, including European and American artists, Indian miniatures, African sculptures and Baluchistani wedding jackets.

Isaacs has been active in the Professional Art Dealers Association of Canada and the Canadian Cultural Property Review Board. He has consulted for Nicaragua's Sandinista government on cultural opportunities. He has visited the Arctic on many occasions and brought together avant-garde luminaries Marcel Duchamp and John Cage for a chess match. He vigorously pursued a ground-breaking legal battle over the graphic presentations of Mark Prent, within a debate about freedom of expression and censorship that continues to this day.

At Hart House, objects sold through the Isaacs Gallery or from the dealer's personal treasures range from items by some of the creators listed above to memorabilia from his many ventures: photographs, artist/poet books and recordings. While not an in-depth focus of this exhibition, selected pieces of Inuit art reflect Isaacs's long association with the Canadian Arctic. Indeed, the impact and contribution of the Innuit Gallery, the first in Canada dedicated exclusively to Inuit art, make up a story worthy of its own exhibition.

When closing out the Isaacs Gallery space in 1990, Av realized that he had been, as he calls himself, a **Closet Collector** of textiles. The Textile Museum of Canada presents an overview of this least known but enduring love of all things woven, dyed, beaded and embroidered. Isaacs has commented that the sight of First Nations deerskin robes alerted him to his own mistaken preconceptions about what constituted Art. In fact, art knows no bounds and is equally revealed through the everyday, functional object. The colour, design, technique, and craftsmanship of textiles from around the world mirror the people and the cultures from which they came, as much as the traditionally defined "fine arts" reflect their times and makers.

Over the years, the Isaacs Gallery and the Innuit Gallery exhibited a wide range of woven and decorated arts: Tunisian kilims, Bolivian weaving, basketry, Plains parflèches and Inuit appliqué. **Closet Collector** displays works large and small, drawn from Av Isaacs's donations to the Textile Museum and pieces still in his possession, as well as items of special memory now in private hands. It includes Paracas Culture fabric, dating from 900-400 BC; a 16-foot beaded decorative edging intended probably for a 19th century Indian wedding tent; and a ceremonial headdress from Siberia. The show ranges through time to include a Canadian hooked rug, a Haida button blanket, an Oonark tapestry, the Captain Burton Banner featuring the famous garter-belt motif, and, in response, Joyce Wieland's embroidered last letters of Wolfe and Montcalm.

The Isaacs Gallery welcomed on its walls the art of photography, including the work of Michel Lambeth, Ralph Greenhill, Michael Torosian and Richard Harrington. Many have been donated to the Art Gallery of Ontario, which is hosting **Two on the Scene**. The Isaacs Gallery sprang from, and reflected, a community created by characters, the city itself, and events national and international. Accordingly, fourteen photographs on display, which include some of Isaacs's gifts to the AGO, look through the lenses of Michel Lambeth and Tess Taconis at the people and the lively and inventive times of the Isaacs years.

Isaacs Seen – exhibition and book – can only begin to describe, with an assemblage of images, objects, and words, the people, complexities, trials, tribulations and triumphs of fifty years in the art world. The poet John Donne reminded us that "no man is an island [but] a part of the main." One can only surmise the outcome without that particular "island" of The Isaacs Gallery, in that particular "main" of Toronto and Canada during the last half of the twentieth century.

Megan Bice, Guest Curator

The Meeting Place

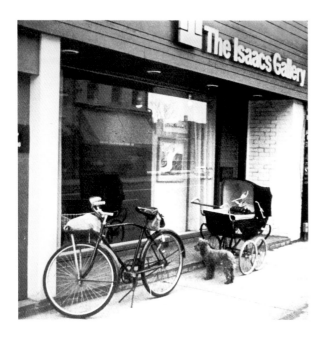

The following essay about a Toronto gallery and its artists is adapted from the publication 'Toronto Suite' of 1988. The historian is Dennis Reid, now chief curator of the Art Gallery of Ontario and a long time observer of Isaacs events. Michael Torosian, photographer and printer of 'Toronto Suite' interviewed Av Isaacs and added the gallery owner's voice (in italics here) to Dennis Reid's text.

In 1986, when The Isaacs Gallery moved to new premises, after twenty-five years in their Yonge Street location, it was naturally an occasion that elicited appraisal and cele-bration for one of the most enduring galleries in Canada. A tribute of particular significance came from Robert Fulford, a supporter and monitor of the scene from the very beginning: "In time Isaacs became the leading dealer in Canada, the one who did more than anyone else to shape critical taste and develop an audience for new art!" Fulford enunciated the fact that the gallery was not simply an entrepreneurial venture, but a social phenomenon.

Half of the story of this phenomenon can be found in the works of the artists, conspicuous among contemporary art in galleries across the country. The other half of the story is in the individuals, the cast of characters who aligned themselves with one gallery and the individual whose gallery showcased their work. Any analysis of temperaments and personalities would demonstrate the diversity of this group of people. From a historical viewpoint it is the gallery that is their point of intersection and public identity, and that which forges them into a community.

Avrom Isaacs was born in north Winnipeg, Manitoba, in 1926. He moved with his family to Toronto in 1941, when his father relocated in pursuit of new business interests. While a student at the University of Toronto, he and a friend started a picture-framing business.

Perhaps this is a sample of my inclinations. I wonder if I'm not a wanderer, just going in directions that present themselves. I had a cousin who lived in a community house on Bathurst Street full of post-graduate students, most of whom were in political science and economics. When it came time to go to university I saw 'Poli Sci and Ec,' and because I had some minimal familiarity with the words I took it.

Partners-to-be: Av Isaacs, Al Latner

Then I went into the framing business with Al Latner – maybe Al pushed me into it. We called ourselves University Framers, and we did very well on a part-time basis, so like fools we thought it would be a good thing to go into. After a year, Al got married and I bought him out for fifteen hundred bucks in war bonds.

By the summer of 1950, Isaacs was the sole proprietor of the Greenwich Art Shop, at 77 Hayter Street, in Toronto's bohemian 'village.' Resourcefulness was perhaps his chief asset.

In the beginning, I had to make a buck any way I could, so I did framing, I had supplies, and I sold reproductions. I remember a guy wandered in one day, a jolly-looking fellow, tall, slim, good looking, and he says, "I've got an idea. I'm a good door-to-door salesman, and I think we can make some money selling religious art. You buy a bunch of pictures of Jesus and Mary, and I'll sell them." He walked the whole city of Toronto, and we split the take. We even had a rubber stamp that said "Gospel Art." But finally we ended that, and he disappeared.

Toronto's old 'Greenwich Village,' centred around Gerrard Street, west of Yonge, was a nucleus of artistic activity. That, and Isaacs's stock of art supplies, soon turned the shop into a gathering place for artists and students from the nearby Ontario College of Art.

Bill Ronald was the first artist I befriended. Then right after that, Graham Coughtry and Mike Snow. A lot of these kids used to hang around my place. The CBC television had just started, and they picked up jobs there – Graham and Denny Burton worked for the graphic department, and Tom Gibson and Murray Laufer in the paint department. Bob Markle, who painted the sign for my Bay Street gallery, made his living painting advertising signs saying things like "Lettuce 10 cents a bunch" for grocery stores on College Street. So this is where my social relations with these people began. When Graham graduated from the Ontario College of Art, he invited me to share an apartment with him, which I did for two years, and which I now refer to as my postgraduate degree in the arts.

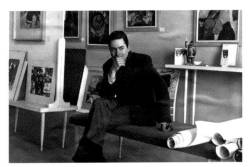

Graham Coughtry in The Greenwich Gallery

Six Weeks Intensive Art Study, 1955 (cartoon by Murray Laufer)

In 1955, I closed down the framing shop for two months and went to Europe. This was another of my postgraduate courses. I went over by myself – I have a tendency to do a lot of things by myself – and just wandered through England, Scotland, France, Holland, and Italy, looking at galleries.

During the years of the framing shop, Isaacs had been hanging out with, and even sometimes selling the work of, this group of young artists, but there were no formal exhibitions. On his return from Europe, he decided to establish a gallery, and late in 1955 he opened a new space, the Greenwich Gallery, at 736 Bay Street, just around the corner from his old location. The framing shop – his financial mainstay – was now in the back room.

Graham and Mike tell me they decided there was no place to show pictures so they talked me into opening my first gallery. The artists in my first show were a very diverse group. They had nothing in common except the fact that I chose them; they were people I was sensitive to. I picked them out of instinct. I was totally insecure for perhaps the first five or ten years. I didn't know whether I knew anything or not. I went with what I felt was good, but I didn't know if I was on the right track. I had certain sensitivities, and you can trace these through the artists in the show.

The five painters Isaacs chose to launch his new space did not share any particular theories or ideologies. Robert Varvarande presented figurative works of an abstract nature. The pictures of Michael Snow and Graham Coughtry conveyed a sense of the particular spatial and atmospheric character of postwar European art, while also revealing an interest in the gestural concerns of the New York School. William Ronald, a member of Painters Eleven, displayed brilliantly vital responses to Abstract Expressionism. Gerald Scott, the most traditional of the five, exhibited intense, painterly portraits.

The debut of the Greenwich Gallery was part of what veteran art dealer Blair Lang has called "the beginning of the golden years of art dealing in both North America and Europe." Critic Robert Fulford, delighted with this dramatic burgeoning, described it as "a spectacular city-wide show, the first of its kind we have ever seen!" By 'show' Fulford meant the entire artistic scene, where new galleries "are born and they die … they blossom gloriously with triumphant new talents."

A steady stream of new artists exhibited over the next three or four years. Outstanding among them were the painter Tony Urquhart and the sculptors Gerald Gladstone and Anne Kahane.

At the end of the 1950s, Isaacs had engaged a significant wave of young artists – individuals who, along with Coughtry and Snow, have in most cases remained with the gallery. The work of this core group has, by its force and the nature of its concerns, established an ethos and 'look' that has been identified with Isaacs's gallery ever since. All of them were deeply involved with New York abstraction, turning it to an examination of fundamental drives and emotions. Their work conveyed a high regard for the physical properties of paint and an expressive brashness.

All of these artists emerged from the growing cultural scene in Toronto, from the coffee-houses and jazz clubs that appeared on the fringes of the old village. As diverse in certain aspects as Isaacs's original five had been, the members of this expanding group were more part of 'the scene.' They frequented the same anti-establishment bars and clubs, as well as one another's studios, talked about books, and shared a passion for music. Dennis Burton, Richard Gorman, Robert Markle, John Meredith, Gordon Rayner, Joyce Wieland – this new and youthful Isaacs group, confidently innovative, soon represented the leading edge of avant-garde art in the country. Isaacs's sensitive response to the artists' integrity was probably the most effective support he could give them.

I started off showing Canadian artists, and to this day I show Canadian artists. Initially it was because I felt this was a young country and we had to do a lot of self-exploration before we could go anywhere. Then I continued showing only Canadian artists, for a reason that may be outdated today, because of the cultural monster to the south of us. I felt that unless we kept stressing our own we were going to be overwhelmed.

At an early stage, I realized that there were a lot of creative people around but it's the ability one has to persevere that is crucial. I believe in developed instinct, because when you take on a young artist – and that is what a lot of the artists I've taken on are – five years down the road you don't know where they're going to be. They change and develop so rapidly.

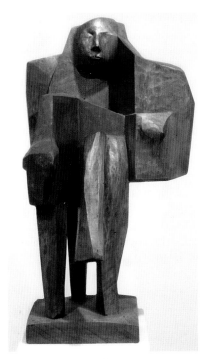

Anne Kahane, *Portrait*

His artists were quickly gaining prominence both at home and abroad. Graham Coughtry and Tony Urquhart were chosen for the Guggenheim International Exhibition in New York and joined Michael Snow and Gerald Gladstone at the Carnegie International in Pittsburgh.

By the end of the 1950s, Isaacs's gallery had secured its place in the vital creative life of Toronto. The Greenwich Gallery Poetry Nights were organized in the spring of 1958 by Raymond Souster and Ken McRobbie and a small committee that included Robert Fulford. By the autumn, these Contact Press Poetry Readings had become a valuable part of the local literary scene. The culmination would come in April 1960 with a reading by the American master Charles Olson.

In September 1959, Isaacs renamed his space The Isaacs Gallery. "I found it very embarrassing to name a gallery after myself," he recalls, "but the boys finally convinced me."

He established his own imprint, Gallery Editions, to publish books in which the artists illustrated the work of local poets – in emulation of, he candidly acknowledges, his 'patron saint,' Ambroise Vollard, the Parisian impresario. Although only two such volumes were produced in 1961-62, they are among the most elegant Canadian books of their day: *Eyes without a Face*, by Ken McRobbie, with a cover and etching by Graham Coughtry, and *A Place of Meeting*, by Raymond Souster, with a cover and drawings by Michael Snow.

In 1956, Isaacs had started exhibiting European graphic art. He presented at least one large show a year and in 1958 also introduced contemporary Japanese woodblock prints. These exhibitions, though staged for pragmatic reasons, also complemented the general ambience of the gallery.

I had to find things to sell, and I was trying to figure out where I was. There was a new industry in lithographs in France after the war, and suddenly this whole exploitation of prints by artists like Chagall and Picasso began. I bought some prints from a friend of mine living in Paris and sold them for $75 to $125 apiece. Today they would be worth thousands. I had a show of Japanese woodblock prints because some guy who'd been with the Canadian embassy and had connections came in one day. So you had this and that. I was new at the game.

We also developed quite a framing business. Bill Kurelek came to work for me about 1958. He had apprenticed for two years as a master framer and gilder in London, England. He brought in some of his own paintings to show me the calibre of his framing, and I was immediately impressed by his capacity as an artist. A little later, I hired an English cabinetmaker to be the foreman. We worked in the old tradition of framing – you start with a raw piece of wood and you shape it and finish it. It was astonishing. Bill had 'goldene hands,' as my mother would say. The framing was just wonderful. We've got frames in the Art Gallery of Hamilton, Hart House, the Art Gallery of Ontario, all over. Half the framers in Toronto apprenticed with me.

In March 1961, Isaacs moved his gallery into custom-designed quarters at 832 Yonge Street, just north of Bloor. The new facility, designed by architect Irv Grossman, was one of the best environments anywhere for the viewing of contemporary art. The clearly lit, expansive white spaces were easily adaptable. A striking cedar ceiling ran out through a glass front wall and up the façade of the building, declaring the bold modernity of the largest private gallery in Toronto.

In the pamphlet issued to mark the opening, Hugo McPherson concluded a short essay with the declaration that The Isaacs Gallery had become "a major institution in the artistic life of the Canadian community!"

For the opening show, I chose works as the best of what I had sold to show the calibre of what I was having. My taste was evolving. I was gradually picking up a bigger and bigger 'stable,' and these artists had evolved rapidly too. When I was on Bay Street, there wasn't an artist who was thirty – it was still a young group.

Sometimes the artist can get ahead of you. What I mean by that is sometimes an artist will have a show and it may be six months or a year until you finally develop your full appreciation of it. I always believe in the theory that there is some kind of time clock working in the back of your head which will eventually help you to resolve whether something works or not. You take an artist on because you think he's got something, and you always give him the benefit of the doubt.

An exhibition the following December (1961) provided evidence of Isaacs's openness to the unorthodox. This seminal show featured new works by Burton, Gorman, Rayner, Snow, Wieland, Coughtry's brother Arthur, and a young artist named Greg Curnoe. Robert Fulford called it "Anarchy" in the headline of his approving review, accurately describing it as Neo-Dadaist. University of Toronto professor Michel Sanouillet, a historian of the original Dada movement of 1916-24, noted in Canadian Art magazine that the show was the first local manifestation of the renewed interest in Dadaism that had been growing in New York and Paris.

Toronto had started to move at a very rapid pace. There was a fantastic feeling of confidence and optimism. The younger generation believed in their ability to do well. For all sorts of economic and historical reasons, Toronto was meant to be the city it is today. I was swept along in the explosion. I was completely immersed in it.

The Isaacs Gallery in fact was the principal focus of this activity. Michael Snow's first *Walking Woman* show at the gallery, in March 1962, was a foretaste of the radical rethinking that painting and sculpture would undergo. Another landmark in the development of cross-media tendencies was a four-evening festival of Canadian experimental film in February 1964. Organized by Isaacs in response to what he called "the growing bond between painters and sculptors and artists in the medium of film," the show featured cinematic works and animation, plus a display of drawings by Norman McLaren. In December of the same year, the Artists' Jazz Band played at the Isaacs for the first time.

The most ambitious programme, however, was the gallery's series of five Mixed Media Concerts from November 1965 to the following April. Arranged by Isaacs and the composer Udo Kasemets, the series crystallized Toronto's earliest interest in what would ultimately develop into performance art. The concerts were seminal events in the city's cultural life. They were formidable and energetic, and they are central to an understanding of the art scene in general and the Isaacs artists in particular.

One of the things I'm most proud of is that so many avant-garde people were associated with The Isaacs Gallery in the performance series. This was a great experience for me. Here were these wonderful concerts, and I hadn't even heard of half the people. To participate to the extent of having promoted them and listened to them was tremendous – I learned a great deal. We brought in some of the most avant-garde musicians in the world. Stockhausen came and performed. I think we brought something to Toronto that Toronto had never seen before.

The Isaacs Gallery actively promoted sculpture. Exhibitions included figurative work by Anne Kahane and John Ivor Smith, large-scale forms by ceramicist Arthur Handy, and the more idiosyncratic pieces of Walter Redinger. A show in March 1965 entitled *Polychrome Construction*, which included the work of Donald Judd, provided an early glimpse of new minimalist influences. That November marked the gallery debut of Les Levine, an artist who pioneered the expansion of sculpture into environmental spaces and made radical use of industrial processes and electronics. The more traditional John MacGregor and Reg Holmes also exhibited, as did the architect-sculptor Nobuo Kubota.

Photographer Michel Lambeth had long been a presence on the art scene and an intimate friend of the Isaacs artists. His work, of the 'documentary humanist' school, concerned with personal reflection and social commentary, was a pioneering force in Canadian photography. The Isaacs showed selections from his portrait of Toronto in 1965 – perhaps the first one-man show accorded a photographer in a Toronto commercial gallery. In addition to future exhibitions by Lambeth, photography had an intermittent presence in the gallery, with shows by Ralph Greenhill, Arnaud Maggs, and Morley Markson.

Isaacs's core group remained in the vanguard throughout the 1960s, but there were notable additions. Jack Chambers showed his highly crafted, intensely personal figurative pictures from 1962 to 1967. Greg Curnoe, with his often-controversial paintings and constructions, joined the gallery in 1966. Christiane Pflug, now something of an underground figure (a consequence of her limited output and her early death), exhibited her engrossing realistic work in 1962 and 1964.

The first one-man exhibition by William Kurelek occurred in 1960. His paintings, often didactically Christian, are as often obsessive in a manner that resembles the work of primitive artists.

> He's an exception to the rule, whatever the hell the rule is. Kurelek was a deceptive artist. People called him a naïve artist. In fact he was no such thing. There was a peculiar twist to his work. If you have it hanging in your house, after a while it starts to magnify itself and bear down on you. If you met him you'd think he was lethargic, but he was a driven, possessed man.

Kurelek was one of the gallery's most prolific and popular artists. His paintings, along with those of Snow and Rayner, have been among the most frequently exhibited.

Isaacs's diverse interests inspired shows throughout the 1960s. His gallery hosted regular exhibits of Eastern and tribal art, including antique Oriental paintings and African carvings, reflecting the growing interest in non-Western art that often influenced some of his own artists.

> It was always clear that my primary direction was contemporary Canadian art, but I also have very eclectic tastes and I like finding strange things that interest me. Without a doubt the majority of my shows were Canadian, but running through them was a trail of this and that. Perhaps it was a bit of showmanship – I realized it would be nice to mix it up.

> By 1961, I was handling Eskimo art, and in both 1968 and 1969 I mounted formal shows. I believed it was an important art form, but I realized I couldn't do the job it deserved through The Isaacs Gallery, so I opened my second gallery. My motives were really quite altruistic. I know my accountant told me I was crazy. Well, the strangest thing happened – it was an immediate success.

> I was making money with The Isaacs Gallery, a very modest amount. With the Innuit Gallery, I was making a comfortable living. I run it the same way I run The Isaacs Gallery – it's not a 'shoppe,' it's a gallery with formal exhibitions.

The Innuit Gallery opened at 30 Avenue Road in the spring of 1970, the first commercial gallery in the world devoted solely to Inuit art.

The establishment of the new showcase clarified Isaacs's role in the avant-garde scene and also aided in the development of a market for Native art. The gallery continued to hold exhibitions of tribal paintings and sculptures throughout the 1970s. In July 1976, Isaacs staged a show of Indian artefacts from the Pacific northwest, marking a new interest that gradually superseded his pursuit of other non-European art. His reputation in this specialized area would eventually grow to international proportions, abetted by the expertise of Martha Black, his assistant of twenty years.

The Isaacs Gallery, reflecting its owner's commitment to fresh ideas, took on several new artists in the early 1970s. Gar Smith's first solo show, in March 1970, consisted of a large slide-projection piece. Two months later, John Greer was introduced to Toronto audiences with a show of visual puns and perceptual tricks made of huge elastic bands. In February 1972, Mark Prent exhibited the first of his lifelike sculptural tableaux depicting grotesque deformity and carnage. Angus Trudeau, introduced in 1973, was an Odawa from Manitoulin Island and a retired ship's cook; he made wonderful models and vivid paintings of Great Lakes steamboats – a presage of the now-popular genre of folk art. A series of group shows throughout the decade would lead to the debuts of Mark Gomes in 1978 and of Brian Burnett in 1979.

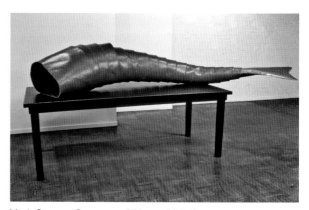

Mark Gomes, *Common of Piscary* (detail)
Art Gallery of Hamilton

In the sixties, I almost had a monopoly, or at least a vital part, of a scene. In the seventies, there were a lot more galleries, Toronto was expanding, and the action spread out. I still had a terrific gallery, but there were a lot of other galleries doing terrific work too.

I think my political science and economics education helped me in an indirect manner. I always had a historical perspective. I knew that time would go by and sooner or later someone else would be the big gun. The way I look at it, I was the hotshot of the sixties, Carmen Lamanna was the hotshot of the seventies, and Ydessa [Hendeles] was the hotshot of the eighties. I don't know that I ever felt I was the centre of it all, even though at times I was.

It was in 1972 that The Isaacs Gallery faced its most significant crisis. A series of incidents arising from the first of two exhibitions by Mark Prent brought unprecedented publicity and controversy.

Following a visit from the police during the course of the first show, in February, Isaacs was charged under an obscure and hitherto-unused section of the criminal code that prohibited the public display of a so-called 'disgusting object.'

From the day we opened, the vibrations were on. Within no time at all we went from having fifty people a day to five hundred, and on Saturdays we'd have a thousand. He was young, and the stuff was very raw. People did strange things; we had to hire security guards. Suddenly I was a potential criminal.

Isaacs contested the charge, and it later became apparent that a right-wing political extremist had made the complaint. The case was dismissed on a technicality when it went to trial in October, but Isaacs remained uneasy. He knew that the law, now highly publicized, had not been tested in court.

His concern was well founded. Part way through Prent's second show in January 1974, the same charge was laid again. Isaacs and his lawyer forestalled a judgment while they challenged the law in the Supreme Court of Canada. They lost, but in December 1975 a grand jury ruled that the case should not have gone to trial. Ultimately, Parliament removed the offensive section. The charges had carried a heavy symbolic weight, and the harassing manner of their application was deeply disturbing.

In the early 1980s a crisis of a different sort came with an economic recession. Yet even during this difficult period The Isaacs Gallery took on new artists. Stephen Cruise, Gathie Falk, and Ed Radford all had their first exhibitions in 1982. Oddly enough, the dramatic economic recovery – more specifically the boom in Toronto – caused even greater hardship. Rent on the gallery soared, forcing Isaacs to move.

When I opened on Yonge Street in 1961, it was one of the highlights of my career. The night before the gallery opened I went across the street and looked into the gallery and thought, "That's my gallery." I was so impressed by it. It was a major commitment. I had the same feeling when Mike Snow had his first retrospective at the Art Gallery of Ontario. I was very proud to be associated with him. There is always a fair degree of pride when something happens for one of your artists and you can share in it.

I was forced to leave Yonge Street because they increased my rent by 250 per cent. In retrospect, it was a good move because I had a chance to take new attitudes.

In late 1986, Isaacs opened his new location at 179 John Street, just north of Queen West, a region favoured by the current generation of artists. As always, the gallery would remain in the heart of the artistic community.

I had an opening which was one of the events of the year in Toronto. The place was jammed. All kinds of people I've never seen before or since. It was a great occasion. There were television cameras, gifts were given to me, I was on a receiving line all night long. I wasn't swept off my feet. In the back of my mind, I knew the next morning it was back to work.

Today (1988) the core artists from the 1950s continue to dominate the scene, their remarkable work still a feature of The Isaacs Gallery. The artists who developed out of the great ferment of the late 1960s, and who sought alternatives to traditional painting and sculpture, with their conceptual art and installation work – Cruise, Gomes, Greer, Prent, and Smith – now also carry the authority that only time, talent, and perseverance can bring. The so-called new figurative painters who blossomed at the beginning of the current decade, marking the resurrection of a much-maligned medium, found a particularly sympathetic environment in The Isaacs Gallery, which had never lost faith in painting. Responding to talent, not fashion, Isaacs discovered in Brian Burnett, Gathie Falk, Ed Radford, and Lorne Wagman distinct personalities rather than representatives of a style.

This dynamic stratification – three generations of artists, all vitally contemporary yet each rooted in a distinct historical moment – is unprecedented in a commercial gallery. A microcosm of the major currents in Canadian art coexists in The Isaacs Gallery. The exhibitions continue in their remarkable diversity, just as they had begun three decades earlier.

I think it's a great time – there is a tremendous amount of richness and vitality. The good thing Toronto has going for it is that it's the centre of Canada and a centre. There is a constant coming and going, with a constant freshness of ideas. How much there is of a nature that might be important twenty or thirty years from now I can't assess, nor can anyone ever assess.

When Barry Hale died, we had his wake at the gallery. A few of us talked about things, and Bob Markle, who has a great mind, got up and said, "Our era is a very important era. Maybe none of us will be known fifty years from now, but I think it's a seminal period. Certain things happened in the city at this time among this group of artists that will have a lasting effect." Something was established – an attitude, a direction. The scene was creative.

This essay by Dennis Reid is adapted from *Toronto Suite* published by Michael Torosian's Lumiere Press, 1988.

at the Gallery

DENNIS BURTON

JACK CHAMBERS

GRAHAM COUGHTRY

GREG CURNOE

RICHARD GORMAN

WILLIAM KURELEK

WILLIAM RONALD

JOHN MEREDITH

CHRISTIANE PFLUG

ROBERT MARKLE

TONY URQUHART

JOYCE WIELAND

GORDON RAYNER

UNKNOWN, SIBERIAN

MICHAEL SNOW

JESSIE OONARK

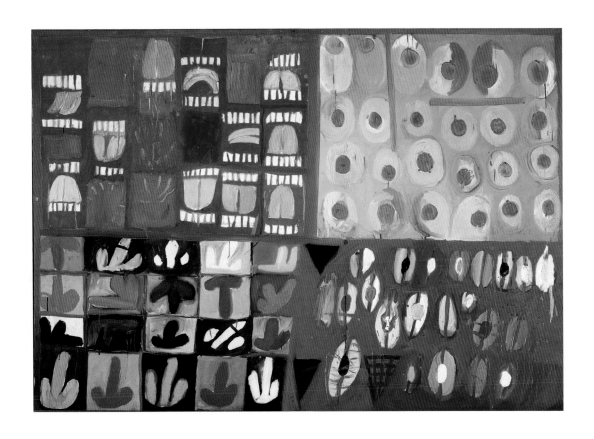

Dennis Burton (Canadian, 1933 –) The Game of Life 1960

Oil on canvas, 137.4 x 198.3 cm

National Gallery of Canada, Acc. No. 15444

Purchased from Isaacs Gallery Toronto 1968

© Dennis Burton

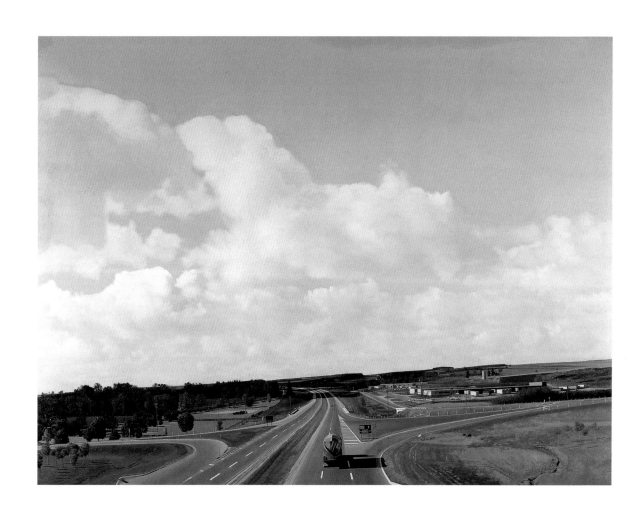

Jack Chambers (Canadian, 1931 – 1978) 401 Towards London No. 1 1968-1969

oil on mahogany, 183.0 x 244.0 cm

Art Gallery of Ontario, Toronto, Acc. No. 86/47

Gift of Norcen Energy Resources Limited, 1986

© Diego Chambers/AGO

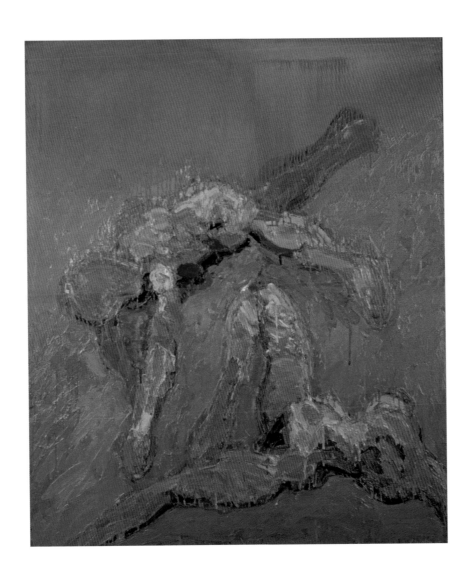

Graham Coughtry (Canadian, 1931 – 1999) Two Figure Series #10 1963

182.88 x 157.48 cm. Oil on canvas

Hart House Permanent Collection

Purchased by the Art Committee 1964, Acc. No. 1964.2

© Hart House

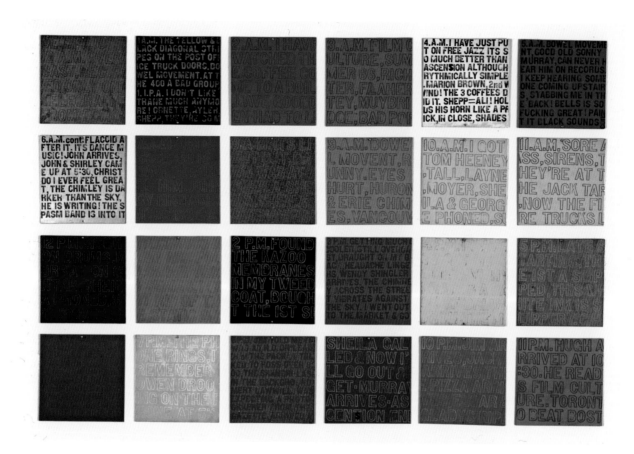

Greg Curnoe (Canadian, 1936 – 1992) 24 Hourly Notes 1966

Stamp pad ink on acrylic, oil,enamel, day-glo, liquid silver and blackboard paint on

Galvanized iron. 24.5 x 25.4 cm (each)

Art Gallery of Ontario, Toronto, Acc. No. 2000/70

Purchased with the help of Av Isaacs, 2000

© Estate of Greg Curnoe/SODRAC (Montreal) 2005

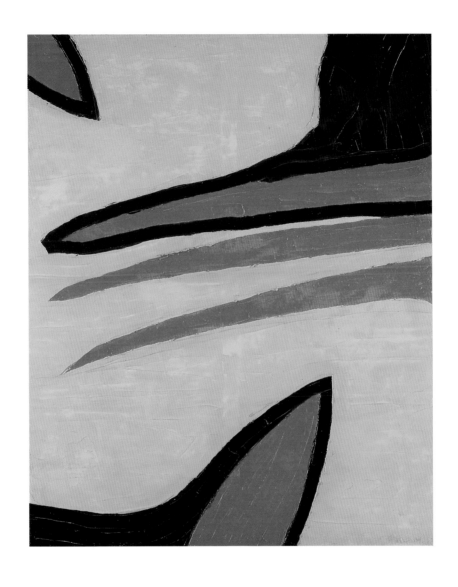

Richard Gorman (Canadian, 1955 –) Spitfire 1963

Oil and acrylic resin on canvas, 212.5 x 174.5 cm

Art Gallery of Ontario, Toronto, Acc. No. 2003/1318

Gift of May Cutler, Westmount, Quebec, 2003

© Richard Gorman

(Canadian, 1927 – 1977) William Kurelek We find all kinds of excuses 1964

Oil on hardboard, 120.5 x 182.2 cm

Art Gallery of Ontario, Toronto, Acc. No. 2001/165

Gift of the Estate of Annette Cohen, 2001

© The Estate c/o The Isaacs Gallery

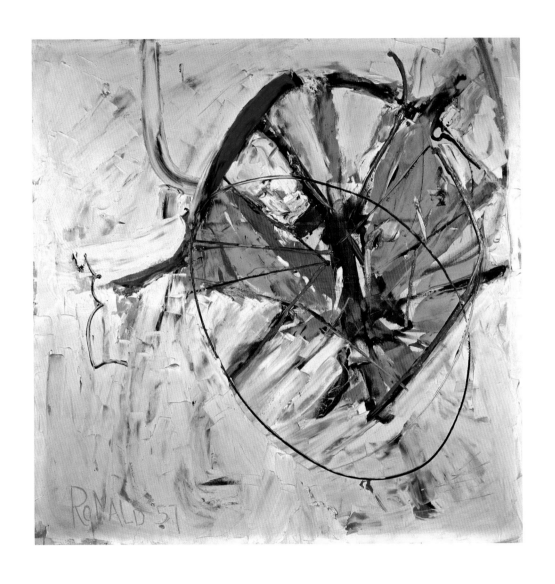

William Ronald (Canadian, 1926 – 1998) Karma 1957
Oil on canvas, 125 x 125 cm
Private Collection
© Helen Ronald

John Meredith (Canadian, 1933 – 2000) Seeker 1966

Oil on canvas, 177.8 x 366.4 cm (triptych)

Art Gallery of Ontario, Toronto, Acc. No. 66/23

Purchase 1967

© Kayoko Meredith Smith

Christiane Pflug (Canadian, 1936 – 1972) Kitchen Door and Esther 1965

oil on canvas, 159.5 x 193.0 cm

National Gallery of Canada, Ottawa, (40963)

Purchased 2002

© Michael Pflug

Robert Markle (Canadian, 1936 – 1990) Conversation Series : Gordon Rayner 1988

acrylic on paper, 75 x 110 cm

Private Collection

© Marlene Markle

Tony Urquhart (Canadian, 1934 –) In Hiding 1961

Oil on canvas, 139.3 x 127.1 cm

National Gallery of Canada, Acc. No. 17030

Purchased from the artist, London, Ontario, 1972

Joyce Wieland (Canadian, 1931 – 1998) Paint Phantom 1983-84

Oil canvas, 170.2 x 121.9 cm

National Gallery of Canada, Acc. No. 28803

Purchased from The Isaacs Gallery, Toronto, 1985

© National Gallery of Canada

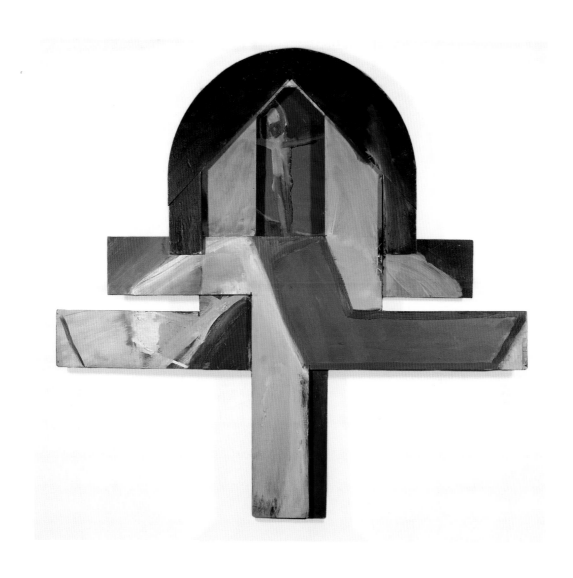

Gordon Rayner (Canadian, 1935 –) The Rood 1962
Wood/painted construction, 130 x 135 x 7.5 cm
Private Collection
© Gordon Rayner

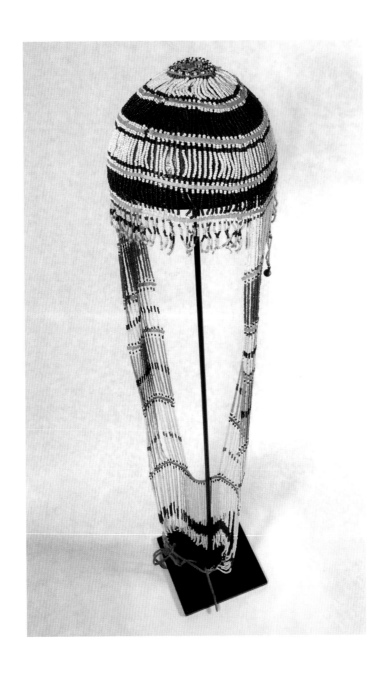

Unknown, Siberian Woman's Dance Headdress 19th Century

Threaded glass beads, 83 x 16 x 16 cm

Private Collection

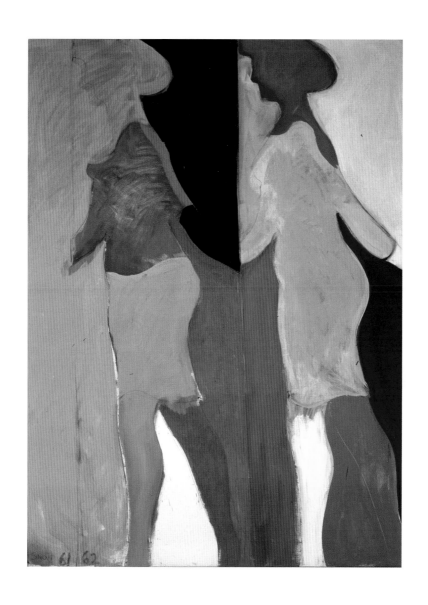

Michael Snow (Canadian 1929 –) 61/62 1961-62
Oil on canvas, 151.25 x 112.5 cm
Private Collection
© Michael Snow

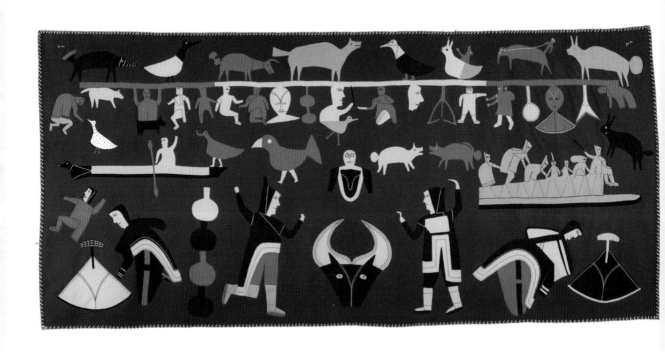

Jessie Oonark (Canadian: Inuit, 1906 – 1985) Untitled Wallhanging 1971

stroud, embroidery floss, thread, 148.5 x 329.2 cm

Art Gallery of Ontario, Toronto, Acc. No. 91/177

Gift from the Junior Volunteer Committee, 1991

© Public Trustee for Nunavut, Estate of Jessie Oonark

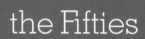

the Fifties

recollections from Av and:

LOTTA DEMPSEY

 MICHAEL SNOW

DENNIS BURTON

WARREN COLLINS

TONY URQUHART

MURRAY LAUFER

Greenwich Art Shop, 1950. Av Isaacs, Abe Chaplan, Murray Laufer, Wally Cohen, and Bernie Waldman.

fifties memories

So there I was, a graduate of the honours course in Poli-Sci and Ec, sawing wood, joining mouldings, and fitting pictures into frames. The place (Greenwich Art Shop) was very modest, probably about 10 feet by 20 feet, with a framing area in the back.

We were located on Hayter Street, one block north of Gerrard, in 'The Village.' Fred Varley had a studio nearby; Pauline Redsell, a sculptor, and Albert Franck and his wife, Florrie, lived there. Albert survived by doing restoring and by selling hand-painted cards, together with his paintings. The area had an antique shop, a lamp maker, a masseuse, and Mary John's Restaurant. For twenty-five cents you were handed the large, fresh salad bowl and allowed to help yourself … the trick was to eat as many helpings as possible before the bowl was removed.

There was a lot of local colour, such as a drunken sword fight in the street one day and a noisy confrontation one Christmas. Albie Franck (who could get very uptight) started playing Xmas carols to advertise the Xmas cards he was selling. Across the street, Willy Fediow, the lamp maker (an easy-going Ukrainian), played a rival speaker. Both men kept turning up the volume. It was a loudspeaker duel, using Xmas carols for bullets. We finally had to call in the police.

In the same area was a gallery that handled decadent nineteenth-century paintings (e.g., the sleeping cardinal in his chair in front of the fire) and Maloney's Gallery (really a bar), a few doors away from Varley. Upstairs Campbell's picture framers, a group of older men, did much of the framing for the Group of Seven. They were wonderful craftsmen and must have looked on me with some amusement.

Proud framer, 1954

douglas duncan

I first became aware of Douglas Duncan and his Picture Rental and Loan Gallery soon after I opened my framing business, the Greenwich Art Shop. Douglas came from a wealthy family, which had a peculiar effect on his modus operandi. Among other things, he had a tendency to forget to deposit the cheques from his sales into the bank. A number of clients complained to me they had to cancel stale cheques because of his "carelessness."

Douglas Duncan was the only dealer at that time who showed younger artists like Jack Nichols and Harold Town. He also exhibited artists who had yet to be properly appreciated, such as David Milne and Paul-Emile Borduas. As far as I was concerned, he was the only game in town. I was so honoured when he would drop in to visit me at my small framing shop. By then, I had a few paintings by Graham Coughtry and Michael Snow on the wall.

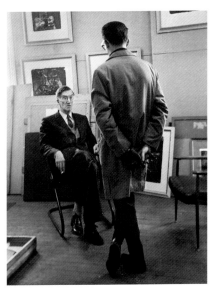

Douglas Duncan

Douglas always had a cigarette going. He was lean and gangly, and when talking to you, he would squat with his back against the wall. Maybe he was tired at having to look down – he was taller than just about everyone. I guess what I appreciated most about him was the fact that, given I was just starting out, he did not talk *down* to me. He was one of our great collectors, and when he died in 1968, his personal collection was so large that pretty well every public gallery of any consequence in Canada benefited. He really was a pioneer on an art frontier.

kenneth forbes

Soon after opening my framing shop, I started to introduce a couple of lines of art supplies. One of my customers was Kenneth Forbes, an academic painter who did a great many formal portraits, still on view around Toronto in settings where the establishment reigns. Forbes was particularly noted for his vehement attacks on the Group of Seven, whose work he thought was of little consequence, as it suffered from the 'disease of modernity.'

On one occasion, he invited me into his studio. In the centre of the room was a wire-haired terrier – stuffed. I was somewhat taken aback. Forbes pointed to a large canvas on an easel. It was a family portrait. The family pet had had the temerity to die before he could finish his work, so he had sent the dog out and had it stuffed, just so he could do a formal precise depiction.

Mr. Forbes, the extreme realist, deplored the Group of Seven and was unstinting in his attacks on contemporary abstract art. "It's a fad," he said. "It's a flash in the pan. It won't last."

Somebody passed these remarks along to Harold Town, the highly articulate abstract expressionist. "Kenneth Forbes ... Kenneth Forbes," Harold mused. "I thought he was dead ... of course, I only had his paintings to go by."

william ronald

Bill Ronald was always very intense. He came into my framing art supply shop one day in an absolute rage.

Jock Macdonald (J.W.G. Macdonald) was probably the only enlightened art teacher at the Ontario College of Art. He had recently come from Vancouver, where he and Fred Varley had an art school, and was a very progressive teacher who veered towards the abstract.

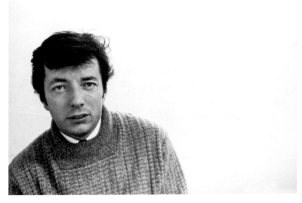

William Ronald, abstract expressionist

Bill had done a number of watercolours while studying with him. One day, in the middle of an exam Bill was having at the Ontario College of Art, Carl Schaefer came storming into the room, slammed down one of Bill's watercolours on his desk, and asked: "Who the hell do you think you are, and how dare you do this piece of crap?" He proceeded to berate Bill in front of the whole class. Bill, who was very emotional, came over to my place and poured it all out.

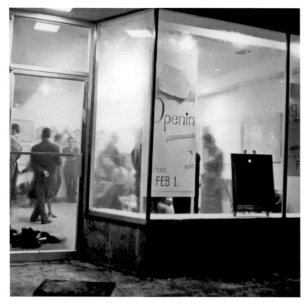

Greenwich Gallery Opening, February 1, 1956

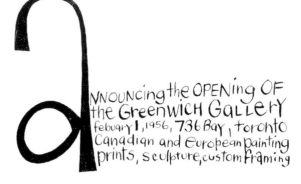

Ad opening Greenwich, 1956

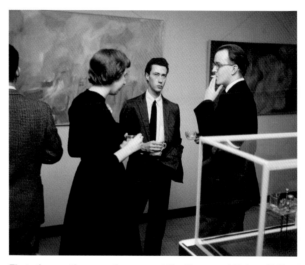

First of many times on the scene: Mike Snow and Robert Fulford, critic.

The Coughtrys: Mother, brother Arthur and Graham.

AV ISAACS' MANIFESTO: 1956

In choosing this exhibition to mark the opening of the Greenwich Gallery, I have endeavoured to present a visual statement of the gallery's aims for the future. While these five young painters represent diverse directions in painting, their work suggests, I believe, a common standard of artistic integrity and it is my earnest intention to adopt this standard and grow with it as it grows, rather than trying to adjust to any mythical "level of public taste."

I hope to make the level that is evident here attractive and easily accessible to the public by making it possible for people to buy paintings by contemporary Canadian painters on a time-payment basis and by featuring low-priced Canadian and European graphic art. Arrangements are also being made to exchange exhibitions with galleries in other countries, and this, along with a planned program of discussion evenings and similar events, should help to make the Greenwich Gallery one of the centres of artistic activity in Canada.

The opening exhibition conveys some of the excitement and optimism that the painters involved and I feel towards these projects.

I also make the best frames in town.

Artist Michael Snow and the elegant Mrs Roy (mother)

Mrs Gerald Scott (Joyce) and collectors…

Excerpt from: *Lotta Dempsey, "Person To Person,"*
Globe and Mail, 16 Feb. 1956

"It is fitting that a small collection of the work of Graham Coughtry, William Ronald, Gerald Scott, Michael Snow and Robert Varvarande should form the opening exhibition at the new Greenwich Gallery at 736 Bay St.

I spent an exciting hour there the other morning with four of the artists (William Ronald, who is also a textile designer, is already finding success in New York) and the proprietor A. Isaacs.

I like Mr. Isaacs and his idea of a small gallery in which good contemporary work will be shown and to which groups of artists and art lovers may come for discussions, afternoon or evening. There will be special evenings set for discussions.

I cannot describe the stirring sense of youth and vitality in the paintings better than to quote Mr. Isaacs.

'While these five young painters represent diverse directions in painting, their work suggests, I believe, a common standard of artistic integrity, and it is my earnest intention to adopt this standard and grow with it as it grows, rather than trying to adjust to any mythical level of public taste.'

Pictures sold on the installment plan, like TV sets, and exchanges of European and Canadian art are in his plans. To keep the dream afloat, Mr. Isaacs also does picture framing."

And in the midst of it all …

"Five Young Painters"

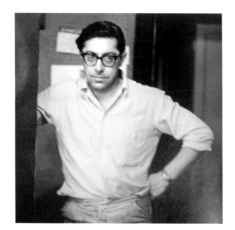

Robert Varvarand

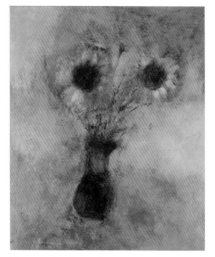

Varvarande, *Vase of Flowers*

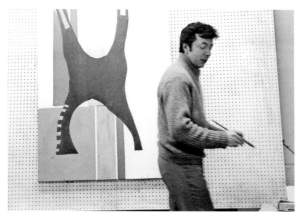

William Ronald

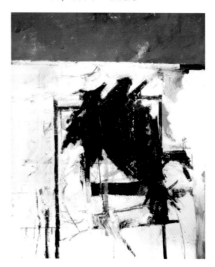

Ronald, *Central Black,* Robert McLaughlin
Gallery, Oshawa

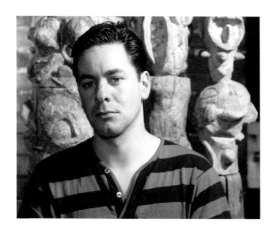

Graham Coughtry

Graham Coughtry, *Interior in Late Afternoon*

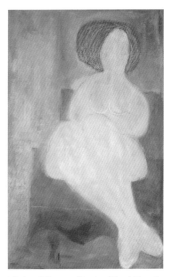

Michael Snow: *Seated Red Head*

Michael Snow

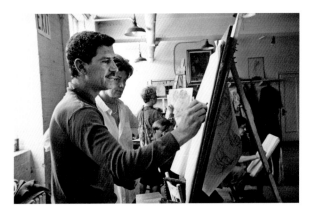

Gerald Scott

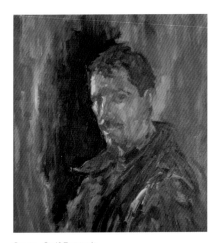

Scott, *Self Portrait*

MICHAEL SNOW

Perhaps it was Graham Coughtry, maybe Murray Laufer, who first took me to the tiny Greenwich Art Shop, saying that the proprietor did good framing cheap, but also that he would HANG THE WORK AND TRY TO SELL IT! We three were at the Ontario College of Art (OCA) the same years, but they were in drawing and painting and I was in design (with a great teacher, John Martin), although I was becoming more and more interested in drawing and painting.

When the Greenwich Gallery moved around the corner to Bay Street, Av Isaacs, the proprietor, took along some of the artists he'd already encountered, and I had my first solo exhibition there in 1956.

Once Av felt convinced of the quality of intensity in someone's work – and of course this decision was "intuitive" – he was surprisingly trusting and confident. We would agree on a date when an exhibition would be possible. I generally described what I was working on and planning to show. When it came time for the exhibit, he usually saw the work for the first time when it was delivered. I always planned what might go where, but hangings were always interesting, with the two of us deciding mutually what would look best.

bay street

When I opened my first real gallery on Bay Street, I had a series of openings with very little commercial success. I found it particularly frustrating because Roberts Gallery was having sell-out exhibitions with much more traditional artists. There were line-ups for its openings.

As I was a competitive person, it would almost give me ulcers. To its credit, despite its traditional position, Roberts Gallery gave the *Painters 11* its first exhibition.

joseph hirshhorn

Joseph Hirshhorn, along with Franc Joubin, became a great developer of a very successful mine in northern Ontario. He was also one of the great international art collectors. Every once in a while, he would hit the galleries in Toronto, to the great benefit of the dealers. He was a short, tremendously energetic man and kind of drove you ahead, like a herder.

The first time he came into my gallery on Bay Street, I happened to have a one-man exhibition of Graham Coughtry. Without much hesitation, JH circled the gallery quickly and asked for total prices on three or four canvases. Then he changed his choices two or three times. His mind was racing ahead of me, and he was doing his calculations a helluva lot faster that I could. He ended up purchasing three paintings, much to Graham's and my delight.

JH had a habit of not wanting to waste time. So whenever he appeared in the doorway of the gallery, he would start shouting, "Isaacs, Isaacs, where are you?" Wherever I was, and no matter what I was doing, I had to drop everything and come running.

At one time he tried to do a deal with the Canadian government to donate his art collection to Canada in lieu of taxes. He was prepared to establish a museum in Elliot Lake (where he had made his fortune in uranium mines). This deal was refused, and the art eventually went to the Smithsonian in Washington, DC, where Hirshhorn's collection is so important it is the only museum in the Smithsonian named after an individual.

graham coughtry

Graham was a very gifted natural painter. He had a great colour sense and was able to bring something unique to the figurative area. He was so talented that I felt that he had to guard against this gift in order to achieve depth. He did lack a strong sense of self-discipline and abused his body.

Coughtry's studio above Switzer's Deli on Spadina Avenue.

One of Graham's early successes was when Joseph Hirshhorn the great collector bought three of his head-and-shoulders paintings. Then Emilio del Junco, a Cuban architect who lived in Toronto and was very well connected, approached us and proposed that he give a Coughtry to the Museum of Modern Art (MOMA) in New York. Any artist would have gladly donated his work to the MOMA, just for the prestige. (Graham would receive no compensation.)

Graham Coughtry, *Portrait #4*

Larissa Pavlychenko – Graham's wife – and I went down for the opening. I guess they couldn't both afford to go. I remember that one of the other artists participating in this exhibition of new acquisitions was Fernando Botero. I do believe that Graham did have it in him to become an equally important world figure.

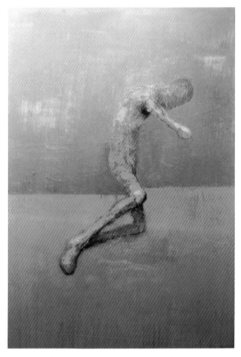

Graham Coughtry, *Leaping Figure*

At one point Graham seemed to have hit a block in his painting. He went off to the island of Ibiza, where he spent three years doing very little besides drinking and smoking. In those days the Canadian dollar had great purchasing power. Later he wrote that he wanted to come back to Toronto so I loaned him the airfare. When he returned he was full of energy, and his career exploded. He went back to the figure and handled it beautifully.

In those years, because of the strong Canadian dollar, many artists went off to Europe for extended periods. From my recollection, this included Bob Hedrick, Ross Mendes, and Gord Rayner among others.

DENNIS BURTON

I had a studio from 1956 to 1958 above Clem Hamburg's House of Jazz. Clem was located behind the present Holt Renfrew. He came from a musical family; all of his siblings were classical musicians, he was the rebel. The place was a continual source of Jazz. The Town Tavern and the Colonial offered jazz by all the greats: Gillespie, Blakey, Miles, Getz, Brubeck, Sonny Rollins, Sonny Stitt, Charlie Parker.

There were nights when there were openings at Dorothy Cameron's Here and Now Gallery, the Moos, and the Isaacs at the same time – lots of free white wine, etc. How's this for a bit of social history: Gord Rayner and Nobby Kubota and I smoked Lucky Strikes. Graham Coughtry smoked Dumauriers. Rick Gorman and John Meredith smoked Black Cat filters. John O'Keefe smoked Peter Stuyvesant, sometimes Parliament, sometimes Peter Jackson. Of course we all stopped smoking some time ago. The feeling was that Lucky Strike was close to dope.

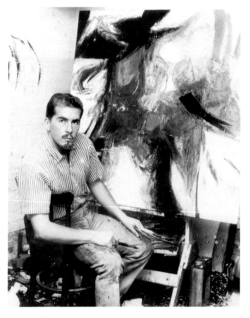

Dennis Burton's studio

Dennis Burton, *Deep Pool*, Art Bank Collection

On the day the subway opened in 1954, Rick Gorman and I went to the Yonge-Bloor station, boarded the front train, and rode it up and down from Union Station to Eglinton (the then-complete route). We sat in the first car to experience the speed and to see the tunnels and stations from the motorman's viewpoint. We rode it all day, until the last train late at night. The experience provoked a painting or two.

Dennis Burton, *Smoke Shop Sex Maraude*

Dennis Burton, *Intimately Close*

charles laughton

I was out of the gallery one day and Marlene Markle, who was fairly new in her job was left in charge. In strolled a portly figure – Charles Laughton, the great actor, accompanied by two other men. Mr. Laughton was in Canada on a reading tour and had spotted one of Dennis Burton's paintings at the Montreal Museum of Fine Art.

He asked Marlene to show him Burton's paintings and as she brought them out she explained that one of them was intended to be hung on the ceiling. At that, Charles Laughton lowered himself flat onto the floor and had his two cronies hold the painting over his head so he could see the work as intended.

To our delight, he purchased five of Denny's paintings. And before he commenced his reading that night, at Massey Hall, he told the audience what a fine artist Dennis Burton was. On his return to California, Laughton arranged the eventual purchase of fourteen more works. Can you imagine how Dennis, a young relatively new artist, must have felt!

WARREN COLLINS

I met Av Isaacs through artists Graham Coughtry, Joyce Wieland and Michael Snow, when we were working at Graphics Associates, a small Toronto company making animation films in the period 1954 to 1956.

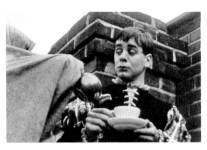

Graham Coughtry as Hamlet, Michael Snow as ghost, spoofing Salada Tea.

While at Graphics Associates, we also made spoofs on TV commercials for "Salada Tea" which the artists were working on at the time. Joyce played a 'victim' assaulted on Grenville Street and consoled with a cup of Salada tea. Graham Coughtry played Hamlet whose depression is lifted by a cuppa Salada, served by his father's ghost (Mike Snow in a Hudson Bay blanket) who joins him in a cup. Gradually everyone got into underground film making.

The poetry readings

In 1957, I was approached by two poets, Ray Souster and Kenneth McRobbie, who asked me to help sponsor a series of poetry readings at my Greenwich Gallery. The idea appealed to me, although I was not a great reader of poetry.

The result was "The Contact Readings," a series of brilliant events running from 1957 to 1962. For the first three years they took place at my gallery. Ray Souster is a man of reticence and modesty – I think in the three series of readings he read only once. Al Purdy gave his first public reading there. Leonard Cohen, Louis Dudek, Irving Layton, Marshall McLuhan, Charles Olson, James Reaney, Jay Macpherson, F.R. Scott, and many, many others also took part.

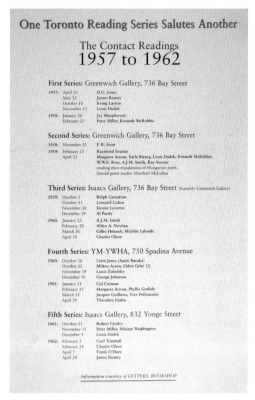

One Toronto Reading Series Salutes Another

The Contact Readings
1957 to 1962

First Series: Greenwich Gallery, 736 Bay Street

1957:	April 23	D.G. Jones
	May 12	James Reaney
	October 10	Irving Layton
	November 13	Louis Dudek
1958:	January 26	Jay Macpherson
	February 22	Peter Miller, Kenneth McRobbie

Second Series: Greenwich Gallery, 736 Bay Street

1958:	November 22	F.R. Scott
1959:	February 23	Raymond Souster
	April 25	Margaret Avison, Earle Birney, Louis Dudek, Kenneth McRobbie, W.W.E. Ross, A.J.M. Smith, Ray Souster reading their translations of Hungarian poets. *Special guest reader:* Marshall McLuhan

Third Series: Isaacs Gallery, 736 Bay Street (formerly Greenwich Gallery)

1959:	October 3	Ralph Gustafson
	October 31	Leonard Cohen
	November 28	Denise Levertov
	December 19	Al Purdy
1960:	January 23	A.J.M. Smith
	February 20	Alden A. Nowlan
	March 26	Gilles Hénault, Michèle Lalonde
	April 30	Charles Olson

Fourth Series: YM-YWHA, 750 Spadina Avenue

1960:	October 16	Leroi Jones (Amiri Baraka)
	October 22	Milton Acorn, Eldon Grier [?]
	November 19	Louis Zukofsky
	December 10	George Johnston
1961:	January 21	Cid Corman
	February 25	Margaret Avison, Phyllis Gotlieb
	March 25	Jacques Godbout, Yves Préfontaine
	April 29	Theodore Enslin

Fifth Series: Isaacs Gallery, 832 Yonge Street

1961:	October 21	Robert Creeley
	November 11	Peter Miller, Miriam Waddington
	December 9	Louis Dudek
1962:	February 3	Gael Turnbull
	February 24	Charles Olson
	April 7	Frank O'Hara
	April 28	James Reaney

Information courtesy of LETTERS BOOKSHOP

Poets and Poetry Readings at the Greenwich Gallery (soon to become Isaacs Gallery) 1957 – 1962.

Michel Lambeth, *Gwendolyn MacEwen and Milton Acorn,* Toronto

F.R. Scott was the big one for me. I'm from north Winnipeg, where we are so far to the left that the right wing is the NDP. You can imagine, then, my excitement when I heard that he was coming to read. He was one of my folk heroes – the man who took on Maurice Duplessis in the Padlock Law case and won. It was news to me that he was a poet!

Our attendance varied from about 30 to 100. You might be able to guess which reader drew the largest audience – Leonard Cohen, the lady's man. There was always a modest charge, and the poets got paid. It wasn't until the third year that the Canada Council gave us a grant of $845, which we were grateful for, even though we had asked for more.

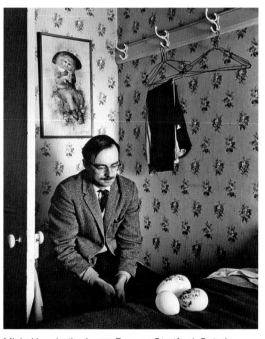

Michel Lambeth, *James Reaney, Stratford,* Ontario

william kurelek

In the l950s, my gallery and framing shop were on Bay Street. One day, a very low-key individual approached me and applied for a job as a picture framer. He had apprenticed in London, England and among other things, had mastered the art of gold and silver leafing. He had brought along four of his own paintings to impress me with their framing. I immediately gave him a

William Kurelek, *Self-portrait*

William Kurelek, master gold leaf artisan

job as a framer and asked to see more paintings as I had instantly decided to exhibit him. His name, of course, was William Kurelek.

And so began a great success story for both of us.

Bill was then living in a small room on the third floor of a rooming house where he paid his rent by painting the rooms. Because he had so little space, he had stored his paintings with several friends so half of the paintings we rounded up for his first show had been gifted to friends and so were not for sale. The rest sold immediately and public response was almost overwhelming. Bill told me afterward that this opened up creative floodgates and paintings began to pour out of him. From then until his death 20 years later, he produced over 2,000 paintings and drawings.

William Kurelek is probably the most published visual artist in Canada, with over 20 books by, on or about him.

William Kurelek, *Behold Man without God*
Art Gallery of Ontario

african sculpture

In 1957 a middle-aged gentleman visited me and asked if I would be interested in an exhibition of African sculpture. I knew very little about this area. I visited his house and in the basement saw a remarkable collection, which had an interesting story behind it. His Israeli brother had been in Nigeria (loaned by his government) to supervise the building of flour mills. When he finished his assignment, the Nigerian government insisted on giving him an expression of its appreciation – the collection that I saw and subsequently exhibited. The brother could not take it back to Israel for fear of appearing to accept a bribe! So it arrived in Canada, and eventually in my gallery, where it sold very well.
The exhibition consisted of masks and figures of a very rich variety. It was only years later, when I was better informed, that I realized I had sold a very old and valuable collection at very reasonable prices. I went on to have a few more shows of similar material but soon decided to give it up, because too many contemporary copies were being made in the African art industry.

Later I had a number of exhibitions of work from New Guinea and Papua. They were sold to me through

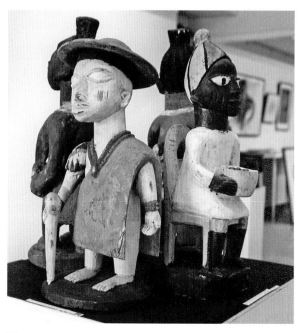

West African sculpture

Australian missionaries who supported their mission by dealing in these wonderful pieces that they acquired from the natives.

showman

I guess I was always a bit of a showman. Early on, I realized that the Canadian market was narrow, so, between my regular stable of artists, I mixed in exhibitions of early North American Native art; contemporary Japanese woodblock prints; Indian miniature paintings; a drawing exhibition by the shy NFB genius Norman McLaren; even a show of beautiful drawings by artist Christiane Pflug's two daughters, who were probably aged three and four.

John and Bill, seldom seen together

the smith brothers

William Ronald (Smith)'s brother was John Meredith (Smith). So these two siblings were Bill Smith and John Smith – not very distinctive names. So they used their middle names for their artistic careers: Bill Ronald and John Meredith. They both had astonishingly huge egos, to the extent that they couldn't stand each other.
The parents of these antagonists were tiny – about five feet tall and eighty pounds when soaking wet. Mr. Smith senior took up painting and was kind of an interesting, folky figurative painter. He said to me once, "You know, I'm a hell of a lot better than both my sons."

Australian aboriginal art

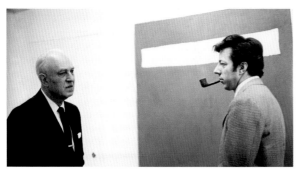

New York dealer Sam Kootz and Bill Ronald

william ronald

Bill Ronald got taken on by Sam Kootz, a very famous and important dealer in New York. Kootz dealt with Picasso and the abstract expressionists, so for Bill it was a fantastic kudo. He was the first Canadian to be taken on by a major New York dealer.

When we were in New York once, Sam invited Bill and me back to his house for drinks. Bill and I got in Sam's chauffeur-driven car and drove to the Kootz home. Out came the hors d'oeuvres, and I saw these tiny, hard-boiled eggs. "Mr. Kootz," I asked, "what kind of eggs are these?" "Whales' eggs" was what I thought he said.

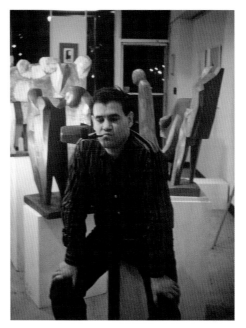

A sophisticated Toronto dealer

"I've never eaten whales' eggs," I replied. "No, you dumb bugger," was his reply, "they're *quails'* eggs." That is how the very sophisticated dealer from Toronto came to make a fool of himself in Manhattan.

William Ronald, *Karma*

first big sale

I made my first major sale, in November 1957, to Gilbert Bagnani for what seemed like the very large amount of $950. It was Bill Ronald's "Karma." By this time, Bill was represented by the prestigious Kootz Gallery in New York, and so his prices were hefty. I, of course, had proudly put a red sticker on the wall beside the painting.

My father, who was retired, wandered in one day, saw the red sticker, and asked me what it meant. I told him it meant the painting was sold. "How much?" he asked. When I told him $950, he chuckled, turned, and walked out of the gallery. I knew the scenario that would follow. At that time, my parents were concerned about me and my having a gallery with strange, indecipherable paintings in it. They could not see much of a future for me. I'm sure he went home to my mother and said: "I don't know what he is up to in there, but it must be OK, because he just sold a board with some paint on it for $950!"

Tony Urquhart

TONY URQUHART

It was 1957, and I was in my studio in Niagara Falls. The day before I had been in Toronto helping to hang my second exhibition in The Isaacs Gallery. Now that the pressure was off and I felt good about the show, I was inspired to paint a new abstract landscape on the only piece of masonite available – the top of a new crate. Just as I was finishing the final touches, the phone rang. It was Av, who announced that the show was all hung, looked great, but there was room for one more painting. Did I have anything? Yes, I did. Great, give me the dimensions and bring it with you when you come in to town for the opening. We'll have the frame ready. The next day, I arrived at the (then) Greenwich Gallery, the still-wet painting went back to the framing room and Mrs. Eaton went in and bought it before it was even hung. What a triumph! Three weeks later, when the show was about to come down, I received a frantic phone call from Av. The landscape had dried and – to his horror – the words THIS END UP had appeared in its painted sky. (The problem was subsequently solved by using white gouache. Acrylics were not yet invented.)

Tony Urquhart, *Evening Image*

I was once introduced to someone from the Art Gallery of Ontario's Women's Committee. "Oh," she said. "I know you. You're 'School of Av'!"

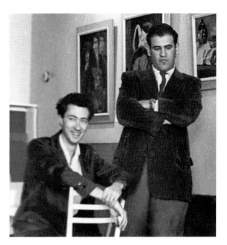

Snow and Isaacs…then

MURRAY LAUFER

My grandmother Bronda Liah Cohen, née Kuflouitch, arrived in Canada from a small Polish village called Dulesschitz in 1904. I am about to tell you how she influenced the course of Canadian art in the 1950s and beyond.

Her coal man, a distant relative, came from the same Polish village. She learned that his granddaughter had married Al Latner, who had a partnership in the Greenwich Gallery on Hayter Street. I was instructed by her to buy my art supplies there and to take my fellow students from the Ontario College of Art to that Hayter Street location. Mr. Latner left the business, leaving Av Isaacs as the sole proprietor. One of the many students who went there at my suggestion was Michael Snow. Together he and Av Isaacs made a spectacular contribution to Canadian art.

Without my grandmother, who knows what would have happened?

Isaacs and Snow…now

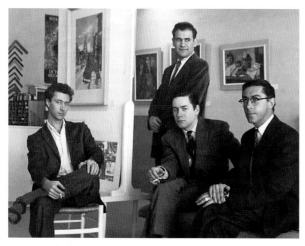

At the Art Gallery and Framing Shop: Michael Snow, Graham Coughtry, Av Isaacs and Robert Varvarande

Graham Coughtry, *Sleeping Figure*

Michael Snow, *Oh*

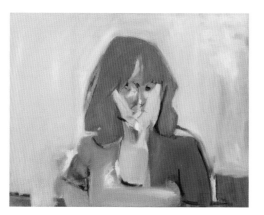

Joyce Wieland, *Myself*

Dennis Burton, *Air Bridge*

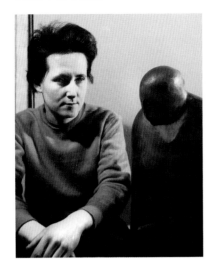

Anne Kahane

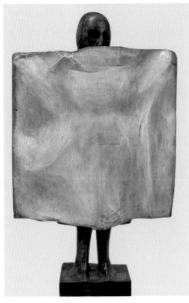

Anne Kahane, *Monday Wash*

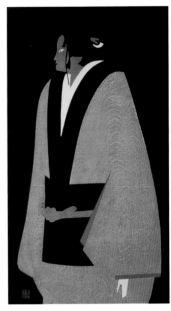

Saito, Japanese woodblock print

Gordon Rayner, *Jugs and Things*

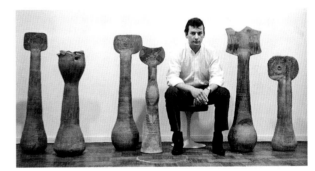

Mickey (Arthur) Handy and ceramic sculpture

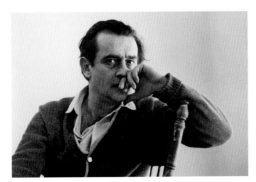

Mashel Teitelbaum

Teitelbaum at the Greenwich

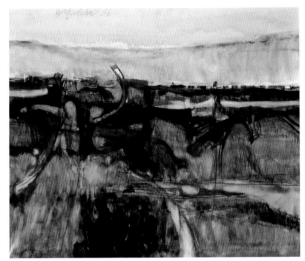

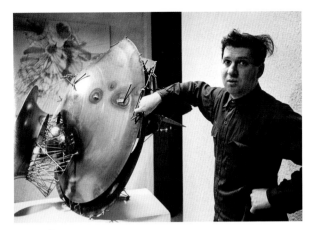

Gerald Gladstone

Tony Urquhart, *Eternal Spring*

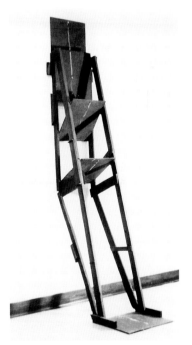

Michael Snow, *Quits*
Art Gallery of Ontario

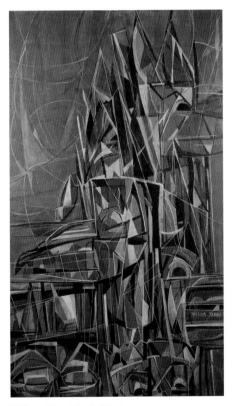

William Ronald, *Untitled*

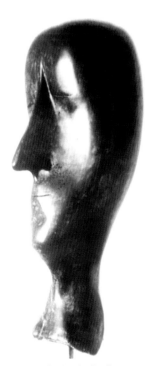

John Ivor Smith, *Lafkadios*

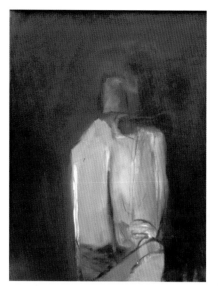

Joyce Wieland, *Green Lady*

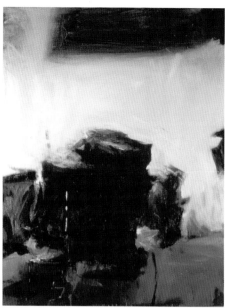

Gordon Rayner, *Zortch*

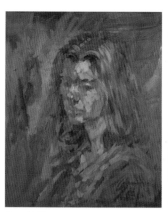

Gerald Scott, *Joyce*

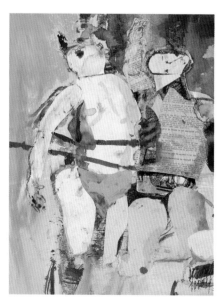

Tony Urquhart, *Japanese Wrestlers*

Michael Snow, *A Man at a Desk*

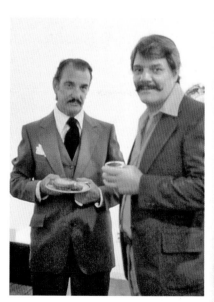

Rayner Senior and Gord

the Sixties

recollections from Av and:

HUGO MacPHERSON

ROBERT FULFORD

PEARL McCARTHY

DAVID SILCOX

CYNTHIA SCOTT

RAMSAY COOK

PAMELA GIBSON

UDO KASEMETS

BARRY LORD

WARREN COLLINS

MICHAEL SNOW

VICTOR COLEMAN

STAN BEVINGTON

GORDON RAYNER

OLGA KORPER

TONY URQUHART

MARLENE MARKLE

GARY MICHAEL DAULT

JOHN REEVES

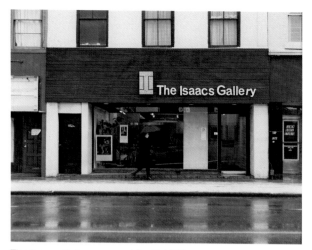

The Isaacs Gallery opens, May 5, 1961

Knoll's president, gallery architect Irving Grossman, and Av

Gord Rayner and Jim Donoahue (designer of Isaacs logo)

HUGO McPHERSON

To open an art gallery devoted to new directions and modes of expression requires an act of faith — faith that man is still capable of exploring, developing and expanding his knowledge of himself and his world. The first group show at The Isaacs Gallery in 1955. (Coughtry, Ronald, Scott, Snow, and Varvarande), was an act of faith in this exciting sense — a recognition that the experimental, questing artist is the man who makes tomorrow's history, and that he must be given an intelligent hearing.

Since that first exhibition, The Isaacs Gallery has added bright new names to its list — sculptors Gladstone, Kahane, and John Ivor Smith, and painters Burton, Gorman, Hedrick, Kurelek, Rayner and Urquhart. Poets have come to read their works in evening hours, and painters and poets have joined to produce a series of illustrated books bearing the Gallery's imprint. In addition, six of the artists represented by the gallery have been invited to the Venice and Sao Paulo Biennials, and the Carnegie and Guggenheim International Exhibitions. The original act of faith has been justified.

But if this success is gratifying, the Gallery's continuing policy of providing a forum for new expression is even more encouraging. It began by meeting a need, and now, as the need grows, the gallery too is growing. It has become, indeed, a major institution in the artistic life of the Canadian community.

Genni MacAulay and Dennis Burton

Gerald Scott and Vince Sharp

Harry Malcolmson, Anna and Rick Gorman

Robert Hedrick

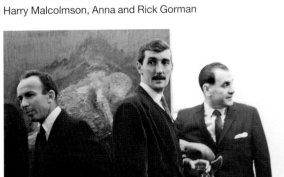

John Gould (center) and Percy Waxer, collector (right)

Collector Sid Wax and Walter Moos with Pearl McCarthy

Kaz Nakamura and Rick Gorman

Celebrants. At far left: Isaac Isaacovitch (Av's father)

Ayala Zacks and Graham Coughtry

Vince Sharp, artist/photographer

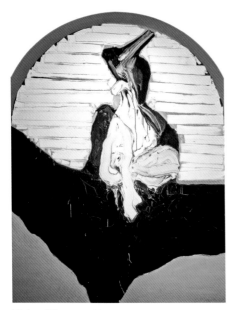

Richard Gorman, *Nexus*

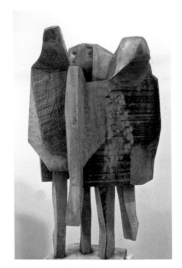

Anne Kahane, *The Talk*

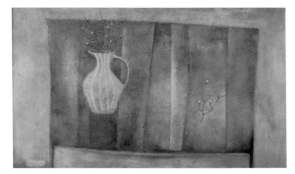

Robert Varvarande, *Still Life on Table*

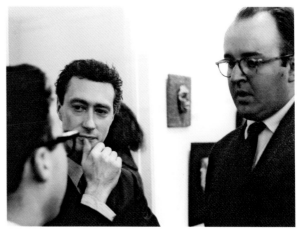

Michael Snow and Robert Fulford

Robert Fulford, *Toronto Daily Star*, May 6, 1961

Smelling of new paint (the painters having left five hours ago) The Isaacs Gallery opened at its new location, 832 Yonge St. It now has exactly what its expansive painters demand – a handsome gallery with vast wall space, superb lighting and excellent facilities for storage. The painters, as if responding to the challenge of the new location, have contributed some of their best recent work. But despite all this, the gallery, designed by the architect Irving Grossman, is itself the real show. It has only one drawback. It may well spoil you for almost any other art gallery you're likely to visit.

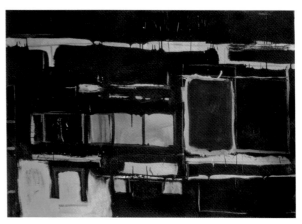

Michael Snow, *Trane*

Pearl McCarthy, Art Critic *Globe and Mail*

Gerald Gladstone

Jessie Waxer and Allan Jarvis, director, National Gallery of Canada

Pearl McCarthy, *Globe and Mail*, May 6, 1961

Nothing is pretentious or too opulent. On the other hand, many may run up a flag of rejoicing that avant-garde art is shown in a place that does not flaunt its meagerness as a kind of snobbery-in-reverse such as was too prevalent years ago, even in the world art centres. I cannot at the moment think of a more agreeable gallery in Europe or America.

Dennis Burton, *Game of Life,* National gallery of Canada

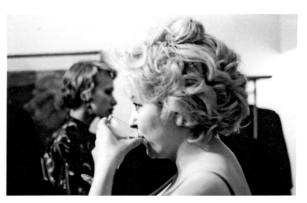

Joyce Wieland

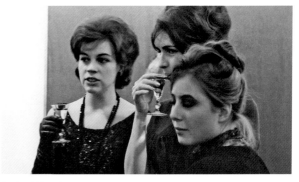

Artists' friends

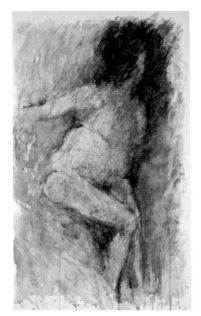

John Ivor Smith, *Vatican Head*

Robert Markle, *Untitled*

Robert and Marlene Markle

Jack Chambers, *The Shepherds*

DAVID SILCOX

Everything was happening all at once. The only thing better than thinking now about Toronto and Canada in the 1960s was being there then.

On the scene with Naomi Cameron, David Silcox, Hugo Macpherson

John MacGregor, *Dutch Lady Walking*

CYNTHIA SCOTT

I don't remember the exhibition … it might have been Graham Coughtry. A friend in London, England, where I had lived for the previous two years suggested a visit to that gallery.

Walking north on Yonge Street, except for Britnell's bookstore across the way, seemed utterly lacking in pleasures or culture … in the good sense of the word.

Then I was in front of it – the gallery. Even as I walked in, I felt the tremor and the Canadian landscape shift. Inside this place were contemporary perceptions, energies, a pulse I did not know existed.

An invisible door had opened, revealing new dimensions, and there for us – the country – to see was new and powerful Canadian art. In that moment I felt pride, excitement, and gratitude for this person Isaacs, who had created this space and nurtured these artists.

Graham Coughtry, *Two Figures #1*

Greg Curnoe, *Figurative Picture #3*

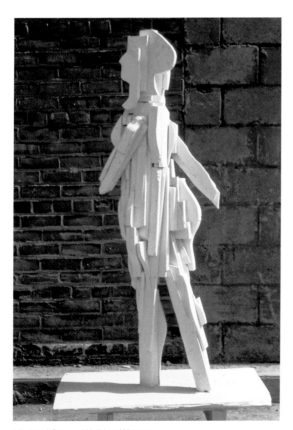

Michael Snow, *Walking Woman*

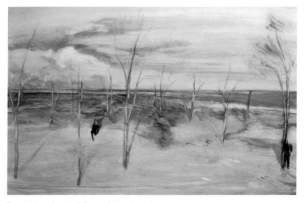

Tony Urquhart, *Mourning Morning*

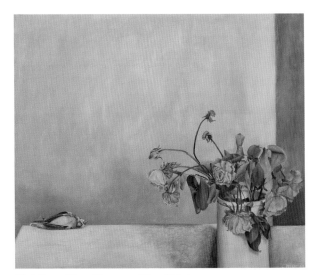

Christiane Pflug, *Roses and Dead Bird*

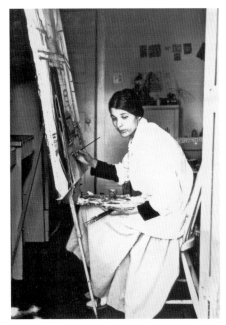

Ralph Greenhill, *Christiane Pflug at Woodlawn*

Gordon Rayner, *Cathedral*

Folk Artist Arthur McTavish and his wife

Nobuo Kubota, *Dissection III*

Robert Markle, *Beginnings*

Dennis Burton, *Metamorphosis*

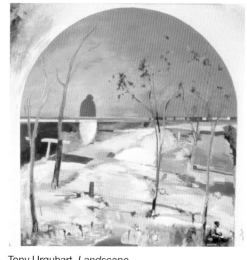

Tony Urquhart, *Landscape*

Walter Redinger, *White Discs*

William Kurelek, *Dinnertime on the Prairies*

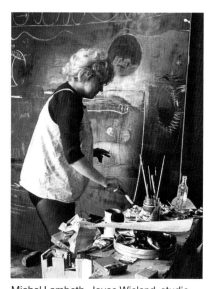

Michel Lambeth, Joyce Wieland, studio.

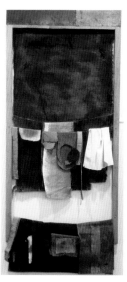

Joyce Wieland,
The Clothes of Love

Michel Lambeth, *William Kurelek, Painter*

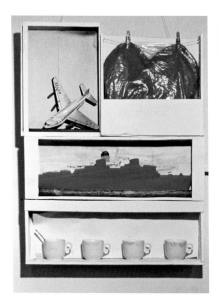

Joyce Wieland, *Cooling Room II,*
National Gallery of Canada

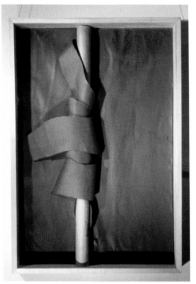

Michael Snow, *Rolled Woman #2,*
Leonard & Bina Ellen Art Gallery,
Concordia University

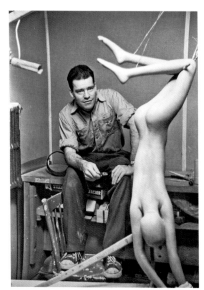

John Ivor Smith

John MacGregor: the 60s scene

John MacGregor, *Six Chairs*

Gordon Rayner, *Little Egypt*

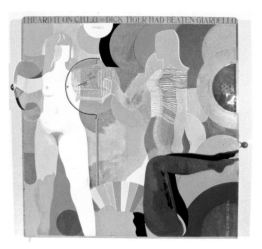

Greg Curnoe, *Feeding Percy*

Robert Hedrick, *Red Silence*

Gordon Rayner, *Midway*

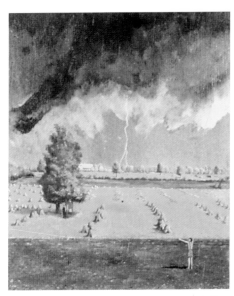

Kurelek, *St. John the Baptist on My Father's Farm*

Indian Miniatur

Claes Oldenburg, *London Knees*

John Meredith, *April '61*

Robert Varvarande

RAMSAY COOK

July 4 to July 24, 1961: William Kurelek: Paintings.

Though Av Isaacs gave Bill Kurelek, his framer, a solo show soon after moving to the Yonge Street location, this wonderful Brueghelesque painter of Ukrainian life on the Canadian prairies and often gruesome, Bosch-like religious parables always remained an outsider in the Isaacs's stable – or rather a testimony to Av's generous vision and good judgment. But Kurelek grouped with Dennis Burton, William Ronald and Graham Coughtry? It couldn't possibly last.

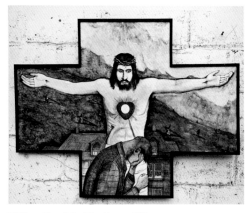

William Kurelek, *The Sacred Heart*

Kurelek, *Watering Cattle in Winter*

May 14-May 29, 1963: William Kurelek: Experiments in Didactic Art.

Kurelek judged his popular works – prairie scenes and childhood pleasures – "potboilers." He preferred religious themes and moral lessons. But he had to endure the slings and arrows of the Toronto critics. "Where Kurelek fails," Elizabeth Kilbourn wrote in 1963, "is when he attempts to paint subjects which he knows only from dogma and not from experience, where in fact he is a theological tourist in never, never lands." Later, Kurelek replied: "Did Hieronymous Bosch, a recognized master in represenation of Hell himself go to hell, and come back before he tackeled it?"

January 10 to January 29, 1968: William Kurelek: the Ukranian Pioneer Woman in Canada.

My first Kurelek opening. In that noisy Saturday afternoon crowd my unease was exceeded only by the obvious shyness of the short, stolky man in the orange embroidered shirt standing silently in a corner. I knew at once that he was William Kurelek. We talked a little about the prairies and a recent giant snowfall in Manitoba. "If only I could afford a trip west to paint it," he said.

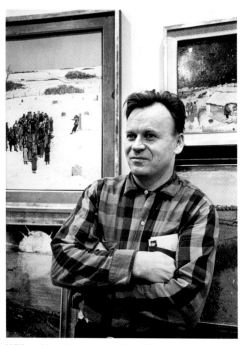

William Kurelek: veteran of prairie winters

DONNALU WIGMORE

I grew up in a small prairie town in a household where there were lots of books but art was represented by my aunt's painted plaster casts of fruit. On arrival in Toronto in l959, I plunged into an interesting job and lots of activities, and it never occurred to me to visit private art galleries.

Then one day in the early 1960s, a CBC friend suggested we drop into The Isaacs Gallery at lunchtime. A Kurelek show was up. I stood in front of a big canvas of children chasing fireflies at night. It enfolded and enraptured me.

Forty-five years later, I still remember feeling that canvas. From then on I spent Saturdays "doing" the galleries (not a huge circuit in those days!), and looking at art became a lifelong passion. Kurelek at The Isaacs Gallery opened those portals for me. Thanks.

DAVID SILCOX

In 1967, the American magazine *Artforum* referred to the Canada Council as "a government program so unobtrusive and enlightened that even the artists like it."

William Kurelek, *Gathering in the Garden Before Freeze-Up*

An opening: Metro Kurelek (Bill's father) and Mrs. Lester Pearson

Brydon Smith, Wieland, Markle and Snow

Robert Markle, *Untitled*

Graham Coughtry, *Rising Figure*, Detroit Institute of Arts

DAVID SILCOX

At the Canada Council, we thought that the most important people in the arts, both in our opinion and in theirs, were artists.

William Kurelek, *In Search of the True God*

PAMELA GIBSON

In the 1960s, when Coughtry, Curnoe, or Kurelek had an exhibition, the excitement was palpable. The paintings by these artists and many others in the Isaacs stable were in such demand that almost immediately red stickers were put on the labels beside the paintings. Always generous, Av allowed collectors to buy over time, thus facilitating many sellouts even on the actual opening nights.

We Art Rental Volunteers would select paintings for the Art Gallery of Ontario to rent out, and it was an exciting experience when we went to The Isaacs Gallery. First, we would look about at what was hanging in the gallery, and then Av would suggest that we might find something more exceptional in the basement.

That was his storage area and was also the location of an enormous pot-bellied furnace that provided the heat. While the furnace jiggled and groaned, one treasure after another was brought out from the stacks, all in seemingly pristine condition, quite unspoiled by their threatening environment, and – bravo! – our choices were made.

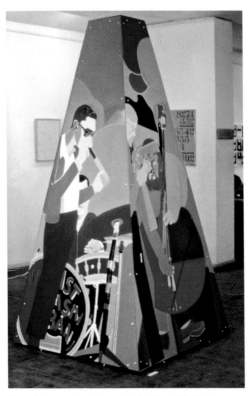

Greg Curnoe, *Kamikaze*, Art Gallery of Ontario

many-use gallery

For the most part, the floor of the gallery serves the purpose of separating the four walls that have pictures on them. The floor is just neutral space.

Then, one day, along came Ray Souster, and I realized that the floor could be *positive* space. Thanks to him, a whole new direction opened up for me. Over the years, the gallery became the host of a series of floor events: poetry readings, mixed media concerts, the Artists' Jazz Band, Underground Film Nights (films made by visual artists), Inuit throat singers, and book launches, to name a few.

Charles Olson, awesome both in size and in accomplishment, gave a poetry reading. If I recall correctly, he sat on two chairs because of his dimensions (no pun intended). Another impressive visitor was LeRoi Jones, who later changed his name to Amiri Baraka, and became a strong proponent of Black Power.

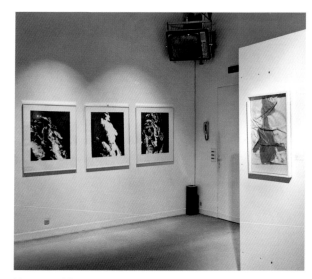

New use of floor space

Charles Olsen

Memories of Olsen at the Isaacs

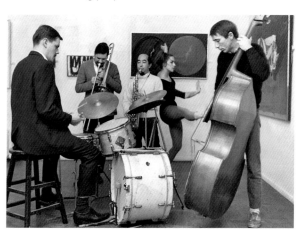

AJB plus Nadia Buchan

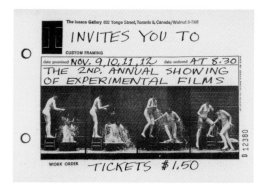

Experimental Films

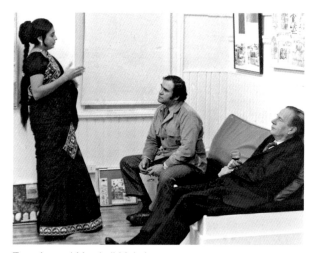

Taru, Av, and Marshall McLuhan

duchamp & cage

One day Udo Kasemets asked if he could come and see me about an idea he had. Once again, God bless the Canada Council. We received a grant and began what was to be for me a puzzling, exciting and astonishing series of "Mixed Media" presentations which culminated in producing a concert/performance of John Cage playing chess against Marcel Duchamp while electronic sound was being created by Gordon Mumma. The chess board was wired so that every time a piece was moved it would affect the nature of the sound. This performance took place in the Theatre at Ryerson and it produced a good sized crowd. As the matches went on and on, our audience began to thin out. Finally, about 11 o'clock we called it quits. Duchamp came back to my home and sat on the sofa smoking a thin cigar. A great individual, he was a modest, seemingly simple man. I went upstairs and woke my two-year-old daughter Renann, brought her down and settled her on Duchamp's lap….I wanted to be able to tell her someday that she had sat on Duchamp's lap.

The hand

Sometime after we had produced Udo Kasemets's Mixed Media Concerts (1965), I received a copy of an underground newspaper called the *Insect Trust Gazette*, which purported to be from England. In it was an article by N.B. Shein titled "The Hand," dated June 1969.

It described in detail a 'performance' at The Isaacs Gallery in which a John Shore had his hand amputated in front of a dismayed audience. It was well written and quite convincing.

I later received a brief note from Shein, who lived in Vancouver, in which he apologized for setting his fictional story at The Isaacs Gallery. He said that he had wanted to give his tale an authentic sound. His fictional character, in various 'performances' starting with a lobotomy, was intending to continue these events until he killed himself. (I figured that Shein had been inspired by a combination of Mark Prent's exhibitions and Udo Kasemets's productions.)

Ever since then, every year or two I receive a letter or an e-mail, from someone in Europe or the United States, asking me to verify the event and to describe how it ended. The article must be sitting in an archive somewhere because these eager inquiries have been going on for over 35 years!

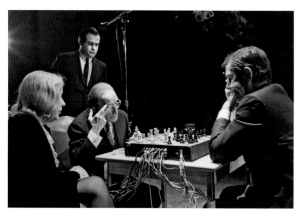
The Game: Marcel Duchamp and John Cage

Some of the performances that Udo and I produced were truly almost mystifying to me. We brought a man from Brandeis University who claimed he could produce signals on TV from his brain. He asked that we cooperate by remaining as quiet as possible. He turned on the set. It was blank. He then placed on either side of his head a contact which was wired to the TV set. After a few minutes a series of lines started to appear on the screen. It all seemed rather eerie to me.

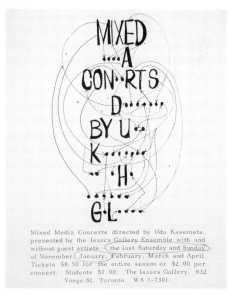
Udo Kasemets, *Mixed Media Concerts*

UDO KASEMETS

In 1965, The Isaacs Gallery Mixed Media Concerts were inaugurated, to explore the ways and means of bringing to life forms of art which then were in their early

gestation period: live and recorded electronic music, visual projections, intermedia art and performance art. Added to that was an attempt to present music not only in a different environment from a concert hall, but to place it also into an unconventional timeframe. The programs were to run uninterruptedly throughout a whole weekend, with featured presentations repeated at given hours.

Several Isaacs Gallery artists eagerly explored possibilities to expand their activities to formerly untried fields, and together with speaker/narrator William Kilbourn and singer Catharine Hinson, became The Isaacs Gallery Mixed Media Ensemble.

The gallery events made a first Toronto link with a number of artists south of the 49th parallel who were pioneering radically new directions for the sonic and performing art and included Gordon Mumma, David Tudor and Alvin Lucier, the first creator of alpha-wave music.

There were double-bass solos by Bertram Turetzky, trombone (and garden hose) music by Stuart Dempster, percussion performances and electronics by Max Neuhaus, theatre of e.e.cummings and Lawrence Ferlinghetti, performance pieces by Pauline Oliveros and Frederick Rzewski, choreographed movement and programmed audience involvement.

The world was changing in the 1960s, arts were changing, society was changing. All kinds of new music were created in the United States, Europe, and Asia, particularly Japan. There was a need to bring it to Canada and explore the new directions here too.

Greg Curnoe and the Nihilist Spasm Band

BARRY LORD

Although I attended many openings later as critic for the *Toronto Star*, my own strongest recollection of The Isaacs Gallery relates to its exhibitions of Dennis Burton while I was curator of art, 1964-66, at the New Brunswick Museum in Saint John.

I persuaded Av Isaacs to send me a gestural abstraction by Burton that I selected from an Isaacs Gallery exhibition.

My Art Department's Acquisition Committee had great trouble with it and finally agreed to its purchase on condition that I present it as part of a full exhibition of Burton's work. This seemed like a good idea, and Av was willing to ship me the next of Burton's exhibitions.

Unknown to both Av and me, of course, Dennis Burton was quietly making his own little corner of art history by moving beyond his previous abstractions to a very definitely representational style, known for its subject matter as the Garter Belt Series.

Dennis Burton, *The Understudy*

I came up to Toronto for the opening and immediately saw that I would have a problem, to put it mildly. Nevertheless, as a dedicated young curator, I was not going to shrink from the challenge, so we brought out all the very strong paintings (I still think the best and most impassioned that Burton ever painted) on the garter-belt theme.

Strongly influencing their reception was the fact that the show was to be up in December, when the museum staged its children's Christmas party! Fortunately I was away then. My secretary, very sensibly, covered some of the most aggressive canvases (as I was later horrified to discover).

The controversy earned the museum and me many inches of ink in the Saint John (and other) papers, with letter writers expressing their disgust, while of course visitor numbers were at an all-time high. The show went on to the Edmonton Art Gallery, which exhibited it without incident. I do hope there will be a garter-belt painting or two in this retrospective to remind us what generated so much anxiety in that long-ago time.

Dennis Burton, *Maple Sugar*

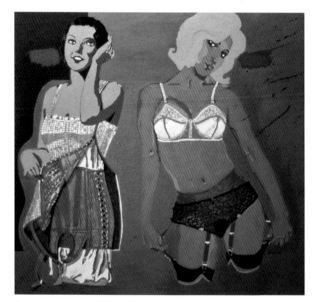

Dennis Burton, *Mothers and Daughters,*
Robert McLaughlin Gallery

Dennis Burton, *Fat Girl, Fat Girl*

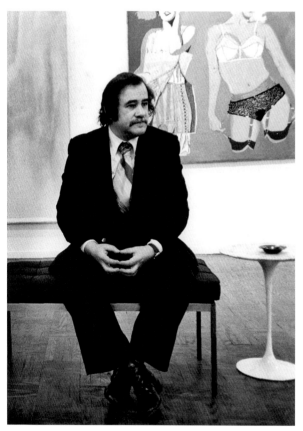

And visions of garter belts…

71

WARREN COLLINS

In l964, Av thought it would be great to have some underground film (and music) evenings, a couple of which I helped organize. Check out the programme for one such event, with films by Brian Barney, Graham Coughtry, Bob Cowan, Louis DeNiverville, George Dunning, Jack Kuper, Arthur Lipsett, Carlos Marchiori, Grant Munro (NFB), Al Sens, Mike Snow, Joyce Wieland, and myself. Surely such an all-star cast of filmmakers has rarely been assembled in Canada. And the event ran for four days!

Av: In later years, George Dunning directed The Yellow Submarine. Mike Snow won first prize in a world competition for his film Wavelength. Joyce Wieland wrote and directed the feature film The Far Shore

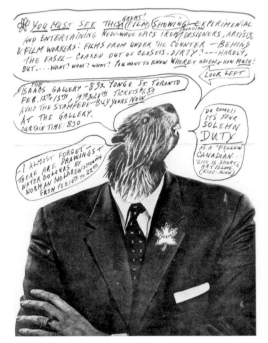

Experimental Films

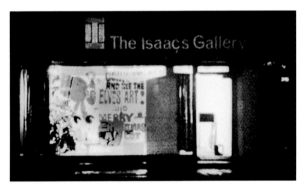

Christmas at The Isaacs Gallery

elves' art

For a number of years, I had Elves' Art exhibitions just before Christmas. They were open to others beyond the artists whom I represented. The idea was to produce and sell objects of a lighter nature at reasonable prices. The original idea came from Rick Gorman. We would offer a free buffet for the occasion. My brother Nathan contributed two Santa Clauses, carved out of chopped liver.

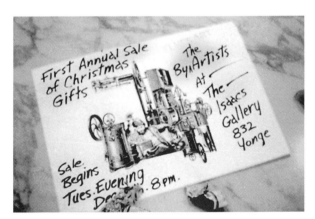

Mike Snow framed a $50 bill and titled it "Fifty Dollars." At the end of the exhibition, since it did not sell, Mike reclaimed it and with his former wife, Joyce Wieland, went to a second hand furniture store on Yonge Street and bought a piece of furniture. They opened up the frame, removed the $50 bill, and used it to buy the table. After they left, the manager ran upstairs to his tenant, Graham Coughtry, on the second floor, exclaiming: "We just had a crazy artist buy something. Can you imagine! He keeps all his money framed!"

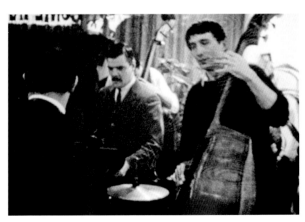

MICHAEL SNOW
A Mis-steak

For one of the "Elves' Art" exhibitions that occurred while I was living in New York (1962-72), I decided to show a T-bone steak. I couldn't come to Toronto for the show, so I asked Dennis Burton if he could buy a steak and put it on a plate to display on a four-foot-high white plinth.

The show was to be on for two weeks, I think, and it happened that I was able to come to Toronto towards the end of it. I was astonished to see on the plinth not a steak but a meat pie! Dennis explained that he thought a steak would definitely rot during the exhibition, but a meat pie wouldn't!

The point of the steak was of course that it *would* go bad. I was interested in what it would look like during the show. It was a mis-steak on Dennis's part. I guess I should've explained more.

Unfortunately, this anecdote is a bit critical of Dennis. My apologies – he was a very good friend and did some fine artworks.

kazuaki tanahashi

In the summer of 1964, I was visited by a young man who had been travelling around North America. He was Japanese and, it turned out, was a master of the art of Sumi painting (Japanese ink-brush painting). His name was Kazuaki Tanahashi. After some discussion, I agreed to have a one-man exhibition in November.

It was almost November, and no work had yet materialized. Kaz assured me not to worry. Everything was ready. I realized that we had different ideas of what 'ready' meant! Kaz finally appeared, the day before the opening, with a bunch of blank white canvases. What, I thought, happens now?

A single, perfect gesture (photo by Michel Lambeth)

Ignoring me, and my look of open panic, Kaz set to work. Wearing a long, dramatic black robe, he first scattered the stretched canvases all over the gallery floor. He then produced a deep ceramic bowl at least 12 inches in diameter, which he proceeded to fill with black ink.

Kaz stood perfectly still, erect and very focused before each canvas. After what seemed like many minutes, suddenly, in a single, perfect gesture, he dipped down into the bowl of black ink. With his large, circular brush, he drew a Japanese character. He then proceeded to make these 'gesture' paintings on every canvas. When I asked, he told me that each painting was a word that described an element of nature, such as fire, water, rock. Within a single hour, the entire exhibition was completed.

An element of nature (photo by Michel Lambeth)
Tanahashi Opening at The Isaacs Gallery

VICTOR COLEMAN

By March 1964, I had become a familiar fixture at Issacs Gallery openings, had struck up an acquaintance with both Av Isaacs and his right-hand woman, Martha Black, and was comfortable in the company of older artists. It was shortly thereafter that Av approached me with the opportunity of a lifetime.

Scheduled for November that year was an exhibition of Sumi paintings by the Japanese master Kazuaki Tanahashi. Av had been given a copy of my first, self-published book, *From Erik Satie's Notes to the Music*. Since the book was ostensibly partly translations of the French composer's idiosyncratic "stage directions" – for example, "Like a nightingale with a toothache" – I guess Av thought I'd be up to the task of providing "translations" of the poetry that Tanahashi san had calligraphed on a series of fans.

When the time came – it was mid-November – Av summoned me to meet the distinguished artist at a tea ceremony performed in my honour in his hotel room. We spent a very pleasant afternoon discussing the best approach to translating the poetry and arrived at a fairly progressive solution, which wed both the sound of the translated language and the sense of the syntax in one strange brew. Everyone involved seemed happy with what I came up with, and I was honoured to be a small part of the eventual exhibition.

I continued to frequent the gallery until it finally shut its doors on John Street for the last time. Approximately ten years after the Tanahashi exhibition, Av Isaacs (with Alvin Balkind, Michael Greenwood, and Marien Lewis) approached me at the Coach House Press one day to be the editor of a modest monthly arts tabloid we called *Proof Only*, which name I changed to *Only Paper Today*. I also subsequently was able to collaborate with Isaacs artists Graham Coughtry, Nobby Kubota, and Michael Snow, all of whom appeared, in their other roles as musicians, on my Music Gallery Editions LP, *33/3*.

STAN BEVINGTON

Coach House Press used to stock a metal postcard stand in The Isaacs Gallery with postcards we printed and announcements of events. It was always interesting to go to fill it because something was always going on at

Coach House Press with criminal intent?

the Isaacs. Well, we made one postcard to celebrate the Queen, who was then on the 6-cent stamp and … blew it up full size.

Somebody sent a card to someone in Ottawa. About a year later there was a loud knock on the door. Two bureaucrats with two briefcases stood there. They had come to investigate our illegal publication of stamps. We invited them in. We gave them tea and a tour. We photographed them with their briefcases and treated them like visting poets. They were appeased … but not before they gave us a solemn reading about the dangers of what we had done and how we must never again produce an image of the Queen "or a likeness thereof."

publishing

With the co-operation of Ken McRobbie and Ray Souster, I ventured into publishing (1961-62) producing two books of poetry. These were *Eyes without a Face*, by Ken McRobbie, with illustrations by Graham Coughtry, and *Place of Meeting*, by Ray Souster, with illustrations by Michael Snow. Mike's drawings were a series of penis-like shapes that progressed around the sides of the page. Ray questioned these images, but in the end we went ahead.

To cover the costs, I put out a special edition in hard

cover, signed and numbered, with original engravings. I quickly discovered that the most exciting part of being a publisher was getting the book out. Selling it was certainly an anti-climax.

Tony Urquhart, Canadian and European Sketches

Poems by Ray Souster,
Illustrations by Michael Snow

pilot tavern

When I first moved into my new Yonge Street gallery in 1961, the old Pilot Tavern was at the northwest corner of Yonge and Bloor. Eventually the Pilot moved onto nearby Cumberland Street, where it is still located.

It was always a hangout for artists. I recall seeing Fred Varley, a regular at the bar in the 1960s. Artists live isolated lives, spending much time in their studios. They need a place to hang out. For the price of a drink, the pub provided a table and companionship. Some observers claim that the need for companionship eventually produced a drinking problem for many of the artists. Because the Pilot became known as an artists' hang-out, various out-of-towners involved in the arts would drop in, Bob Dylan among others. Coughtry, Markle, and Rayner particularly held court there. I think Telford Fenton was tossed out more than anyone else.

Charles Higgins was one of the high school students I often hired on Saturdays to do odd jobs around the gallery. One of his jobs was to go back and forth between the Pilot and my gallery, delivering and receiving messages to and from the artists who used to hang out there on Saturday afternoons.

Meeting all of these artists, listening to their conversations, and carrying messages primarily of a social nature, was an exciting experience for a high-

school kid, and years later, when Higgins had become a successful Bay Street lawyer, he still recalled those rich and romantic Saturday afternoons.

Well, the Pilot Tavern came up for sale and he and some buddies bought it – for sentimental reasons.

If you go there today, there is an acknowledgement of the input of The Isaacs Gallery on the back of the menu.

The old Pilot: Fred Varley's hangout

carmen lamanna

Carmen Lamanna and I had galleries a few doors apart on Yonge Street, just north of Bloor Street, directly across from the Metropolitan Reference Library. Carmen and I got on very well. At the time I was an occasional smoker and would often walk over to bum a cigarette from him and have a chat.

Carmen Lamanna Gallery, three doors from the Isaacs.

There was very little element of competition. Carmen tended towards the conceptual and minimalism, whereas I tended towards expressionism. My gallery was kind of the star of the 1960s, while his was the star of the 1970s. Carmen was always a mystery to me because he wrote very articulate, well-crafted letters, yet his spoken English was broken and strongly accented. For a while I suspected that he had a ghost writer. Then I decided that in conversation he used what seemed to be his weakness in English as a protective device.

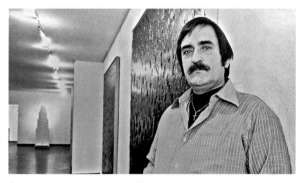

Carmen Lamanna at Yonge Street gallery

Carmen's signature was a work of art … like the Italian futurist, Bala … a dynamic explosion of circular lines. The Carmen Lamanna Gallery and The Isaacs Gallery moved from Yonge and Bloor about the same time … in the 1980s. It certainly was the end of an era.

NOBUO KUBOTA

The most vivid memory I have of the Issacs Gallery is the time I spent playing with the Artists' Jazz Band and the life that revolved around the artists, writers, and musicians.

The Isaacs Gallery was at the centre of our world. A stone's throw away were the after-hours jazz clubs: the First Floor Club, Clem Hamburg's, Melody Mill. A little

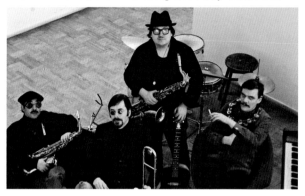

Kubota, Coughtry, Markle, and Rayner

further south, at Yonge and Queen, were the Colonial and Town Taverns, where we heard all the jazz greats. And of course, a few steps away, was the Pilot Tavern, where artists and writers met to drink beer and boiler makers and talk about everything. The New Yorker theatre two blocks away showed all the great classic films.

Av Isaacs was kind enough and perceptive enough (and very trusting and courageous) to let us use the gallery as our rehearsal and jamming studio. We played every week, sometimes twice a week. The original members of the band were Graham Coughtry (trombone and vocals), Rick Gorman (double bass), Bob Markle (tenor saxophone), Gord Rayner (drums), and myself (alto saxophone). Mike Snow joined us whenever he was back in Toronto from New York. Later others joined the band: Terry Forester (double bass), Ian Henstrich (double bass), Wimp Henstrich (tenor saxophone), Jim Jones (electric bass).

The Henstrich brothers and Terry Forester were working jazz musicians, while the artists were self-taught – we couldn't have read a note of music if our lives depended on it. Nor did we know the difference between a chromatic scale and a tetra chord. Ian Henstrich played for years with Lennie Breau, Canada's most famous and highly respected guitar genius.

So what drew them to play with a bunch of artists who played with such wild abandon and disregard for formal discipline? Why did they expose themselves to the scorn of the establishment jazz musicians? Perhaps it was because the Artists' Jazz Band and the music we created were part of the exuberance and excitement of the times – abstract expressionism, the avant-garde, Jack Kerouac and the Beat Generation, Zen Buddhism, John Cage, Timothy Leary, LSD, love-ins, the Beatles, and on and on. It was a time of positive thought; my god, some of us really believed we could ban the bomb!

Whatever it was, we embraced our music without any self-consciousness or expectations. The band was creating a new form that had everything to do with exercising a freedom of expression for what we felt and loved. No expectation highs here – just highs.

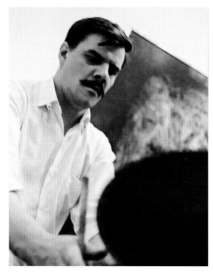

Gordon Rayner on drums

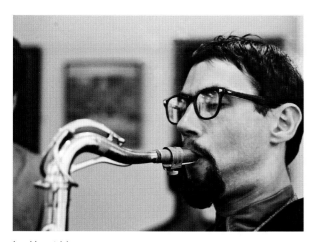

Ian Henstridge on sax

Sleeve of AJB Record

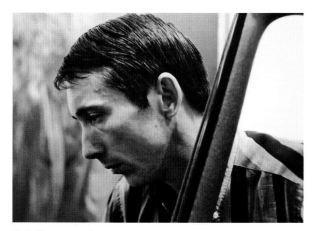

Rick Gorman on bass

Multi-signed cover:
Artists' Jazz Band

toronto twenty

In 1965 a group of dealers and the Art Gallery of Toronto (now the Art Gallery of Ontario) got together on a project named the Toronto 20. I believe that Gerald Morris, the former director of the Morris Gallery, put the plan together. This was probably the first and only time that a group of dealers worked as equals with a public gallery. There is a tremendous amount of knowledge and ability among the good contemporary dealers that the public galleries rarely exploit.

The idea was that 20 artists who exhibited in Toronto would each produce one original print in an edition of 100. A fine container was designed. The grand opening was at the Art Gallery of Toronto, and every set sold!

The Isaacs artists invited included Burton, Coughtry, Curnoe, Gorman, Hedrick, Markle, Meredith, Rayner, Snow, Urquhart, and Wieland. (I believe Harold Town turned it down for ego reasons, as he would be put on the same plane as the other artists).

All the artists had to work on the same size sheet of paper (26 inches by 20 inches). Their choice of medium was a reflection of a young visual art society that did not have readily available techniques now standard, such as lithography, etching, and photography (as a matter of fact, I imagine that photography was still suspect as an art form).

Toronto 20: Gord Rayner's frogs

Gord Rayner did a series of frog prints … no two were alike. Gord printed them while spending a summer at an isolated hunting lodge, which he appropriated each year. He caught a frog and kept him a willing prisoner, feeding him large, juicy worms. From time to time he would dip the frog's underside into a dish of black ink and release him for an instant onto the sheet of paper. The result was 100 sheets of paper with the imprint of the hopping frog … there were tremendous visual differences among them.

Dennis Burton, with an inked roller, painted his wife's panty-clad butt and then had her sit down on the paper … 100 times.

Greg Curnoe in London went to a local hockey rink and picked up a number of the taped blade ends of damaged hockey sticks. Then he laid them out in groups of two or three, inked them, placed them in a press on a sheet of paper, and produced a wonderful edition.

Another creative piece was made by Rick Gorman. He wanted to develop the idea of controlled spontaneity. He set up a card table and placed his sheet of paper on it. He dipped four steel ball bearings in different-coloured inks and with one hand rolled them across the paper as you would roll dice. With the other hand he held a magnet under the card table and attempted to control the movement of the ball bearings – a very innovative idea.

new city hall

The image on the front of our 20/20 series brochure was that of Toronto's new City Hall, which became a symbol of the new era of creativity that swept the city in that dynamic era. It still remains one of the few original buildings in Toronto, designed by a Finnish architect in an international competition that was initiated by Professor Eric Arthur. Arthur had convinced Mayor Nathan Phillips to take that route.

Phillips earlier was conned into entering Hart House at the University of Toronto, a private institution, to demand the removal of a slightly suggestive two-man exhibition by Coughtry and Snow. He was made a bit of a fool. He had been led down the garden path by a young reporter working for the *Globe and Mail* who was friendly with Snow and Coughtry. Attendance soared at the exhibition. The reporter went on to become the director of the Brooklyn Museum and then of the Glenbow in Calgary. His name was Duncan Cameron.

Av: Charlie's Place was a disintegrating hunting lodge on 600 acres bordering the Magnetawan River in northern Ontario. The absentee owners let Gord Rayner use the place for several years.

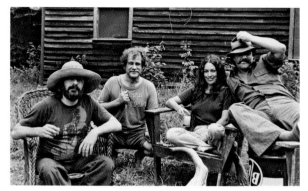

Graham, Av, Nadia, and Gord

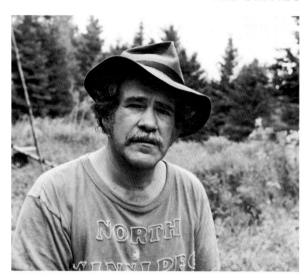

North Winnipeg woodsman

GORDON RAYNER: Charlie's Place

For years I had access to the bush and to the big hunt lodge … actually a big, big shack. Drinking from the river was no problem at that time; the water was clean and pure. There was great cooking on wood stoves.

Over the years, as the resident lord of the woods, I invited my peers and even older guys, like Coughtry and Isaacs, to spend days or weeks up there. And here's a list of some of the other people who were there: Rick Gorman, Barry Hale, Ydessa Hendeles, Kubota, Markle, art students, and writers.

What were we doing? Everyone was into photography. We made lamps and masks and paintings and drawings. I made my frog prints there. We invented games and made chess pieces that are still hidden away in the basement of the Art Gallery of Ontario.

In the past, Charlie (the original owner) had dragged in every piece of metal and wood he could find … he was a pack rat. So we ended up with all these found objects, and so there we were, out in the field or down by the water, making these wonderful found-object sculptures. Coltrane played across the river and the small field and into the bush through a battery-operated whatever. Coughtry used to take his trombone and go down and play against the rapids.

Art, music, good food, good companions …

charlie's place

Many of Gord Rayner's friends came and visited for a period of time. You had to bring your own food, booze, dope and whatever. The guys arrived with many female companions and so there was a great deal of carrying on …very lively fun. There was an upstairs that had about a half dozen beds in one room with old mattresses on them. When you were tired, you just flopped on one of the beds. At night we sat around a table lit by coal-oil lamps where I actually completed a drawing (my first and last). One vivid memory is Graham Coughtry waking me up in the middle of the night. He was terrified. He had just seen a subway train racing along the Magnetawan River!

Night visions

donald judd

In March 1965, in discussion with Joyce Wieland and Mike Snow, who were living in New York, I decided to have an exhibition of Canadian and American artists. The list included Joyce and Mike, Dennis Burton, Donald Judd the minimalist, Gord Rayner, and David Weinrib, who worked in bright-coloured plastics.

I recall Judd as being a rather severe, exacting individual. I did not immediately react to his minimal structures. Dennis, in his attempt to compete with those New Yorkers, created a totemic structure made up of multi-coloured toilet seat covers. They certainly were a contrast to Judd's minimalism. If only Judd had left a piece behind.

We had also invited another Canadian, Ron Bladen, living in New York, who made huge plywood sculptures. When he and I went to visit his studio/loft I recall that, as he turned on the lights, the sink seemed to MOVE. It was covered with cockroaches. We had to rule Ron out at the last moment because his pieces were too large for the truck we had hired.

snow sculptures

Michael Snow received a commission from the Ontario government to create a sculpture for the entrance to the Ontario Pavilion at Montreal's Expo 67. He created a stunning group of eleven stainless-steel sculptures of *Walking Woman*.

Some months after Expo ended, we began to wonder where the sculptures were. After a fair amount of looking around, we found them in various states of disrepair in a Montreal storage yard. It seems that a truck picked them up from Expo and unceremoniously dumped them there, backing over the big one in the process.

The Art Gallery of Ontario found that it could have them for free – the problem was, it would be responsible for the restoration costs. The AGO raised $10,000, which enabled it to restore all the figures, except the big one.

Today, you can often see *Walking Woman* in the main lobby of the gallery. I would guess that any single one of the saved pieces would be worth at least fifty times the cost of restoring them all back in 1968.

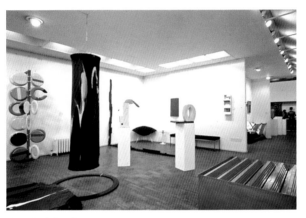

Donald Judd

Mixed minimalism

Women Walking at Art Gallery of Ontario

80

Michael Snow, part of *Four To Five*

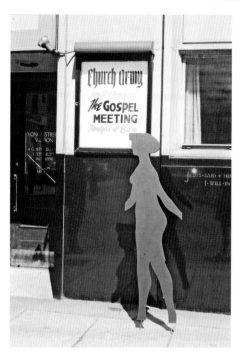

Michael Snow, *Walking Woman*

Michael Snow, part of *Four To Five*

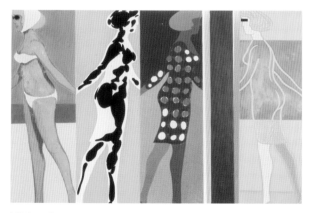

Michael Snow, *Bikini*, Art Gallery of Greater Victoria

Michael Snow shaping up…

Rick Gorman, *Dada Wheel*

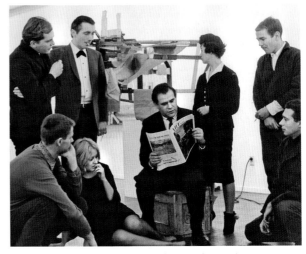

Dada group with inexplicable Air Canada Stewardess

Neo-Dadaism

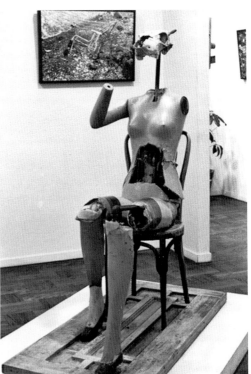

Greg Curnoe, *Dada drawer* Dada door

Rick Gorman, Dada Woman *Goddess*

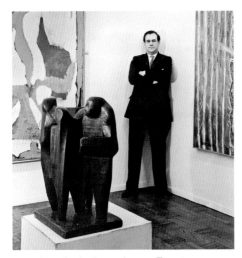

Michel Lambeth, *Avrom Isaacs, Toronto*

OLGA KORPER

"Only in Canada can passion be mistaken for asthma." So observed Av Isaacs to graduates at the Ontario College of Art and Design some years ago. The art community has tackled a steep and often slippery slope in the last fifty years, and Isaacs has certainly been fearless in leading the pack. He was known as Mr. Integrity at PADAC (Professional Art Dealers Association of Canada), and I recall his comments very fondly. At meetings where current issues were argued ad nauseam, with no possible resolution or conclusion in sight, Av would raise his hand, address the chair, and issue his wise: "That's crap!" The meeting would promptly get back on track.

TONY URQUHART

It was early in the evening at one of my openings at The Isaacs Gallery. I was honoured that Kaz Nakamura had come to all of my openings, and here he was again. As we talked, a lady photographer circled around us snapping photos. My head swelled: here was the famous artist talking to another famous artist at his opening. Just then, the photographer stopped snapping, approached us, and asked Kaz, "Mr. Nakamura, do you know whether or not Mr. Urquhart will be at his opening?"

Before my box sculptures started to open, they were often large – about four to six feet tall. A gallery-goer came up to me and remarked, "Your show is very monumental." "Oh," I replied, pleased. "Yes," he continued, "these things are just like tombstones."

Tony Urquhart, *Nostalgia Cube Grandpa's*

Tony Urquhart, *Landscape on a Tapestry*

MARLENE MARKLE

1960-70 my years with Avrom Isaacs:
I stand still, and the world comes to me: Poetry readings, Mixed Media Concerts, The Artists' Jazz Band, Japanese woodblock prints, Georges Rouault lithographs (Miserere series), African sculpture, Papua/New Guinea carvings, Picasso etchings,Inuit sculptures, drawings, and prints, and, of course, the most exciting and challenging work by young Canadian artists.

Showing the flag: Marlene Marckle and Av

The event: Every Saturday, a steady stream of young couples with babies in arms and toddlers at their sides visits the gallery. Talking excitedly to each other, they approach Avrom Isaacs to ask if they could please, please, have such and such and pay $25 a month for it. The answer is always "Yes." Great happiness all round. I wonder how many of these purchases are still bringing pleasure to these early collectors.

John MacGregor, *The House*

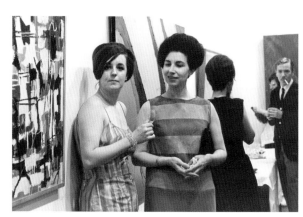

Sheila Gladstone and Elizabeth Dille

GARY MICHAEL DAULT

When I was young and eager and still wary of my slowly maturing sensibility, back in the early 1960s, I used to venture forth occasionally from Hamilton – where, for two purgatorial years, I taught high school – and journey to Toronto for the big Saturday afternoon openings at The Isaacs Gallery.

Given my shyness, I'm surprised now, when I think back on it, that I was actually up to the sturm und drang of those intoxicating events. There'd be maybe three hundred people there, swarming the gallery and spilling out onto the Yonge Street sidewalk, and I'd just sort of hover by the walls and gape at the exuberant crowd and wonder at the press and throb of so many people crazy about contemporary art.

It seems to me – though perhaps my memory is faulty – that the artist whose opening it was and whose achievement was being so lustily celebrated would invariably manage to arrive a little late. This was a matter, I guess, of making an appropriate entrance. I always thought it was pretty dramatic.

I remember one opening – I think it was Gord Rayner's (or was it Graham Coughtry's?) – when Gord (or Graham) came swaggering through the front door and into the madding crowd pushing a motorcycle, carrying a case of beer under one arm, and encircling the tiny waist of some impossibly beautiful girlfriend with the other. I think I remember a roar going up from the crowd – but maybe this was just in my own mind. Hail the conquering hero! I remember thinking to myself, "Man, that is definitely the way to live!!"

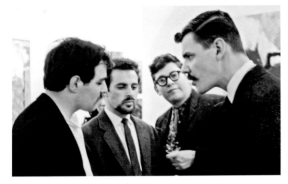

The Isaacs Gallery Boys Club

And so I clung to my wall and hero-worshipped these guys, The Isaacs Gallery Boys Club (plus one girl, Joyce Wieland): Dennis Burton, Coughtry, Richard Gorman, Rayner, Michael Snow. I was maybe twenty or twenty-one. And, although they were only a half-dozen or so years older than I was, I was way too shy to talk to any of these larger-than-life characters. Richard Gorman tells me now that he recalls coming up to me on one of those incandescent Saturdays and saying "Hello," but I can't remember that. Too awestruck, I guess.

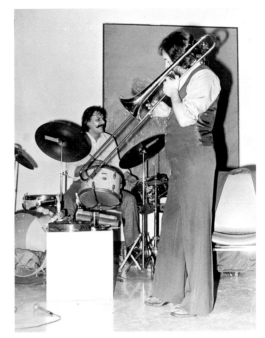

Coughtry on trombone

JOHN REEVES

Back in the 1960s, Toronto's art world was a burgeoning, socially vibrant, intellectually hot, economically optimistic place. The city's growing roster of contemporary art dealers opened their exhibitions on midweek evenings, and these events were always well supplied with free beer and wine. Opening nights provided frequent opportunities for the art world's key players to meet and mingle. This was an era when uptown art-collecting chips off the 'vertical mosaic' not only encountered the *vie bohème*, they got right down and boogied with it on a regular weekly basis. Apart from major collectors and artists, opening night attracted a rich variety of the visual arts' other players – artists' friends, wives, lovers, critics, curators, sundry scholars, sundry journalists, photographers, graphic designers, architects, musicians, picture framers, just plain fans, and heaven knows who else – all busily engaging in all manner of art-world interactions. You could do some serious art-world business at an opening, or you could fire up a love affair.

DAVID SILCOX

Back then, we thought we could do anything. So we did.

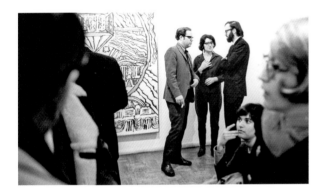

Two critics: Barry Hale, Barry Lord

Donna Montague, Joyce Wieland, and Ray Jessel

Joyce Wieland: one-woman show

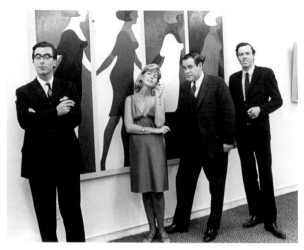

Geoffrey Rans, Edie Frankel, Av Isaacs, and Barry Lord

Dennis Burton, *Three Graces After Rubens*

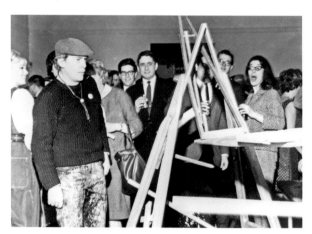

Dennis Burton, art extravaganza at the AGO

Walter Redinger, *Wall Relief*

Michel Lambeth, *Greg Curnoe, London, Ontario*

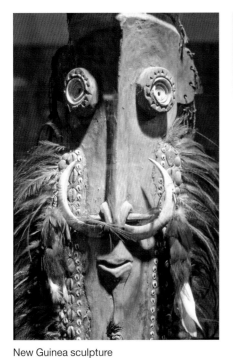

New Guinea sculpture

Dennis Burton, *Tip View*

Kaz Nakamura and Margaret Break

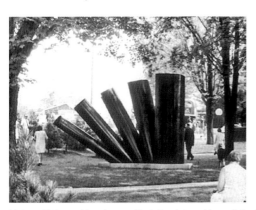

Nobuo Kubota, *Kensington Park Sculpture* (demolished)

Les Levine reclining with chair sculptures

Dennis Burton, *Northbound*

John Meredith, *Painting on Violet*

John Meredith, *Atlantis*

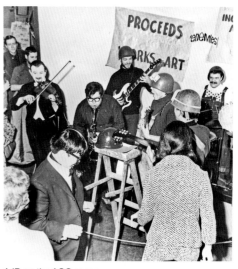

AJB on the AGO scene

Jeanne Parkin, Marie Fleming, Ayala Zacks

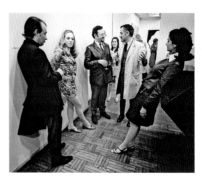

Bob Hedrick, Harvey Cowan, Irving Grossman

Graham Coughtry, *Self-portrait*

William Kurelek, *Stooking*

The sixties look: Wally Steffof and friend

the Seventies

recollections from Av and:

RAZIE BROWNSTONE

KAREN WILLIAMSON

RAMSAY COOK

BRUCE KIDD

GATHIE FALK

STAN DENNISTON

JARED SABLE

GREG GATENBY

RAMSAY COOK

STAN DENNISTON

ARNIE BROWNSTONE

SUE PRENT

MARIE DAY

JUDY STOFFMAN

OLGA KORPER

JUDI SCHWARTZ

UDO KASEMETS

MENDELSON JOE

JUDY STOFFMAN

PIERRE THEBERGE

RAMSAY COOK

JOHN ROBERTS

RAMSAY COOK

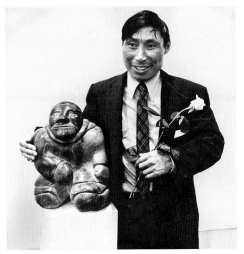

Axangayu of Cape Dorset

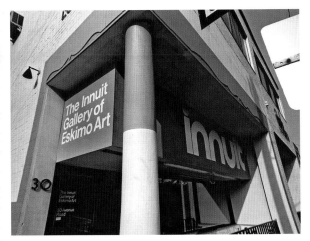

The Innuit Gallery of Eskimo Art, June l970

First private gallery solely dedicated to Inuit Art

the innuit gallery

About 1950, powerful art from the Inuit (referred to then as 'Eskimos') started to appear in the south. This work was created by people who still lived on the land, surviving by hunting. They continued to work with their hands and they could manipulate the stone as we would plasticine. As a result the Inuit were able to make death-defying sculpture. In addition they didn't know our rules, and so they kept breaking them, to wonderful effect.

In the early 1960s, Canadian Arctic Producers, a co-op representing all the Inuit communities in the Northwest Territories, opened a warehouse in Ottawa, full of visual riches. I began to make frequent trips there to buy works. I had two exhibitions in the 1960s at The Isaacs Gallery and then decided that this was too important an art form to confine to occasional shows. Also, it was culturally distinct and unrelated to the other work I was displaying.

I decided in 1970 to open another space devoted to the art of the Inuit. This was the Innuit Gallery on Avenue Road, which later moved to nearby Prince Arthur Avenue. Its philosophy was to be the same as the Isaacs: a continual series of formal exhibitions. To my knowledge, this was the first commercial gallery devoted solely to the art of the Inuit.

By the time I closed the Innuit in 2001 I had had over 200 exhibitions, which introduced the works of many of the great Inuit artists, including Anglosaglo, Karoo Ashevak, Joe Talerunili, Avaalaaqiaq, Davidialuk, Oonark, and Parr.

Today it's interesting to note that, although there are no commercial galleries outside Canada that show only southern Canadian artists, there are four dedicated to the art of the Inuit.

Jessie Oonark, *Rivals From Two Tribes*

Razie Brownstone, Innuit Gallery

Nathan Isaacs, Mary Craig (Canadian Arctic Producers), Av

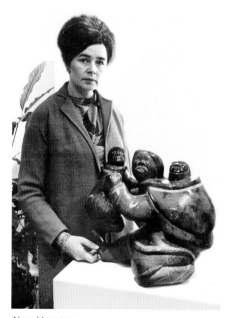

Alma Houston

RAZIE BROWNSTONE

Twenty years with the Innuit Gallery! How else would I have met the poised, elegant Oonark of wallhanging fame who, after a restaurant dinner party, stood up and acknowledged her pleasure with a loud belch? Or George Arlook, an accomplished artist at twenty, who wanted to be taken to a hospital because he loved nurses? Or the elderly sculptor who asked to see a TV studio to confirm the reality of soap opera life, only to find a DJ on camera?

Another sculptor explained why so many of his figures carried knives: to ward off the evil night spirits. One artist, after a Chinese dinner, gathered up all the plastic chopsticks, later to transform them into ivory tusks and knives. Unforgettable was seeing Avaalaaqiaq off to Baker Lake clutching a bouquet of artificial flowers. Lucky me.

Marsha and Harry Klamer: early collectors and founding donors of AGO's Inuit Collection

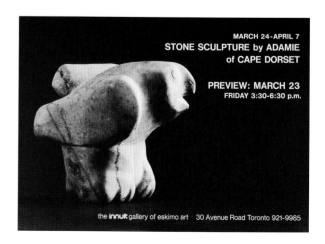

KAREN WILLIAMSON

The Isaacs galleries were the stage, the venue, but they were also the catalyst, the spark where both likely and unlikely events in Canadian art history took place. To borrow from an Inuktitut term they were the Qaggiq or gathering place where images, and voices, resonate; a person could learn about Canadian art and culture; and where artists from across the country could learn about each other. One of these moments, perhaps fleeting in the larger scheme of things, but significant for each was when Jessie Oonark and Joyce Wieland met in Toronto at The Innuit Gallery in the early 1970's. Both influential figures in the contemporary Canadian art world in their own right, powerhouses really, but also quite simply two people, two artists making a connection via the work and the Gallery. For me this is the most important legacy of the Isaacs galleries – the ability of these links, these connections to be made – creating bigger ideas, significant art; a larger context and maybe even a little history.

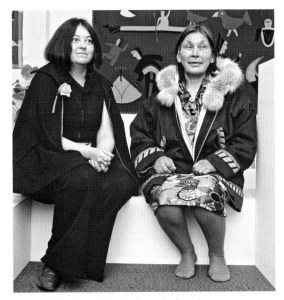

Joyce Wieland and Jessie Oonark: *Qaggiq*

Joyce Wieland, *Sorosiluto, Artist of Cape Dorset*

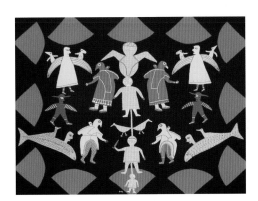

Jessie Oonark, *Spirit Figures*

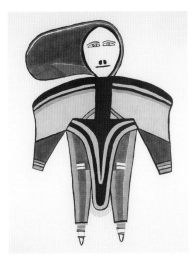

Jessie Oonark, *Woman*

Joyce Wieland, *The Square Mandala*

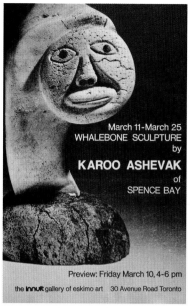

March 11-March 25
WHALEBONE SCULPTURE
by
KAROO ASHEVAK
of
SPENCE BAY

Preview: Friday March 10, 4-6 pm

the **innuit** gallery of eskimo art 30 Avenue Road Toronto

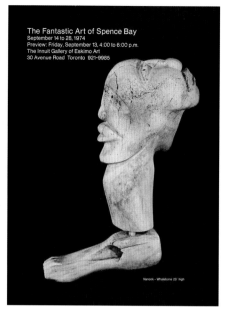

The Fantastic Art of Spence Bay
September 14 to 28, 1974
Preview: Friday, September 13, 4:00 to 6:00 p.m.
The Innuit Gallery of Eskimo Art
30 Avenue Road Toronto 921-9985

Nanook - Whalebone 23˝ high

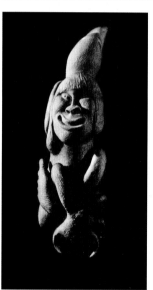

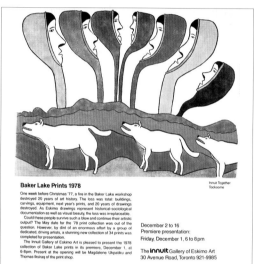

Baker Lake Prints 1978

Innuit Together
Tookoome

One week before Christmas '77, a fire in the Baker Lake workshop destroyed 20 years of art history. The loss was total: buildings, carvings, equipment, next year's prints, and 20 years of drawings destroyed. As Eskimo drawings represent historical-sociological documentation as well as visual beauty, the loss was irreplaceable.

Could these people survive such a blow and continue their artistic output? The May date for the '78 print collection was out of the question. However, by dint of an enormous effort by a group of dedicated, driving artists, a stunning new collection of 34 prints was completed for presentation.

The Innuit Gallery of Eskimo Art is pleased to present the 1978 collection of Baker Lake prints in its premiere, December 1, at 6-8pm. Present at the opening will be Magdalene Ukpatiku and Thomas Iksiraq of the print shop.

December 2 to 16
Premiere presentation:
Friday, December 1, 6 to 8pm

The **innuit** Gallery of Eskimo Art
30 Avenue Road, Toronto, 921-9985

NATIONAL PREMIERE
1972 BAKER LAKE PRINTS
Friday 12 May 3:30-6:30 pm

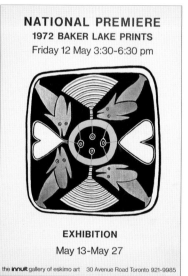

EXHIBITION
May 13-May 27

the **innuit** gallery of eskimo art 30 Avenue Road Toronto 921-9985

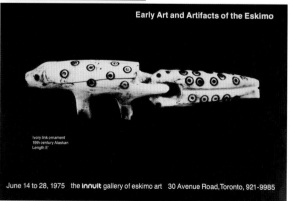

Early Art and Artifacts of the Eskimo

Ivory link ornament
19th century Alaskan
Length 5˝

June 14 to 28, 1975 the **innuit** gallery of eskimo art 30 Avenue Road, Toronto, 921-9985

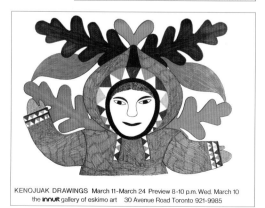

KENOJUAK DRAWINGS March 11-March 24 Preview 8-10 p.m. Wed. March 10
the **innuit** gallery of eskimo art 30 Avenue Road Toronto 921-9985

RAMSAY COOK

American Indian Art

What would a modern art gallery – and The Isaacs was certainly that – be without allusions to the 'primitive,' as it was once called. In 1961, Isaacs showed African carvings and later Oceanic sculpture and Australian aboriginal paintings. Though the Innuit Gallery was separate, Av brought American Native work right into the art gallery. And what stunning stuff it was: masks, rattles, baskets, and jewelry – always equal to, sometimes outshining, the modernist stuff in the main room. For Av and Martha Black, his expert assistant, there was never any need to ask: art or anthropology?

Martha Black and Ed Radford

BRUCE KIDD

What I most remember about the 1970s was how alive the gallery was. I would drop by at the beginning or end of a run – I started at Hart House, and, if I went east, I usually headed into the Don Valley system via Rosedale Valley Road and returned down Yonge Street, so I could pop in as part of the warm-up or warm-down. I did that as often as once a week.

There was always something happening – you were hanging a show or dissecting someone's work or scheming about a project, and there were lots of people around to talk to. I was dressed differently – not many people ran through the streets in tracksuits and shorts and T-shirts in those days, and sometimes I was sweaty – but you never minded, and no matter whom you were talking to included me in the conversation. I loved the energy.

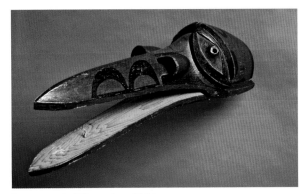

Raven mask, l9th-century, Haida

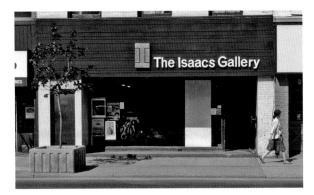

The Meeting Place, 832 Yonge Street … and upstairs?

the speakeasy

Sometime in the 1970s, I rented the space on the second and third floors above The Isaacs Gallery to Jimmy Hill, a leading book illustrator. Jimmy moved into the third floor, but it was a while before I discovered that he was running a speakeasy on the second floor.

My lawyer told me that as long as I didn't frequent the place, I could not be implicated. This I very much regretted – it was a convivial place, with good company and the prices were reasonable.

Jimmy's Place had a club-like atmosphere, and was frequented by those in the know. Artists, journalists, senators, lawyers and judges came. Pierre Berton, Mort Shulman (the former coroner), Harold Town, Senator Peter Stollery, John Siebert and Jock Carroll were a few of Jimmy's patrons. The interesting thing was that although the police were probably aware of it, they stayed away. Maybe it was all those lawyers and the judges. Jimmy's Place only lasted for about 4-5 years. That was Jimmy – he had moved on.

Gordon Rayner, *Dervish Singer*

Gordon Rayner in studio

Michel Lambeth, *Self Portrait, Union Station, Toronto*

William Kurelek, *Not Going Back to Pick Up a Cloak*

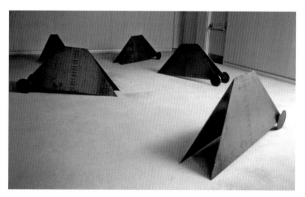

Mark Gomes, *Endgame*

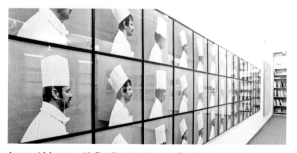

Arnaud Maggs, *48 Profiles, Ledoyen Series*

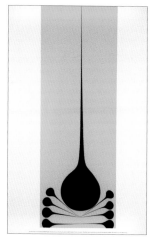

Harold Town

Dennis Burton

Graham Coughtry

William Ronald

stop the spadina expressway

The "Stop the Spadina Expressway" movement of 1975 became the great unifying force in Toronto during that decade. Its purpose was to stop the expressway being rammed through the heart of the city and destroying a number of residential areas. Jane Jacobs, who had recently been involved in a similar battle against Robert Moses in New York, had recently moved to Toronto and was one of the leaders.

To raise funds for legal expenses, a number of artists designed large, colourful posters which were then sold. Burton, Coughtry, Markle, Meredith, Ronald, Snow and Town were all involved.

The popular uprising was successful. It set an example for the rest of North America.

Gerald Gladstone

John Meredith

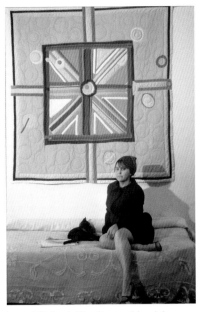

Joyce Wieland, *The Square Mandala*

John Ivor Smith, *Chelsea Micro*

Robert Markle, *Her Thin Long Legs*

Joyce Wieland, *Flag Arrangement*

Gathie Falk, *Picnic With Clock and Bird*

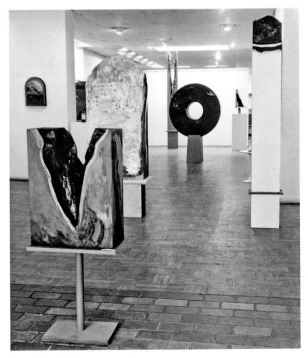

Tony Urquhart: one-man show

Bruce Kidd, Canada's first 4-minute miler

Claude Tousignant

BRUCE KIDD

Av Isaacs, Abby Hoffman, and I decided there should be a set of posters by Canadian artists for the Montreal Olympics in 1976. We approached the Ontario Council for the Arts, and Director Lou Appelbaum quickly authorized a grant of $15,000. Next we sent off a proposal to the Canada Council.

Tim Porteous of the Council flew to Toronto to meet us at The Isaacs Gallery, where he gave us three conditions for support. First: Av, as a private dealer, represented a conflict of interest and should be dropped (we refused). Second: we must put "Canada" instead of "Montreal" on the Olympic posters (we agreed reluctantly). Third: he said, "We have a problem with the money. What you propose isn't enough. We'd like to double the budget"! After we pulled ourselves off the ceiling, there were big hugs all round.

In the end, we printed 10,000 sets of l0 posters. Sunoco provided the tubes with the artists' names printed on the outside, and we distributed them to athletes, coaches, officials, sports clubs, and universities across Canada and around the world.

Av: All in all, we raised over $100,000 (a committee of three amateurs!). In those days, Canada was in such a state of euphoria that anything seemed possible. Nowadays, to raise that kind of money would almost be impossible because our society has become so much more complex and bureaucratic.

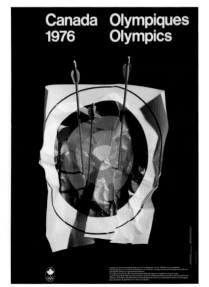

Pierre Ayot

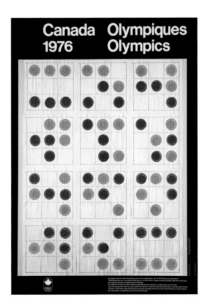

Michael Snow

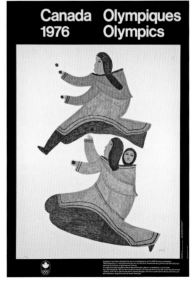

Lucy of Cape Dorset

Gathie Falk, *Fruit Piles*

GATHIE FALK

In 1972, Tom Graff and I (with the assistance of Elizabeth Klassen, Salmon Harris, Anna Gilbert, and Janet Malmberg) did two nights of performance art in The Isaacs Gallery. I had a heck of a time getting Av to bring a saucepan from home so that we could boil six eggs for one of my pieces. After I joined The Isaacs Gallery, I may have offered to knock Av down a few times, but I never again asked him for a saucepan.

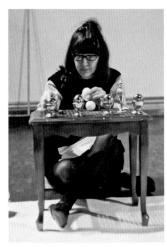

Gathie Falk, *Performance Piece*

Angus Trudeau, *The Manitou*

STAN DENNISTON

Av had purchased a new station wagon – a navy blue Oldsmobile, as I recall. What I can't recall precisely is how I damaged it. I do remember how tight things were in the alley behind the gallery.

Somehow, while turning the wagon around to back into our spot, I clipped the low wall separating the ramp from the alley with the right front fender. Of course I felt bad about it and dreaded having to tell him; but, in the back of my mind was the salve that Av himself was pretty hard on his vehicles and that they inevitably accumulated quite a collection of scrapes and dents. He'd understand. (I won't say that Av was a bad driver – 'carefree' might describe it.)

I certainly wasn't prepared for the ferocity of his anger.

Narrow back alley, The Isaacs Gallery

Later, near the end of that day, Av came downstairs to the frame shop and apologized for his outburst. "It isn't so much that you've damaged the wagon," he offered. "It's more the fact of it being the FIRST DENT…that you beat me to it."

JARED SABLE

Writing for the Toronto Telegram I had occasion to criticize very severely one of The Isaacs Gallery artists. This appeared in a Saturday edition of the paper. The following Tuesday Av called me. I figured "Ah Christ, I'm going to get it now." On the contrary. He thanked me for writing the review, agreeing with me all the way and saying that he was sending it to the artist in New York, and possibly it would straighten him out. That was The Isaacs Gallery, open to all and willing to take whatever life offered. Toronto missed it sorely and misses it to this day. It was a time and it was a place and Av Isaacs was its custodian. We were just the lucky recipients.

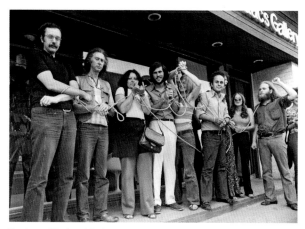

Protest, Chained Artists Protest American Appointed as Head Curator AGO: includes Kirwin Cox, Mike Snow, Joyce Wieland, Charles Pachter and Jim Brown

Stephen Cruise, *Wolf At the Door*

Gordon Rayner, *Rattler, Hatband Canyon*

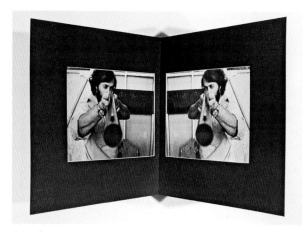

John Greer, *Dual*

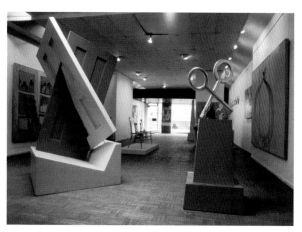

John MacGregor, One-man show

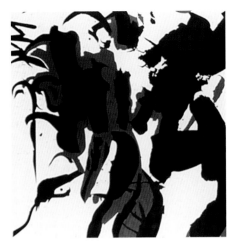

Dennis Burton, *Purple Tense*

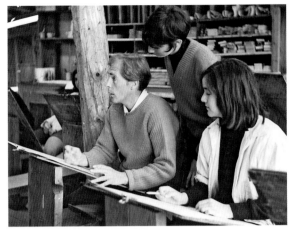

Dennis Burton, Teaching

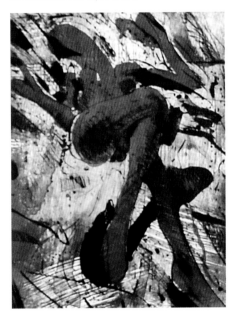

Graham Coughtry, *Reclining Figure Moving #4*

Greg Curnoe, *Self Portrait with Galen on 1951 CCM*

Angus Trudeau, *Boat with Red Sails*

William Kurelek, *Nativity in Canada Series*

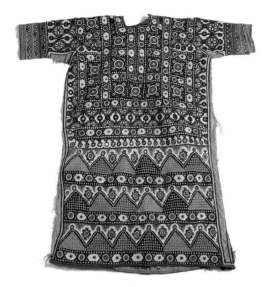

Woman's Tunic (Cholo) Sindh, Pakistan mid 20th c
collected in Baluchistan

One day, a pregnant and attractive woman in her
twenties came into the gallery. She showed me a
beautiful embroidered woman's jacket, and wanted to
know if I was interested in buying it. She had a collection
of them, she said. It was a Baluchistani wedding jacket –
sewn into it were small mirror-like pieces of mica.

I was curious, so I went along to her apartment, where it
turned out she had twenty more jackets. Now, I knew
little about clothing or fabrics, but I thought they were
quite beautiful, so I bought the lot.

The jacket exhibition was a wild success, so I phoned
her and asked her if she could get some more jackets for
me. It seems she was married to a Baluchistan
aristocrat, and had come to North America to have her
baby – the jackets were her means of support. So she
called her husband in Baluchistan, and he mounted his
camel and set out to look for more. But in all his
scouring, he could find only three more jackets. It seems
I had exhibited and sold the largest collection of
Baluchistan wedding jackets in the entire world.

Detail

GREG GATENBY

Av Isaacs changed my life. In the mid-1970s, I was
doing research at the Toronto Reference Library, near
Yonge and Bloor, for an anthology of poems about
whales and dolphins. Exiting the library, I crossed
Yonge. Suddenly, my eye was caught by a huge painting
of a whale in the front window of Av's place. I doubt I'd
ever entered a private gallery, but I did that day, to ask
about the work and the artist. Av himself answered my
queries and was so friendly and unintimidating that I
went back several times to look at Michaele Berman's
airbrushed cetacean images. During one of those visits I
decided to include visual artists in my anthology, and
I've been an extremely happy aficionado of the visual
arts ever since.

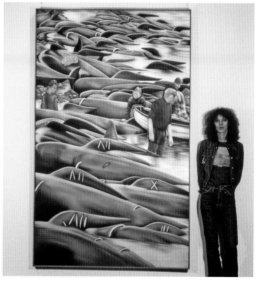

Michaele Berman, *Curse of the Faroes*

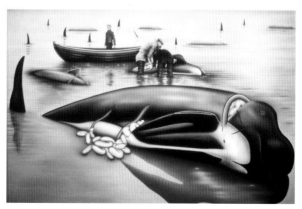

Michaele Berman, *I Cry Tears of Blood for the Power Man*
Wields on the Hierarchy of Being: to Nulijuk

William Kurelek, *Chasing a Chicken in the Snow*

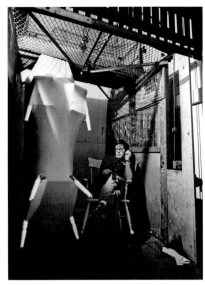

Les Levine in the gallery elevator

RAMSAY COOK

William Kurelek: A Prairie Boy's Winter
The collectors arrived early. I was the second or third to join the line that began to form about 9 on that cold, dreary Saturday morning. When Av arrived, he immediately offered to buy us all coffee. Just before the doors opened he set the ground rules: until the first arrival had chosen, no one else could claim a painting. Then the second and so on. Obviously, this was an art show not a Boxing Day stampede.

Av and Walter Redinger

STAN DENNISTON

The Isaacs Gallery on Yonge St. had a freight elevator at the very back of the building that ran between the basement, main floor, and mezzanine. It was the most rudimentary of elevators – no doors, just a cage. Even I, an artist familiar with old Toronto warehouses and their elevators, found this one a little rickety and unreliable. It should have been condemned and sealed up — and would have been save for whatever Av said to, or slipped, the inspectors from the Ministry of Labour. I think that his plea was that we only used it for storage. Of course, it really was invaluable for moving artworks between floors. And Av did make the point with staff never to ride with the artworks.

One morning I arrived at the gallery, minutes early and pulled the door. Locked. Not having a key, I waited for another of the staff. I noticed that the lights were on in the rear of the gallery — either they were left on overnight – a no-no – or someone was already in. I knocked. No one answered. After Martha arrived, for the entire length of our walk back through the gallery, we tried to recall who had been the last to leave the night before and speculated on who might be in already and why. We were interrupted by a loud commotion further back. Av yelling. I don't know why but I had the thought he was fighting off an intruder. But no, we found the boss all alone in the elevator. He'd been stuck in the cage all night.

Ralph Greenhill, *Post Office, Bethany*

Tony Urquhart, *Temple I970*

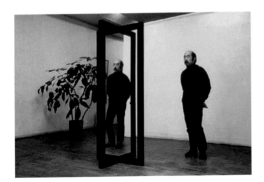

Nobby Kubota, *Reflections I*

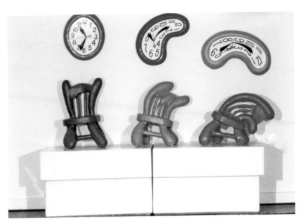

John MacGregor, *Time is a Prison Without Walls*

ARNIE BROWNSTONE

The 140-foot basement, corresponding to the footprint of the building, seemed to go on forever in both time and space. Although there was a long masonite-covered table along its spine, where Av and Razie priced legions of Eskimo soapstone figures with machine gun rapidity, and Stan performed secretly concocted repairs to injured art, the basement was primarily for storage. Like all real basements it was both soulful and exciting. It held things which might never again see the light of day, and sleepers whose secret qualities waited for discovery. Like an archaeological dig, the further you travelled the more ancient and unknowable the artifacts: Les Levine's pink enveloped chairs and vacuum-formed disposables, black canvas grottos with dream interiors, Anne Kahane's wooden figures, Ted Bieler's monolythic sculptures of unknown material and Arthur Handy's ceramic forms.

John Meredith, *Untitled*

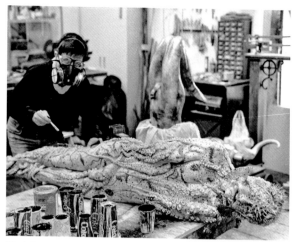

Mark Prent: work in progress

mark prent: meeting mark

John Ivor Smith was a sculptor I represented. He was head of the sculpture department at Montreal's Concordia University, and in the late 1960s he began to badger me about a young artist who was a student of his. Finally, I arranged to meet Mark Prent on my next trip to Montreal.

Mark told me that his work was stored in his father's apartment. It is difficult to describe my shock on entering that two-bedroom apartment. Mark's work was all three-dimensional figurative, made of cast polyester resin. It was extremely graphic, and to describe it as disturbing is a vast understatement.

It portrayed the human condition in the worst possible light: a baby covered with hair in a child's car crib, a quadraplegic sitting on a toilet with a grimace on his face as if he was constipated (you viewed him through a small window, as he was in an outhouse-like structure). And much more.

The work was intense, extremely realistic, technically superb. It was particularly disturbing to see it crammed into all parts of the apartment: the living-room, the bedrooms, the hallway, even the kitchen. Mark's world was a world of the macabre, with a certain quality of irony and humour (although I certainly did not recognize that aspect of it at the time).

The only warm and humorous note about the entire episode was his father, who was so proud of his son's work. It reminded me of the phrase that immigrants often used about their children who were beginning to move up in the world: "my son the doctor." But this was "my son the artist"!

Well, I kind of fell out of that scene and wandered the streets for a while, reeling as if I had been punched. Three days later I was still preoccupied and disturbed by my recollections of that experience. I then decided that that was reason enough to represent Mark. It was impossible to separate my emotional reaction from my sense of aesthetics.

I was fortunate in that I was not aware that there might be criminal implications to exhibiting the work.

SUE PRENT

When I say that we were chronically late and out of money, you know that I don't exaggerate. When we made our biennial trek to Toronto to install Mark's latest environments in The Isaacs Gallery, it always took us a week or more to do so. We'd start out all right, confident that we had plenty of time; but we were kind of like the circus, with three rings of simultaneous activity and every possible kind of thing going wrong at the last minute. As the opening approached, we were up all night, with floodlights attracting all sorts of interesting Yonge Street characters to peer in at us in that fishbowl. And then you, Av, would roll in (at something like 1 in the morning?) with a thermos of hot coffee and an offer to drive us way the heck out of town to some great little Italian delicatessen, where you'd order big fat veal sandwiches for us; then tuck us back in the gallery, all warm and fed, before bidding us goodnight.

In those days, you were more like a Dad than a dealer.

mark prent: the exhibition

For his first exhibition at The Isaacs Gallery (1972), Mark and his girlfriend (later wife) Suzy worked around the clock setting it up. They slept only three to four hours each night.

Mark Prent, *Is There Anything Else You'd Like, Madam?*

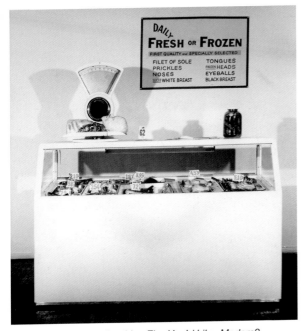

Mark Prent, *Is There Anything Else You'd Like, Madam?*

Exhibition Visitors

The installations were enormous physical efforts, taking several days. In retrospect, I feel sorry for my two assistants who had to live in this milieu. It was not their choosing.

On your left, near the entrance, was a real butcher's display case holding trays full of various cuts of meat, with the prices marked beside each tray. The cuts (not real, but looking extremely real) were various parts of the human body, such as breasts and soles of feet. On top of the counter was a jar of Kosher Prickles (related to male anatomy). There was also a butcher's scale with a human chest and head on it. This area was titled "Is There Anything Else You Would Like, Madam?"

On the floor were the mangled "remains" of somebody who had been run over. Four crows were feasting on this road-kill. Further back in the gallery, and titled "The Last Supper," was a table beautifully set with crystal glasses, sterling cutlery, and a tall, elegant candelabra. The main course was a large roast of human torso. All the side dishes were portions of human anatomy.

The public reaction to Mark Prent's 1972 exhibition was immediate. On an average gallery day we might have had twenty-five or thirty visitors. During this show the atten-dance swelled to hundreds daily. On Saturdays, I suppose at least a thousand turned up.

Mothers with five-or six-year-olds would wander in. They took one look and immediately tried to shelter their children from seeing the work by dragging them (literally) out of the gallery. The youngsters, who had caught a fast peek at the work, were fascinated and wanted to stay. I guess the mothers thought the experience would make a mess of their kids.

I noted that visitors under thirty were able to appreciate the work, whereas those who were older had real problems. Mark's exhibition preceded the science-fiction horrors that came along later. Someone reported that a woman in the gallery had become physically ill. Somebody came in one day and placed a bouquet of flowers on one of the figures. There was a rumour that a well-known pederast had started hanging around, as the show was full of disturbed but real-istic human anatomy.

The crowds became so large that I had to hire a uniformed security man to stand at the door. My staff and I were near emotional wrecks. We did not know what to expect next.

MARIE DAY

When The Isaacs Gallery was charged with "displaying disgusting objects," the work of Mark Prent, several people came forward to "offer to purchase" some of the works in order to prove they were recognized as works of art.

Amongst those 'purchasers' were Murrary Laufer, Marie Day, Barbara and Murrary Frum, Percy and Jessie Waxer. The trial was at the Old City Hall. None of the artists that Av Isaacs represented showed up.

The only people present were Nathan Isaacs, Murray Laufer, three or four students from York University, plus a reporter from a publication known as *Gorilla* magazine.

Outside the courtroom reporters from the Globe and the Star waited for the results. They did not attend the trial.

Charges were dismissed on a technicality.

JUDY STOFFMAN

One magic summer night in 1972, I was at a packed opening at The Isaacs Gallery, carrying my newborn daughter in a Snuggly – the first vernissage she ever attended. And of course I remember the shock of seeing Mark Prent's meatmarket, the penises like pickled cucumbers in a jar, and meeting Mark in the gallery; he seemed surprisingly harmless and nerdy. Av clearly enjoyed the furor around the artist. He knew that art matters and that it was fine for people to argue about it.

OLGA KORPER

Av's sometimes controversial exhibitions became part of my daughter's early education. Mark Pent was showing and I took my seven-year old daughter Sasha to see the show. Two visitors were expressing their disgust and outrage at the imagery and discussing appropriate action when Sasha tugged at one of the ladies' sleeves and assured her that "It's OK. It's not real. It's art and we just have to look at it."
For all your fights for freedom, Av, we thank you.

gumby goes to heaven

In 1975 three establishment citizens – a city bureaucrat, a very wealthy individual, and a retired major-general – decided to commission a memorial to Canadian airmen who had served in the Second World War. They gave themselves the authority to appropriate an important piece of public property on the boulevard at the corners of University and Dundas streets in downtown Toronto.

Without consulting any members of the arts community, they commissioned a very tall statue that suggested a figure with arms outstretched. It was so amateur – it reminded me of something made with silly putty by a child. I found it embarrassing and thought it an insult to a supposedly large, sophisticated city.

Artist Dave Clarkson painted the title "Gumby Goes to Heaven" on the wooden hoarding surrounding the sculpture.

A group of us in the arts organized a protest that started in the morning and went on into the early evening. Participants included people from dealers to public gallery curators to collectors. We made signs and marched around the statue. Arnaud Maggs, an important artist and an RCAF veteran, called the piece an insult to the airmen's memory.

We received terrific press – but to no avail. Even though the monument was illegal, politicians were not ready to act because it was a memorial.

The only positive result was that a member of Metropolitan Toronto staff took me out for lunch and asked me what procedures to follow in the future.

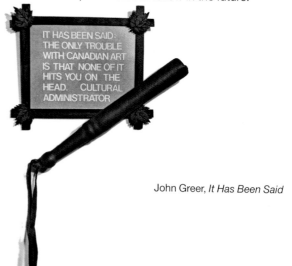

IT HAS BEEN SAID: THE ONLY TROUBLE WITH CANADIAN ART IS THAT NONE OF IT HITS YOU ON THE HEAD. CULTURAL ADMINISTRATOR

John Greer, *It Has Been Said*

michael snow: flightstop

Michael Snow is one of those rare artists who can apply their creativity to any situation. He can use it to introduce an exhibition (Gord Rayner opening) … to produce a great series of photographs in an isolated cabin in Newfoundland … or to fill a vast space in a public arena (Toronto's Eaton Centre).

Flightstop (at the Centre) depicts a flock of 60 Canada geese about to land. It is superb use of the space. Eb Zeidler, the architect of the Centre, told me that "Flightstop" appeared on over twenty-five magazine covers around the world.

A year or two after the flock's installation, just before Xmas, someone on the decorating staff got the 'bright' idea of tying red ribbons around the geese's necks, to enhance the holiday cheer.

Mike rightly took the position that this was a defacing of a work of art. He hired a lawyer, and we appeared before some sort of tribunal for questioning by the Centre's lawyer. We stuck to our position and created a legal precedent when the decision was made in his favour. This means that: YOU CANNOT DEFACE A WORK OF ART, EVEN IF YOU HAVE COMMISSIONED IT.

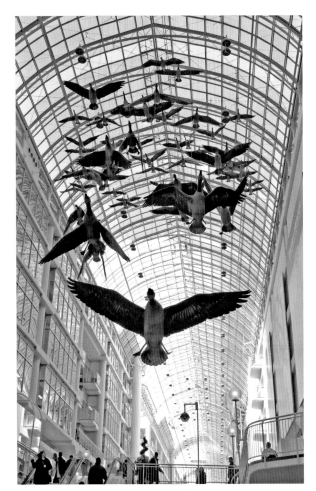

Michael Snow, *Flightstop,* The Eaton Centre

Michael Snow, *Traces*

Mike is an intellectual. Often during his exhibitions it would take me a while to figure his work out. There is a quality of humour in his work and an ever-present awareness of women. At this point, he is a truly international figure … I never know whether he is in Canada, Europe, Australia, or Asia … always on some art-related project. Over the years he has adapted his gift to whatever was on the horizon … film, video, holography, and the latest-computer technology.

Scholar, musician, and filmmaker, Mike is a wellspring of creativity.

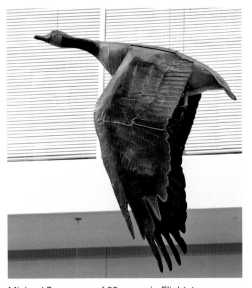

Michael Snow, one of 60 geese in *Flightstop*

JUDI SCHWARTZ

On arriving at Hart House in 1975, I found that my very first challenge was to get the House art gallery in the good books of Canadian Artists Representation (CAR). The gallery was on the CAR's blacklist for not paying fees to artists.

That is how I met Joyce Wieland. She had been one of the artists who picketed Hart House. She charged into my office within a week of my arrival, demanding that I do something. That was the start of a lifelong friendship.

I am happy to say that after an investigation of Hart House practices, the artists began receiving the equivalent of what would amount to artists' fees. I met Gary Conway, who headed up CAR, and between us we rectified the situation, clearing up any misunderstandings.

Joyce Wieland, *Self Portrait*
Agnes Etherington Art Centre, Queens University

vietnam draft dodgers

During the Vietnam War, I was occasionally asked to send letters to young men in the USA who were likely to be drafted. The letter offered them a job as a picture framer in my shop. They were then able to more easily immigrate to Canada.

Souvenir of George Feyer, illustrator

On occasion a young man would approach me, thank me, and leave.
These American so-called draft dodgers made a great contribution in Toronto. Like so many Americans they brought that special brand of energy. They were intelligent and educated. I still run into a number of them in the arts.

Serra

I met Richard Serra at a party in Rosedale. He was an aggressive individual who didn't suffer fools or enjoy light banter. He almost got into a fight at the party.

I agreed to have him install a sculpture in my gallery. This consisted of a single sheet of one-half-inch-thick steel about 8 feet by 10 feet. It weighed 1800 pounds.

Richard Serra: window removed for installation

I had to remove my huge plate-glass window fronting on Yonge Street to install it. The concept was another of Serra's visually death-defying installations. The sculpture was positioned in the corner of the gallery, jutting into the centre of the room. All that supported it was its position in the corner.

Richard Serra: seven-man installation, 1,800 pounds

Every day of the exhibition I feared not only its collapse, but that it would fall on some poor observer. At the end, rather than risk removing the window again, I had a metal dealer cut the steel sheet in half with a torch. In removing the smaller pieces through the doorway someone dropped one section. There still exists a permanent memento of it where it chipped the front sidewalk.

Three Callaghans: Barry, Morley, and Michael at Barry's booklaunch

Barry Callaghan book launch,
The Hogg Poems and Drawings

Robert Markle, *Untitled*

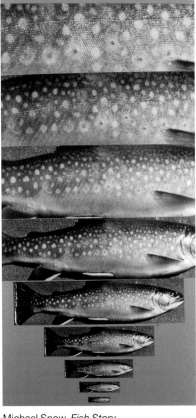

Michael Snow, *Fish Story*

Gordon Rayner, *Two Weavers*

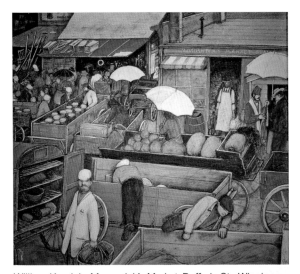

William Kurelek, *Morosnick's Market*, Dufferin St., Winnipeg

joe mendelson

I had been aware of Joe Mendelson (later Mendelson Joe) for some time. He was an occasional visitor to the gallery. There was something about his appearance that made him memorable. He was large had a powerful voice and there was a self-confidence about him. He certainly did not shy away from issues of principal. He went on hunger strikes for just causes. For some time he positioned himself in front of the Ontario Hydro offices on University avenue protesting their use of atomic energy.

On occasion I would stop to talk when I ran into him at street corners painting a scene. I saw his last perform-ance with his band Mendelson Mainline at the Victory Theater. It was great theatre ! He then disbanded the group.

At one time he approached me for an exhibition which I initially refused. After some thought, since I found his painting naïve but charming, I offered him a one-time only exhibtion to help him out. (joe might not appreciate this statement as he is a very independent guy).

At one time I wrote a letter supporting him for a Canada Council grant which he received. He used the money to buy a new motorcycle. Well, I thought it's up to the artist to best decide what will contribute to his development.

Mendelson Joe, *Humble Nurse*

Isaacs Gallery, *Painted Window by M. Joe*

mendelson joe

It was a busy Saturday afternoon. Mendelson Joe came in. "Av," he said, "I have some of the best dope I ever smoked. Come into the back and let's share some."

"Joe," I said, "I can't. I'm busy."

"It will only take a few minutes, and you will love it."

"OK," I said.

So we sat down on the steps at the back, behind the closed doors of the gallery. I took a few deep-breath drags, and Joe said, "Av, this is the most powerful dope that I ever smoked."

A few minutes later, I had to go out front, as I had an appointment with a client. We sat down in my private viewing room facing each other. As we sat there talking, my head started to droop; I found myself facing the floor, and I couldn't raise my head. I was very embarrassed and made some excuse and said I would be right back. I got up, left the gallery, and walked around the block, taking deep breaths.

I felt much better, went back into the gallery, sat down facing my client again, and started back into our conversation. My head began to sag again, and I just could not lift it. My client perhaps sensed what was up and gave me a pitiful look and left.

MENDELSON JOE

I attended at least two Mark Prent exhibitions at Isaacs. Prent's fabrication (resin sculptures of ghouls) was superb. Masterful. Amazing! Was the work disgusting? No more than Brian Mulroney was disgusting. Should Avrom have been closed for displaying a disgusting object? Never – I'm against censorship.

Were Prent's horror movie freaks art? Nope, not for this Joe. Thems my comments.

electrocution chamber

For one of his works in his 1974 exhibition (when I was once again charged with "exhibiting disgusting objects"), Mark constructed an execution chamber. As part of his research, he had received permission to visit the room where electrocutions took place at a penitentiary in Chicago. Mark's piece consisted of a full-scale room with a glass front.

Mark Prent, *Death in the Chair:* Mount the stairs and pull the switch

Inside was a figure strapped to an electric chair and blindfolded. On one side of the room was a door with a window inset and a set of stairs leading up to the window. On the wall to the left of the window was a switch. While you stood looking at the figure, you could pull the switch. There would be a crackling sound (like electricity jumping a gap), and the figure in the chair would simultaneously lurch!

This became a very successful 'audience participation' artwork. At the time, 2 Bloor West (a twenty-four-storey building) was under construction. Every lunch hour, the hard-hat workers would flock into the gallery. They stood in line to climb the stairs and pull the switch. Many returned to the back of the line to repeat the artistic execution. Give the people what they want, and they will come!

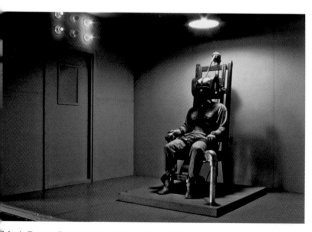

Mark Prent, *Death in the Chair:* Convulsion

JUDY STOFFMAN

I was only 22 or 23, recently arrived from Vancouver by way of graduate school in England, when I first discovered The Isaacs Gallery on Yonge Street. It opened my eyes and blew my mind, to use an expression that was so popular in the early 1970s. The art jumped off the wall and demanded that I pay attention. What was it saying to me? Maybe this: that I was living in an era of unprecedented creative freedom and that I too could do anything.

I would drop in regularly just to look, a girl making $115 a week as a production assistant at the CBC, who longed to buy a drawing by Joyce Wieland, or one of the mysterious, intense paintings by William Kurelek, or a wacky assemblage by Michael Snow – I remember one made out of a drawer – but couldn't afford to. I also remember a colourful arched sculpture by John McGregor, a troubled artist whom Av tried to encourage.

Av was patient with me and explained who the different artists were and what they were doing, even though he must have guessed that I was not then a customer. Eventually, when he moved the gallery down near the AGO, on John Street, I was able to buy a Wieland from him and an Inuit print.

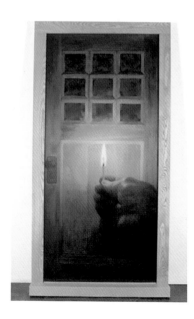

Michael Snow, *Door,* Macdonald Stewart Art Centre, Guelph

PIERRE THÉBÈRGE

Greg Curnoe and Joyce Wieland's culinary triumphs at the National Gallery of Canada:

To celebrate the opening of the National Gallery's 1967 exhibition *Three Hundred Years of Canadian Art*, organized as part of Canada's Centennial celebrations, Director Jean Sutherland Boggs gave an enormous party for Canadian artists in the gallery's vast basement workshops area.

She had agreed to my suggestion of commissioning artists for a specially designed birthday cake for the occasion. I asked several artists like Harold Town, Claude Tousignant, and Greg Curnoe to send submissions.

In the end, only Curnoe did, and his design was realized: an enormous flat cake on which was inscribed in green and blue lettering on orange icing: "300 YRS OF CANADIAN ART I THINK I LOVE YOU! BUT I WANT TO KNOW FOR SURE! 300 YRS OF CANADIAN ART, HOLD ME TIGHT! I NEED YOU!

Secretary of State Judy LaMarsh inaugurated the exhibition and cut the cake. It was enjoyed by all.

The second cake for the National Gallery was designed by Joyce Wieland for her 1971 show *True Patriot Love*. Called *Arctic Passion Cake*, it was her rococo interpretation of an archetypal Canadian mountain landscape.

Joyce Wieland, *White Snow Goose of Canada*

Joyce Wieland, *Arctic Passion Cake*

I had persuaded the parliamentary restaurant's chef to execute Joyce's vision, and he produced an extravagant and spectacular object, six feet across, which astounded and delighted her.

Never intended to be eaten, the cake was displayed for the duration of the exhibition. Two years later, the gallery purchased Joyce's pen-and-ink drawing for the cake from The Isaacs Gallery.

As far as I know, no other artistic culinary experiments were commissioned at the gallery since then. Times have changed, and I doubt it could ever happen again. Now, even a tea party *sans gateaux* would probably be seen as an extravagant folly.

RAMSAY COOK

Joyce Wieland, *True Patriot Love*
The sober red cover of the catalogue for this show (it had opened in Ottawa on July 1), looked like a government document. And that's exactly what it was – or had been: a botanical report on Canadian flora. Wieland's unorthodox photos, scribbles, scripts, pressed leaves and flowers were clipped to pages filled with dry scientific data. Patriotic Pierre Trudeau's quilted *La Raison avant la Passion* was on the wall, in both official languages naturally. (Trudeau owned only the French one!) So, too, was the gorgeous, embroidered crest, *White Snow Goose of Canada*. Av Isaacs stylishly stitched his version onto his blazer pocket.

Joyce Wieland, *Wolfe's Last Letter / Montcalm's Last Letter*

JOHN ROBERTS

When I first saw the Last Letters of Wolfe and Montcalm I began to reflect on what the picture 'signified.' I liked its use of a traditional craft – embroidery – in a contemporary context. That linkage reinforces the picture's subject, which captures a fleeting moment in time and preserves it. It connects to us by providing the 'shock of recognition' of two men writing before the prospect of death (which can come to countries as well as individuals) – a fate that we all know will come to us one day.

I was then a parliamentarian, preoccupied with questions of national unity. There seemed to me a parallel to our times in these iconic figures of our two founding nations within a single frame, joint emblems in a common heritage. They represented for me a hope that, despite our diversity, we could live side by side in harmony in one country and not be doomed, as Wolfe and Montcalm were, to die in misunderstanding, exhaustion, and conflict. I had that hope when I first saw the picture, and I have it now. I loved the picture then, and I love it still.

RAMSAY COOK

Vancouver, Emma Lake, Winnipeg, Toronto, Montreal, Mount Allison: Jack Shadbolt and Takao Tanabe, Dorothy Knowles and Ron Bloore, Ken Lochhead, Michael Snow and Joyce Wieland, Jean McEwen and Guido Molinari, Alex Colville, Christopher and Mary Pratt.

From the sixties to the eighties Canadian art bloomed, cultivated by the Canada Council. In Montreal, Borduas' influence remained powerful, sometimes radically transformed into hard edge abstraction. In the Atlantic provinces, "magic realism" evoked a new figurative vision, while Emily Carr's landscapes and representation of Native art inspired new perspectives on the Pacific region. On the prairies, especially in Saskatchewan, abstract expressionism from New York found an unlikely but fertile environment. In Toronto, where the experimental art scene focused on Av Isaacs's various spaces (always following the movements of the counter culture in Toronto the less and less Good), variety, controversy and just plain fun prevailed.

The vital visual arts scene shared in a much broader cultural explosion that, in the 60s and after, took many forms. Here are a few random (mainly Toronto-centred) glimpses of the cultural history of these years: classical music: Glenn Gould, Murray Schaefer, Harry Somers and Maureen Forrester; popular song: Gordon Lightfoot, Anne Murray and Neil Young; in scholarship Northrop Frye and Marshall McLuhan; in literature; The Stone Angel and Prochain Episode by Margaret Laurence and Hubert Aquin and Alice Munro's stunning short fiction; publishing: Tamarack Review and Anansi; poetry: Eli Mandel's An Idiot Joy and Michael Ondaatje's The Collected Works of Billy the Kid; plays: Michel

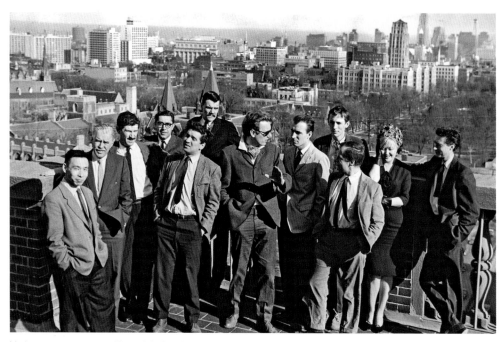

Variety, controversy and just plain fun: Nakamura, Bush, Scott, Varvarande, Gladstone, Rayner, Town, Hedrick, Wolfendon, Gibson, Wieland, and Snow. (photo by Tess Taconis)

Tremblay's *Les Belles Soeurs* and Thomson Highway's *The Rez Sisters*; theatres: Bill Glascoe's Tarragon and Honest Ed's Royal Alex; comedy: Old Rawhide, Dave Broadfoot and the Air Farce; film: Don Shebib's Goin' Down the Road and Claude Jutras' *Mon Oncle Antoine*. On and on.

Even our politics briefly became theatre in the years between the baby boom and the stock market bust. Pierre Trudeau and René Lévesque starred on the main stage, but the lesser venues were full of talented players: Tommy Douglas, Peter Lougheed, Jean Lesage and Richard Hatfield. In one decade: a terrorist kidnapping in Montreal, the invocation of the War Measures Act and a referendum in Quebec that first threatened the country's unity and then its sanity. An enlivened city politics responded to rapid urbanization and multicultural transformation. Dignified English-speaking Toronto became a raucous Tower of Babel. Reformist mayors David Crombie and John Sewell fought manfully against sprawling development, billowing pollution and clogged traffic. The Spadina Expressway stopped but Hippie Yorkville turned into a Yuppie boutique. William Kurelek's *O Toronto* pictured the changes and warned against the temptations.

Canadians watched and wondered at the emerging American Empire: the Cuban missile crisis, Vietnam and Bomarc warheads stymied both John Diefenbaker and Lester Pearson: US direct investment, free trade and Star Wars left only the Irish eyes of Brian Mulroney and Ronald Reagan smiling. Nationalism in English Canada, often articulated by artists like Greg Curnoe and publishers like Mel Hurtig, rose and fell with the times. In Quebec, nationalism marched to the same drummers but with a different destination. One day two prophetic works of imagination may seem best to sum up these exhilarating decades when The Isaacs Gallery flourished: Margaret Atwood's *The Handmaid's Tale* and Denys Arcand's *Le Déclin de l'Empire Américain*.

Ramsay Cook, Av Isaacs

the Eighties
and onward

recollections from Av and:

BRIAN DEDORA

MARTHA BLACK

TRISH BEATTY

NATHAN ISAACS

LARRY PFAFF

RENANN ISAACS

HOWARD ISAACS

ROBERT FULFORD

DOROTHY CAMERON

CHRISTOPHER HUME

GARY MICHAEL DAULT

GREG GATENBY

MICHAEL SNOW

UDO KASEMETS

DON LAKE

GAIL DEXTER LORD

SARAH MILROY

William Kurelek, *The Workshop* (includes Brian Dedora)

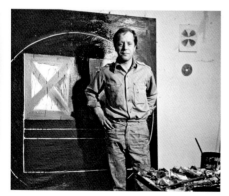

William Kurelek and Av Isaacs

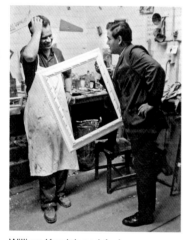

Tom Gibson (photo by Tess Taconis)

Stan Denniston

artists who worked for me

I wish that over the years I had kept a list of the artists who worked for me. My policy – and that of many dealers – was to hire young artists. They were often available for either full-time or part-time work, and their profession prepared them for the gallery system.

Past employees of The Isaacs Gallery are:
Martha Black: curator, Provincial Museum, Victoria, BC
Arnie Brownstone: ethnologist, Royal Ontario Museum
William Kurelek: a master gilder
Brian Dedora: a gifted former apprentice of Bill's
(Brian wrote a book on the Isaacs Framing Shop).
Stan Denniston: artist using photographic techniques
Telford Fenton: artist
Tom Gibson: photographer, Head of Fine Arts, Sir George Williams College, Montreal
Brian Groombridge: artist
John Meredith: artist
Bernie Miller: artist
Ludzer Vandermullen: creator of the mythological figures in front of the Toronto Children's Library
Robert Wiens: artist

And many more… a group exhibition of their lifes' works would certainly be resounding today.

Telford Fenton

Isaacs workshop

Eskimos… great readers?

BRIAN DEDORA

I was so intimidated by the Isaacs reputation when I went in to ask for work that I downed a couple of beers beforehand. When I first met Av Isaacs I thought to myself, "The guy's a bulldog."

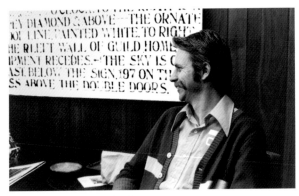

Greg Curnoe's written landscapes

It took bpNichol to explain Curnoe's written landscapes to me. Everything after that opened up, and the whole art adventure that became my career began.

The excitement of an art gallery opening

I was so excited about going to my first art opening. I dressed up in black pants and a horizontally striped black-and-white shirt. John Meredith walked up to me and told me I looked like an asshole …

Unpacking Inuit sculpture embedded in tons of shredded newspaper caused me to wonder why the Eskimos read so much.

One of the most significant and powerful painting exhibitions ever was Meredith's show, with only five paintings.

At one client's house, with no more room on the walls, we attached paintings to the ceilings.

The backs of the white letters on a Joyce Wieland quilted piece were highly coloured polished cotton, which glowed and reflected on the white background. I thought only a woman would think of this and that this was truly feminine art.

Wieland sensibility: *Lens* (detail)

Martha Black, associate director, The Isaacs Gallery

MARTHA BLACK

Two decades in The Isaacs Gallery.
At the University of Toronto in the 1960s, there was a single course on Canadian art, and it stopped with the Group of Seven. There didn't seem to be much of a contemporary Canadian art scene, but I soon found out that there was and that it centred on The Isaacs Gallery. I went to work there about 1970.

The Isaacs Gallery was instrumental in the creation and continuation of a Toronto/Canadian art scene. When I started at the gallery, the London artists were a strong presence there, and their insistence on the possibilities of the local epitomized the values of the gallery.

Av had been in business for fourteen years and represented some of the big names in Canadian art, but the gallery seemed very much of my own generation nevertheless. Dan Solomon, John MacGregor, Gar Smith, John Greer, Paul Hutner, and others – all artists around my own age – showed there. This mix of young and old, new and established, continued. It was always a vital place.

Joyce Wieland and Robert Markle, The Isaacs Gallery

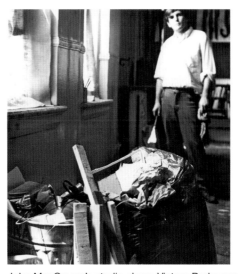

John MacGregor's studio above Victory Burlesque

John Greer, *You Are Where Your Eyes See*

Barbara Pringle, staffer, and Paul Hutner, artist

Richard Serra seemed as stern and frightening as his sculpture: a huge, rectangular piece of steel wedged in a corner in the middle of the gallery. Moving a huge plate of glass was involved as well: the front window came out to get the sheet of steel in. This was typical of Av: no difficulty was too great to present a work.

One of Gar Smith's exhibits involved rivers of pennies and cutouts on the wall … but the installation was never finished. There was some anxiety about this on our part, because we were *always* ready for an opening. But it didn't seem to bother Gar. I learned a lesson about the importance of process from that show.

At one of Robert Markle's exhibitions, the frames had strips of bent metal inserted under the edges at the back of the pictures to hold the paper against the glass. It became apparent that the strips had a tendency to spring out of the frames, propelling them off the wall and flinging pieces of metal about the gallery. None of this bothered Bob or Av.

Gar Smith

Robert Markle

Markle was the reason for two extraordinary events: The Big Bad Bob Benefit Bash and the opening of Markelangelo's restaurant. The first happened because of Bob's nearly fatal motorcycle accident in the late 1960s, with a long and difficult recovery period and no health insurance. The Isaacs Gallery and other venues sold tickets to a benefit concert at the Masonic Temple building, and there must have been thousands of people there.

Years later, Stephen Centner opened a restaurant that was extensively decorated with Markle's neon drawings, and of course everyone went to the opening. Everyone adored Bob.

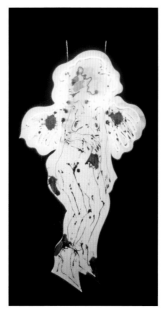

Robert Markle, *Markelangelo's Front Angel* (neon), Art Gallery of Ontario

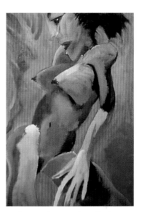

Robert Markle, *Far Cultures*

Av was lucky to have the people he had working for him. Although he was a bit of a loner, despite his gregariousness, and tended to think of himself as a one-man show, he had a lot of help from people who were very loyal to him. Among the most important figures in the gallery were the ones the public did not see. Av's brother Nathan was the accountant. Elsie Roberts was the bookkeeper – a little lady from Newfoundland whom we all loved dearly. Later Mary Becker joined us, a sustaining force who brought hot bagels and cream cheese every Friday morning. Terrific.

Every three weeks there was an opening. At first these were evening affairs. Later we switched to Saturday afternoons. Parties afterwards were extraordinary. Those were the days of enormous studios, and crowds were often huge. Well-known cultural figures, students, collectors, curators, and family members were all welcome, and there was great food, lots to drink, music good and bad (the Artists' Jazz Band usually 'played,' with uneven results). Those parties celebrated the artist's work and the gallery's success and embodied a scene, a place.

Although many of Av's artists had financial troubles, difficulties getting recognition for their work, troubles with relationships, and the usual quotidian stuff, the atmosphere around the gallery was headily optimistic. Av didn't create it, but he was an axis for this creative energy. Today much of this energy has moved to the art schools and the academy. These mainstream institutions owe a great deal to the possibilities forged by those times and those people.

Michel Lambeth, *William Kurelek, Painter*

Kurelek moved in a completely different milieu from that of the Spadina Avenue artists such as Coughtry, Markle, Meredith, and Rayner. And yet Av got along just as well with him. Kurelek's audience was different as well, and many people visited the gallery only for his editions. Some purchased paintings directly from the artist. Bill often worked in the workshop in the early morning before going to Mass and would leave notes, lists of sales, and cheques for deposit. I clearly remember how the large paintings from *Nature Poor Stepdame* hung in the gallery. Bill's genius for composition met his narrative talents in a powerful way in that series.

Graham Coughtry and Av

William Kurelek, *Nature Poor Stepdame* series: *Eve, Be Soon*

The Isaacs Gallery's eclecticism made it a fascinating place. We had exhibits of African sculpture, Baluchistani wedding jackets, Berber tent rugs from Tunisia, North American Native art and artefacts, Japanese prints, Indian paintings, carpet designs, political posters, folk art, Australian Aboriginal painting, and so on. Internationally known artists such as Michael Snow shared space with Angus Trudeau from Manitoulin Island. Ralph Greenhill's photographs of industrial structures might hang beside John Meredith's sublime abstractions and John Greer's visual puns. There was a commercial reason for this: it was wise to diversify. But it also illustrates Av's personal curiosity and perhaps intellectual restlessness.

Michael Snow

Ralph Greenhill, *Headstock*

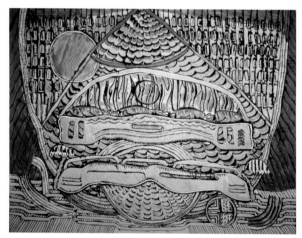

John Meredith, *Courrier*

Baluchistani Wedding Jacket, detail

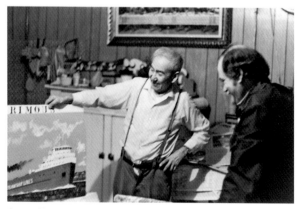

Angus Trudeau and Av, Manitoulin Island boats

832 Yonge Street was a storefront, long and narrow, with dark wood parquet floors and mid-century modern furniture scattered about. It was important to Av that people feel comfortable walking into the gallery and just looking around. You didn't have to buy anything to be a valued visitor. Av loved talking to people and could tell great stories and put on a good performance when he wanted to. Many would make it a habit to visit on Saturday mornings or on their way home from work. When we moved to John Street, Av sought a similar accessibility.

We had wonderful clients and supporters. Some were important customers who purchased regularly; others bought very little or perhaps nothing. Ramsay Cook, Elizabeth Gordon, Marie Fleming, Pam Gibson, Florence and Mickey Winberg and family, Fay and Jules Loeb were just a few of the people who took an active interest in what we were doing and contributed to the gallery's success, financial and otherwise.

After the gallery's framing shop at the back of the adjacent building on Yonge Street closed, some of the preparatory work went on in the basement. It was here where all the Inuit works were unpacked and where Stan Denniston expertly repaired Inuit sculpture. Besides Stan, many artists, including André Fauteaux, Richard Bonderenko, and Bernie Miller, worked for Av when they were young and in need of money to finance their work. Their varied interests and social circles contributed to the gallery's cultural survival and continuing engagement with the changing Toronto scene.

Pilot Tavern Coaster Coaster into art: Bob Markle

The Isaacs Gallery was local – a storefront on Yonge Street that was part of a distinctly Toronto scene … but it also had a national presence. There were exhibits of its artists at the National Gallery and the Art Gallery of Ontario, as well as in Oshawa, Thunder Bay, Victoria, Sackville, Kingston, and so on. Jack Chambers, Greg Curnoe, and Joyce Wieland were the most overtly nationalistic, but the entire gallery contributed to the sense that Canadian artists could work and get recognition in their own country. Av was never seduced by the lure of New York that so attracted much of the Toronto crowd.

Isaacs workshop with Stan Beecham

Greg Curnoe, *Christmas Tree Ornament*

People were drawn to Av's rather benign persona, but he was actually pretty tough and definitely a fighter. Witness the high-profile court cases the gallery was involved in – concerning Mark Prent's disturbingly surrealistic exhibits there and the Christmas bows that decorated Michael Snow's Canada geese (*Flightstop*) at the Eaton Centre.

Although the Isaacs artists were predominantly male, and there was a core group that was decidedly macho in style, Av showed several important women artists over the years, including Christiane Pflug, Michaele Berman, and Gathie Falk. Joyce Wieland was the most important of these pioneering women artists. Her *True Patriot Love* at the National Gallery of Canada was a significant exhibit. Joyce's work was purposefully feminine and feminist and among the best that the gallery showed. She had a great bunch of women supporters too.

Av always went with his 'gut' reaction, and for him recognition of important art was basically a subconscious process. Not for him the academic approach, as he knew what was going on in the work, even though he rarely articulated anything but the emotional aspect. Paradoxically, he sought novelty while at the same time building and continuing a historical tradition.

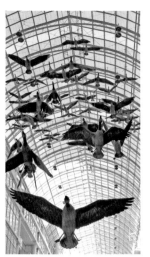

"The guy's a bulldog."

Unlike some dealers, Av continued to exhibit and store works from shows throughout the gallery's history. When pieces did not sell, they went into the racks and slowly went up in value. This was financially astute, but also gave the gallery a distinctive historical significance and continuity. You had the sense that a Canadian art history was in progress, and it was. You could see it on the walls.

Gordon Rayner, *Ascension from the Depths*

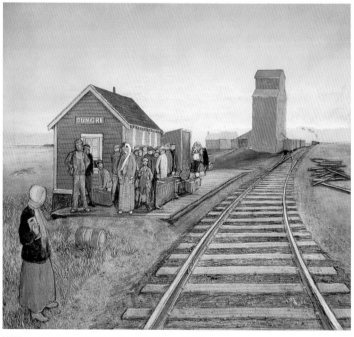

William Kurelek, *Immigrants at Railway Station*

Barry Hale, a good friend, remembered

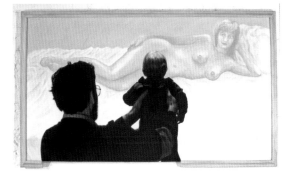

Michael Snow, *Quintet* (with 1-yr old Alexander Snow)

The engagement party

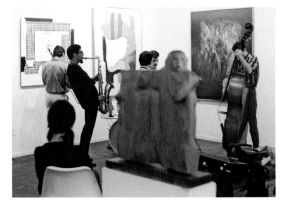

AJB practice

Isaacs, Don Owen, Michael Snow, and Dawn Cree

gallery as a social centre

The gallery was a sort of microcosm of our larger social structure. We had a wake there for our friend Barry Hale, the art critic. John Meredith the artist had his first engagement party there. I gave the Artists' Jazz Band a key. They rehearsed there at least twice a week, at night.

Dennis Burton lived nearby. Occasionally he brought his beautiful baby daughter in, set up her crib, and left us to babysit. Young mothers used my viewing room to breast-feed their infants. The same space was popular with my artists for private conflabs.

A group of socially conscious young people booked the gallery for a meeting with Joan Baez.

Telephone messages were accepted and a runner sent to deliver them to my artists hanging out at the Pilot. From time to time a drunk would wander in. Since I was the only male on staff, I was not only the director … I was also the bouncer. This was a very macho, demanding job. Fortunately, they were usually so drunk it was easy to get rid of them.

Viewing room: Ed Radford and Av Isaacs

STEPHEN CRUISE

A truly profound space was the basement, where histories of past exhibitions revealed themselves far from the measured sight of the gallery. There was the storage of the great equalizer. A simple excursion down the back steps, ever mindful of one's head, was the journey through time … years of fragments waiting for their re-emergence.

Stephen Cruise, *Harbour* (detail)

Stephen Cruise

And if you made it past the table saw and workbench, at the far end were a series of wooden racks. It was there that you found another world of practice: shelves of Inuit pieces in bone, antler, and stone.

I never grew tired of poring over the collected works, of coming on treasures 'illuminating.' And if you went to Av to inquire about one in particular, inevitably a story would come forth … of an artist and a time and the circumstance of its creation. They had a way of feeding one from the inside, of directing one to a place where there would be space round the fire, if one wished to get warm.

Stephen Cruise, *Israeli Sketch Book*

insecurity

It was a quiet mid-afternoon, in the middle of the week, and I was walking through my gallery on Yonge Street. One of the artists I represented was sitting very still on the bench, looking at one of his paintings. "I have to come here regularly to see my paintings on the wall," he said, "in order to restore my sense of security."

Stephen Cruise, *Fame Passion*

Sandinista posters (nicaragua)

In 1984, I received an invitation from the Sandinista government in Nicaragua to visit the country. (I am not sure how this invitation came about – perhaps through my cousin Meyer Brownstone, then chair of Oxfam Canada, which was doing a lot of work in Nicaragua.) Under the new government, the country was emerging from years of exploitation by the dictator, Anastasio Somoza.

The Sandinistas were very committed to education and culture. I was given an appointment to see Ernesto Cardinale, a well-known Nicaraguan poet and priest who was now minister of culture. I saw exhibitions of paintings in support of the Sandinistas and was taken on tours of the countryside. I noticed that, because of the high degree of illiteracy, the Sandinistas used posters to communicate all kinds of issues: health, education, politics. I found this interesting and began to collect the posters. Soon, I had thirty or forty, and, when I brought them back to Canada, I had them framed and exhibited them. They then toured in an exhibition to some of the alternative galleries in Ontario.

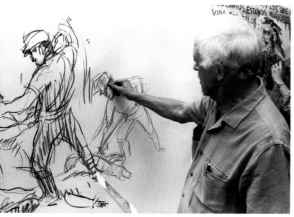

TO THE WALLS: Sandinista supporters creating one-week poster-art show at The Isaacs Gallery, 1984.

North Winnipeg roots: Isaacs, far left, and associates

winnipeg

Winnipeg has a fascinating political and soci
history. There were only two political positior
If you were on the right, you were CCF (later
NDP). If you were on the left, you were a
Communist sympathizer. There was no room
for a middle ground. Winnipeg had the One
Big Union strike of 1919, which shut down ju
about all services. My sister, Evelyn, was bor
during that strike, and, since the phone oper
ators were off the job, Dad had to go for the
doctor on his bike. Between immigrants from
eastern Europe and those of Scottish-
workman descent, there was a strong fellow
feeling of social consciousness. Maybe this
background explains my various socially
conscious activities over the years.

TRISH BEATTY

Toronto Dance Theatre's first studio was at 22
Cumberland Street, around the corner from The Isaacs
Gallery and the Pilot Tavern and all the energy of
Yorkville in its great hippie days. These were
rambunctious times, but serious as well, as the granting
councils were interested in truly creative Canadian art of
all kinds. These were the real stirrings of Canadian
identity, but we all benefited from the daring and
inspiration of those south of the border who were
celebrated in the United States in its last days as an
innocent, life-affirming force.

One day I stood in front of one of Gordon Rayner's vivid
and demanding paintings and the frame of the painting
turned into the proscenium of a theatre. From that
moment came a project called *Painters and the Dance*.

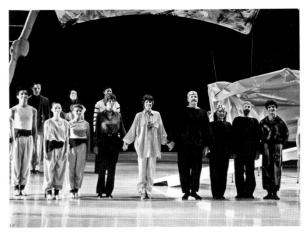

Artists and the dancers take a bow

Graham Coughtry creating scenery for Toronto Dance theatre

For me, this was a way to put two loves together and
create as much beauty as the audiences at the three
performances at the St. Lawrence Centre could stand. It
was a huge challenge, but extremely sumptuous. Gord
Rayner and Graham Coughtry created sets and
contributed to the production. We got set painters for a
song because they were eager to work on a large scale
in three dimensions.

The event cost well over $100,000 and the whole project
was repeated at the National Arts Centre in Ottawa a few
years later by the Danny Grossman company. Rayner
and Coughtry's sets and paintings have been left to the
National Gallery.

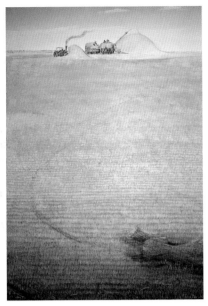

Kurelek, *If God So Clothes the Grasses*

Av Isaacs and Joan Murray

Kurelek, *No Grass Grows on the Beaten Path*

The Party

Joan Murray, the Director of the McLaughlin Gallery in Oshawa, put together a retrospective of William Kurelek's landscapes in 1983. It was a great popular success and travelled right across Canada. Bill had been a strong Catholic, so when "Kurelek's Vision of Canada" arrived in Oshawa, Joan threw a dinner and invited Cardinal Carter to open the exhibition. We were all sitting around before dinner waiting for the festivities to begin. I had my back to the main door. Suddenly the room went silent and everyone stood up. I turned around and was awed by the presence of Cardinal Carter in his long rich robes. I am not a Catholic, but I was affected by the theatrics of it.

After the speeches and the opening, a number of us were invited back to the Murray household. The cardinal and his entourage of priests had already left. Everyone was in a state of euphoria, probably feeling somewhat giddy over the success of the evening. At some point someone led the charge into the swimming pool and most of us spontaneously stripped (to our underwear) and jumped in. It was all in good fun. Even Jean Kurelek jumped. I did admire her for letting loose. At one point I saw a senior member of the bar leave the pool abruptly. He had tried to grope someone who turned out to be another male. At the side of the pool, a man was necking with an attractive woman who turned out to be the Cardinal's secretary. What a wonderful evening.

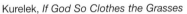

generosity

A fair amount has been said about my generosity in helping artists financially. The fact is that the risk is minimal. I advanced funds only to artists with whom I felt secure. After all, an artist without the means to work is of no value to himself or herself or to me. I got to know my artists well. I could tell from the sound of approaching footsteps in the gallery who the artist was. If there was a subtle hesitancy in the footstep, I was going to be hit for an advance. In a number of cases, I advanced money to a talented artist whose work was not selling well. To get my advance back, I took paintings as payment, which the

artists preferred. As time passed, and they became more recognized, the paintings I acquired appreciated in value. They were good unintentional investments.

NATHAN ISAACS

As Avrom's financial adviser and accountant, I had times in the early years of The Isaacs Gallery when I didn't know whether he was operating a small loans society or an art gallery. There always seemed to be a steady flow of artists coming in for advances on their future sales. It was a rarity for any of their accounts in the ledgers to show a credit balance. Avrom, however, had faith in what he saw, and we all know the results.

LARRY PFAFF

In 1984, Av Isaacs phoned us, wondering if the library of the Art Gallery of Ontario would be interested in acquiring his Inuit library. I was sent to look at it and met Av where the books were stored – in boxes on the second floor of a store on Yonge Street. Av left, and I spent a couple of happy hours opening the boxes and finding a comprehensive collection of books detailing the life and art of the Inuit, right from early explorers' accounts in the eighteenth and nineteenth centuries to complete runs of the catalogues of the various present-day artist co-operatives. The ensemble of some two thousand items had been carefully and systematically brought together: it was all the more attractive to the Art Gallery of Ontario, which had just acquired the Sarick collection of Inuit art.

I went back to the gallery and phoned Av: "We'll take it."

"What did you say?"

"I said we'll take it."

A brief, stunned silence followed.

"Well, by God," said Av. "This is the first time in a lifetime of dealings with the AGO that anyone has said yes to a possible acquisition in less than a year!"

Supplemented by purchase funds from the Ivey Foundation, the gallery gratefully received Av's gift, which became the Isaacs Inuit Library.

Kenojuak, *Owl*

RENANN ISAACS

One winter my father and I travelled to the Arctic to interview artists in different communities. We journeyed from Iqaluit to Igloolik, meeting many Inuit, including director Zacharias Kunuk, who had just begun working on his award-winning film *Atanarjuat: The Fast Runner*.

Artist Agnes Nuluuq, Pelee Bay, NWT, and hunter

While we were visiting shaman/artist Nick Sikkuark in Pelly Bay, a blizzard struck, and we learned that no flights would fly in or out of the area for four days. Stuck in a tiny motel, my father decided to venture into the blizzard. Next thing I knew, he was almost horizontal, hanging on to the railing of the stairs. The powerful hurricane-force wind had lifted him right off his feet.

Av Isaacs: It was a hurricane blizzard. When it finally stopped and we could look out across the street, it was a different landscape. No buildings to be seen. No roads to be seen. Just a big, continuous new mountain of snow.

Gordon Rayner, *The Emperor*

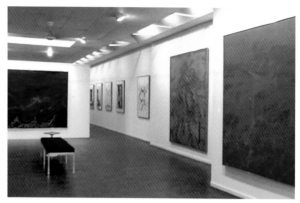

Graham Coughtry, one-man show

norval morrisseau

On a quiet day I wandered into my centre gallery on Yonge Street and found the formidable native artist Norval Morrisseau sitting there very still, looking intently at a painting by Gordon Rayner. Morrisseau was known to be a complicated, mysterious person. He turned to me and announced, "I have used that painting to project myself out into space, and now I have just come back." In his society, Norval Morrisseau was known to be a shaman and his own paintings reflected spiritual voyages that had curative powers. An interesting bond to Gord.

HOWARD ISAACS (nephew of Av)

Isaacs on Yonge Street—amazing! The magic of new shows appearing perfectly lit, full of colour, movement and controversy. Coughtry, Burton, Rayner, Ronald, Snow, Wieland, Urquhart, Markle, Curnoe, Handy, Chambers, Joe Mendelson and Mendelson Joe and so many others …. spending time in the framing shop with Stan, Bill and others…learning about gold leaf…the fascination that Kurelek's prodigious work held for me…my first encounter with Mark Prent's sculpture and installations (and feeling outraged by the ensuing reaction but inspired by the publicity and the battles that followed). The other gallery that was to be found in the basement…several areas extending back to the Yonge Street furnace…the further in the greater the adventure…a forest of Mickey Handy's 'Sign Posts', Angus Trudeau's astonishing boat models… Macgregor's 'Alice in Wonderland' chairs… African carvings both fascinating and frightening and so much more, boxed sets of Warhol's Marilyns" (if only I had had $800), Lefty Grove's painted image proclaiming "I smoke Luckies because they don't cut my wind." Marlene and the other ladies who kept an eye on me and always made me feel welcome. And finally, the indelible memory of leaving Yonge Street for John Street – impressive, but not the same.

Works by Judd and Snow

William Kurelek, *Ukrainian Orthodox Easter Vigil*

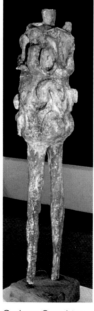

Graham Coughtry, *Goddess*

133

CHRISTOPHER HUME

"Art Folk Paint Town at New Isaacs Gallery,"
Toronto Star, 16 Feb. 1987

Av Isaacs opened his new downtown gallery Friday night, and all of Toronto's art community showed up to celebrate the occasion.Located at 179 John Street, the gallery is a spacious, well-lit space ideally suited to displaying the kind of large, expressionistic paintings that have always been associated with Isaacs.

Spotted among the revellers were veteran Isaacs artists Michael Snow, Robert Markle, Gord Rayner, and Graham Coughtry. Also present were bureaucrats Christopher Wooten, recently appointed head of the Ontario Arts Council, and Roald Nasgaard and Philip Monk, Art Gallery of Ontario curators. Other art dealers included Olga Korper and Jared Sable.

Queen Street was well represented by the likes of artists Andy Fabo, Michael Merrill, Oliver Girling, and Brian Burnett.The entrance of the night came when the entire Flesherton art colony, Harold Klunder, Lorne Wagman, Catherine Carmichael, and Shane West, arrived en masse. They drove down from the small town, north of Toronto, where they have lived for several years.

The centre of attention, of course, was 60-year old Isaacs. After 32 years in the art business, the last 25 on Yonge Street just north of Bloor, he instantly became Queen Street's senior art dealer. Despite the heat and smoke, he is clearly relishing the moment. "It's a nice feeling," he shouted over the din. "There's no one left to come, they're all here."

John Meredith, *Portrait #3*

John Meredith, Portrait #1

Appropriately, the inaugural exhibition was a show of big, boldly coloured canvases by Isaacs stalwart John Meredith. The big news about Meredith is his switch to figurative work. After years of producing totemic abstracts, he is now painting women.

Reaction was mixed. Meredith's trademark, the smudged line, is still evident, as is his distinctive use of pastel pinks and light blues, but for many of the opening-night guests, the use of female models was too much. One younger artist called Meredith's paintings "politically incorrect" and predicted they would be rejected by the feminist-dominated art world.He may be right. So might those who feel that, despite his move to figuration, Meredith is repeating himself.

Although their criticism is understandable, I think this exhibition rates as Meredith's best in years. The work is controlled and self-assured. Certainly it's startling to find him painting women, but, once the shock has worn off, chances are this show will be seen as the re-emergence of one of Canada's most talented artists.

john meredith

John Meredith (Smith) and his older brother, William Ronald (Smith), were both quite brilliant artists. The resemblance ended there. The brothers had huge but quite different egos. They did not get along and probably had not seen each other for years. For a short time in the late 1950s I represented Bill. I represented John from about 1960 until I closed The Isaacs Gallery in 1991.

John Meredith

John was self-isolated, and as time went on he became more so. Over the years he had serious problems but had the capacity to overcome them and continue very successfully with his painting and drawing. He produced brilliant paintings that just popped with vitality. His colour sense was quite unique. His works on paper, both colour and black and white, were just as important. He created lines that had an electric quality to them.

Alcohol became a problem for John in later years. If he found some sympathetic soul to lean on, he would. This included phone calls at 3 a.m. Some years after I closed my gallery, he called me at 7 a.m. and insisted and begged that I come over as soon as possible—it was a "matter of life or death." I arrived to find him looking terrible. He thrust a $20 bill at me and demanded that I go out and buy him two bottles of wine (which I explosively refused to do).

I next saw him in October 2000 in his coffin. There were just a few people at the funeral near Fergus, Ontario. I found a certain amount of humour in the fact that Bill and his brother John, who rarely got on and at least once had a physical confrontation, were sharing the family plot. I thought of the possibilities of vibrations coming from the soil above them as we left.

I remembered an incident in the 1970s when Barry Hale, a respected art critic, encountered John. John said that he had seen a double-page colour spread that Barry had written in the *Saturday Star*. Barry felt very pleased and asked John what he thought about the piece. John replied, "Oh, I didn't read it. I was using it to catch the paint drippings on the floor and happened to see your byline."

John Meredith, *Black Circle with Yellow*

John Meredith, *Untitled*

John Meredith, *Passage*

Later John had to restrict himself in terms of people and participation in events. Somehow he needed to control the world around him. I think if you dropped in to see him, you had to phone first so he would not be spooked by the doorbell. He said that painting was the hardest thing in the world to do. And yet when you look at his work there is an immediacy to it, as if he had had a flash of inspiration and it was done. In the early days I would advance him money against sales. In the beginning I could not make enough sales to cover his indebtedness. From time to time he would get ahead of me. And I would then have to buy some works to balance the account. This came to be to my advantage, as his works gradually increased in price.

I often think John was a naïve artist. He had gone to the Ontario College of Art for only one year. He told me that early on he had invented the cross-hatched technique of painting. This involved first doing a watercolour on graph paper. He would then take a canvas of the same proportion, draw the same number of graph lines onto the canvas, and proceed to paint an amazingly accurate, blown-up copy interpretation of the watercolour, only on a larger scale. The amazing thing is that it worked, and the damned large painting felt completely spontaneous.

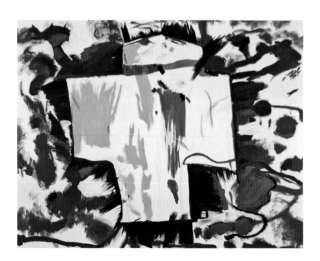

John Meredith, *White Cross on Blue*

GARY MICHAEL DAULT

I always maintained, even though I actually knew better, that there was a kind of Isaacs 'look' to the art that Av exhibited. It was hard to define exactly (indeed it was probably impossible to define or even describe, no doubt because this mysterious, ineffable look didn't really exist), but for me, well, I thought it lay in a kind of confident directness of approach by each artist –

Gary Michael Dault and Robert Fulford

Rayner's inventive and surprising use of unlikely materials, Coughtry's lush, buttery brushwork, Burton's high-spirited boyishness in combination with his tireless archival fervour, Wieland's sustained naughtiness and wit, Gorman's pauseless sensuousness, Snow's conceptual power yoked to his rawness of attack (I loved the *Walking Woman* sculptures for their clumsiness as much as for their morphological relentlessness; for me, there was a sort of sad aesthetic hardening of the arteries that set in when Michael began, near the end of the *Walking Woman* trajectory, to bring then to a sort of apotheosis in stainless steel).

Well, whether there was or whether there wasn't an Isaacs "Look" there was assuredly an Isaacs "atmosphere" – and that I loved and fed on and doted upon. When you were at Av's in those days – in the 1960s and early 70s – you felt you were pretty close to the forge, pretty close to where art actually happened. My sensibility was more or less formed at 832 Yonge Street. I'll always be grateful.

Gordon Rayner, *Frog He Would A-Wooing Go,* 1976
Art Bank of Canada

Dennis Burton, *Escalator Tour De Force,* 1973

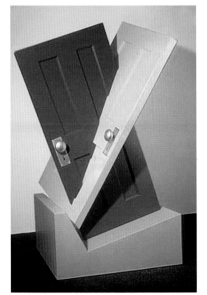

John MacGregor,
Only Doors in Existence, 1969

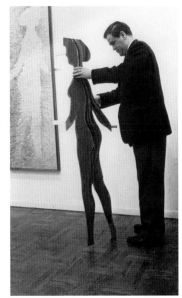

The "Isaacs atmosphere"

Graham Coughtry, *Foot,* 1960

Joyce Wieland, *Reason Over Passion*, 1968
National Gallery of Canada

Rick Gorman, *Green Lady*, 1963

139

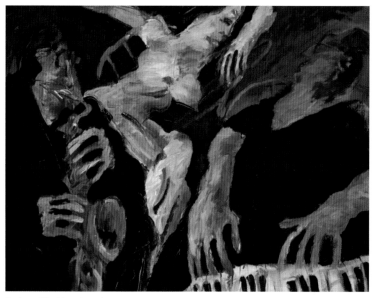

Robert Markle, *Jazz Lover*

Marlene and Robert Markle

Mark Prent, *Armistice*

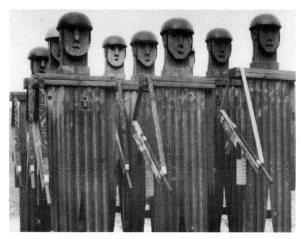

Viktor Tinkl, *Forty 8 Mothers' Sons*

Mark Gomes, *Water Works*

Gordon Rayner, *Sisyphus*

Coughtry, Rayner, Burnett, and Snow

Michael Snow, *Steamer Trunk* (hologram) Expo 86

Gathie Falk, *My Dog's Bones*

Michael Snow, *Steamer Trunk* (looking in)

Gathie Falk in studio

141

Lorne Wagman

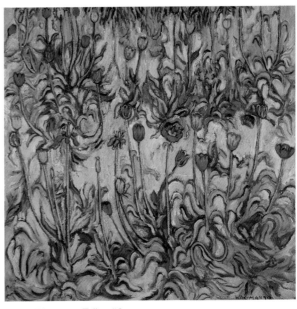

Lorne Wagman, *Tulips #2*

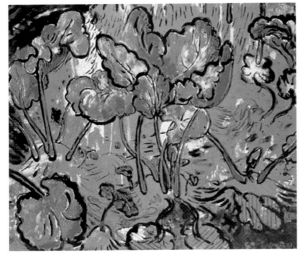

Lorne Wagman, *Untitled*

Stephen Cruise, *The Visitor's Book, Object 4*

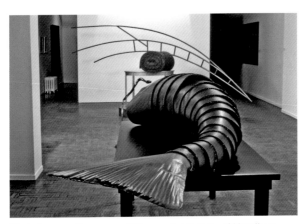

Mark Gomes, *Common of Piscary,* Art Gallery of Hamilton

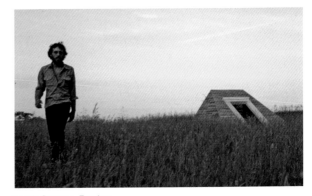

Mark Gomes, *Bunker*

Gordon Rayner, *Concerning a Drowning on Canoe Lake*

Mark Gomes, *Untitled*

Ed Radford, *White Roses*

Brian Burnett, *Metamorphic Road*

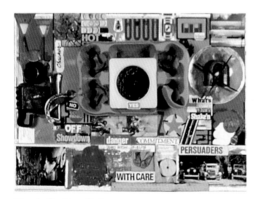

Dennis Burton, *Collage*

Joyce Wieland, *Artist on Fire,* Robert McLaughlin Gallery, Oshawa

galleries gone

Many galleries which no longer exist have contributed to the vitality of today's scene. Some may have been around for quite a while, others for just a short period. Perhaps for some, the seeming romance of being an art dealer did not realize itself. The sum total of all of them added up to a richer environment, providing exposure for a large number of artists. In the period I had my gallery, the following Toronto galleries came and went:

The Gallery of Contemporary Art
The Pollock Gallery
The Dunkelman Gallery
The Mirvish Gallery
Alkis Klonaridis
The Dorothy Cameron Gallery
Lillian Morrison
Carmen Lamanna Gallery
The Park Gallery
Doris Pascal Gallery
Laing Gallery
Douglas Duncan's Picture Loan Society
Morris Gallery
Mazelow Gallery
And many more …

GREG GATENBY

Av Isaacs is *sui generis* as a dealer. In many ways he reminds me of Jack McClelland in that both men were passionate advocates for the artists with whom they worked. And both were actively engaged with their communities, always right in the middle of artistic and political frays, especially when the artistic and political melded into one. Both fought for free speech and expression when the Toronto establishment still thought it was OK to arrest poets for reading their work aloud on a Sunday, and thought go-go dancing was the devil's work. Av, like Jack, was an indefatigable champion of the best Canadian talent at a time when most believed you left this country ASAP if you were any good. Clearly, Canadian art has never seen his equal.

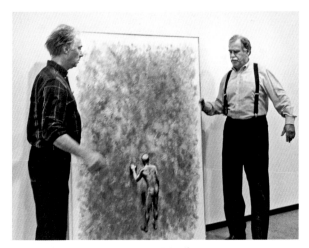

Michael Snow and Av Isaacs at John Street

MICHAEL SNOW

Av's intuitive recognition of 'quality' also applied to the many non-painting and sculpture events, music, poetry performances etc, that he staged at the Gallery.

Related were the 'Dada' and 'Elves Art' (Christmas) shows where some of the artists broke into discoveries that they might not have shown in another context.

Events presented by the great Toronto composer Udo Kasemets and Av's support of The Artists' Jazz Band are memorable.

I think Joyce Wieland would say something similar. Our closest Isaacs Gallery friends at different times were Dennis Burton, Graham Coughtry, Robert Markle and Gord Rayner, the names of which bring back the many amazing AJB parties at Gord Rayner's Spadina Street loft. Wow.

Also in the Isaacs orbit for many different reasons are/were these memorable and extraordinary people:
Betsy and Bill Kilbourn, Robert Fulford, Barry Hale, Harry Malcolmson, William Kurelek, Martha Black, Diane Broadway, George and Donna Montague, Arnold Rockman, Eldon Garnet, Nobuo Kubota, Irving Grossman, Mickey Handy, Ray Jessel, Michel Lambeth, Gar Smith, Robert Hedrick, Ydessa Hendeles, Sheila MacKenzie, John Meredith, Rick Gorman and Don Owen. Thank you for being who you are and were, then and now.

Also unforgettable is the frighteningly packed basement storage of the Yonge St. Isaacs Gallery.

Gathie Falk, *There Are 14 Ships in English Bay*

Ed Radford, *Vancouver*

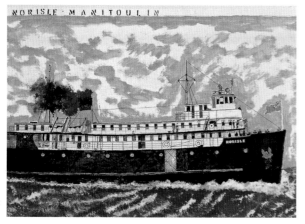

Angus Trudeau, *Norisle Manitoulin*

Gathie Falk, *Apple Table*

John Meredith, *Green, Pink, Yellow, Blue*

John Ivor Smith, *Bog Head*

UDO KASEMETS

Many of The Isaacs Gallery artists were, and some still are, seriously involved in communicating their artistic ideals and expertise to younger generations of art learners. The faculty lists of the now defunct New School of Art, the Ontario College of Art (now of Art and Design), the Vancouver Emily Carr Institute of Art contain the names of many of The Isaacs Gallery artists. As webs go, one may eventually lose track of the original webber; but, this web keeps living. It would never have been without Av.

DON LAKE

Avrom is a man of his time. He is more passionate than most about a full participation in his milieu. He has championed many important causes, movements and artists. Many dealers made more money and when their artists stopped selling, they walked the plank. The Isaacs Gallery was about timeless activities above and beyond day to day sales, that constitute collective importance.

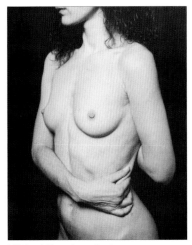

Michael Torosian, *Anatomy*

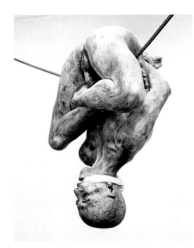

Mark Prent, *Bondage*

Joyce Wieland, *Flight into Egypt (after Tiepolo)*

GAIL DEXTER LORD

The Isaacs Gallery was confident and diverse. Sometimes, Kurelek ... often Rayner, Curnoe ... Snow ... Coughtry ... African beads ... Wieland ... Mark Prent and Inuit art. It always looked great. Confidence in diversity, or diverse in confidence. Not what Toronto was then, but what Toronto would become.
Thanks so much to you, Av.

Ed Radford, *Almost Done*

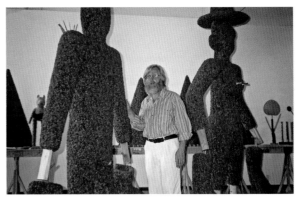

Viktor Tinkl, *Travellers in a Land Strange and Not So Strange*

Viktor Tinkl: final Isaacs Gallery exhibition before closing 1991

Onward at theIsaacs/Innuit Gallery

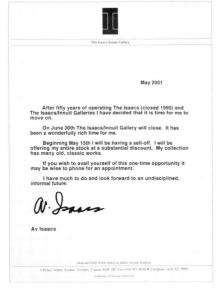

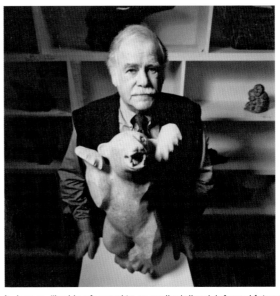

"It has been a wonderfully rich time for me."

Av Isaacs: "looking forward to an undisciplined, informal future"

SARAH MILROY

Goodbye to all that, one more time
Globe and Mail, Saturday, May 26, 2001

There have been many endings, but this time Avrom Isaacs is serious. After 50 years as an art dealer, he's hanging up his last 'Closed' sign.

Avrom Isaacs, the legendary Toronto art dealer, has been a man of many exits. When he closed the much-beloved Isaacs Gallery on Toronto's Yonge Street in 1986 to move to a new location on John Street, the press described it as the end of an era. After all, this was where the famous Isaacs All Stars (Michael Snow, Gordon Rayner, Greg Curnoe, John Meredith, Dennis Burton, Joyce Wieland, Graham Coughtry, Richard Gorman, Robert Markle et al.) had staged their landmark exhibitions. It was here that the Artists' Jazz Band had torn the night air with their wild noise. It was here that Alfred Barr, founder of the Museum of Modern Art in New York, had come to proclaim the merits of abstraction to the Art Gallery of Toronto's Women's Committee. It was here that Michael Snow in 1962 presented his first exhibition of the *Walking Woman*, which was immediately embraced as the icon of a newer, hipper Canadian art scene. And it was here that the police came, in 1972 and again in 1974, to shut down exhibitions of work by the sculptor Mark Prent, an artist whose gruesomely morbid and wickedly humorous work brought the Toronto art community to its knees.

It was the end of an era all over again in 1990 when Isaacs closed his John Street location, but now the valedictory incense was swung in earnest. Isaacs was officially getting out of the business of selling contemporary art, closing The Isaacs Gallery to focus instead on Inuit art, which he has been selling at his second space, the Innuit Gallery, since 1970.

With the closure of the Isaacs/Innuit Gallery at the end of this month, we are saying goodbye again, but this time, unfortunately, he means business. His notice of closure was vintage Isaacs; utterly without sentimentality and boldly printed on gallery letterhead, it brusquely announced that after 50 years of dealing art, "it was time for me to move on," adding, with an unmistakable hallelujah tone at the end, that he is looking forward to his "undisciplined, informal future."

The signature was a bold scrawl of heavy black marker, as feisty and intractable as the man himself.

Very much to his credit, discipline and formality are the two characteristics that one would least likely ascribe to Isaacs's approach to dealing art. From his beginnings as the proprietor of Greenwich Art Shop, a framing store in the city's Gerrard Street Village, following his graduation from the University of Toronto (political science and economics), to his launch of the Greenwich Gallery on Bay Street in 1956, to the christening of the canonical Yonge Street space he inhabited from 1961 to 1986, Isaacs managed to create and sustain an atmosphere of tolerance and freewheeling improvisation unknown in Canadian art circles of the time.

"He had an intuitive recognition of quality," recalls Snow. "There was never some sort of style that he was trying to push. Once he recognized something as authentic, he was completely supportive and he didn't interfere." As well, Snow remembers, the gallery set itself apart in its down-to-earth ambience. "Av was like the friendly shopkeeper who is always there," he recalls with affection. "He was never interested in the screen of glamour and power that most dealers try to put up."

Gail Dexter Lord, who is now a museum consultant, began her career at 18 as the art critic for the *Toronto Star*, and she recalls: "For Av, a youngster writing for her high-school newspaper was just as worth talking to as the newspaper critic, which I later became."

Art collector Pamela Gibson remembers the glory days on Yonge Street in similar terms. "He never made you feel like an idiot. As well," she adds, "his basement was famous for its treasures – everything was crammed in together – and also for the boiler that you always thought was about to blow up. You just learned so much. Of course, he was learning too."

Without an academic background in fine art (as he puts it, "I didn't know a watercolour from an oil"), Isaacs took his cue from the artists around him, and the parameters of the enterprise were never set in stone. While the gallery initially focused on abstract expressionism, pretty soon the gallery programme began to take some surprising turns. A Snow exhibition might be followed by an exhibition of Japanese woodblock prints or an exhibition of Baluchistan wedding jackets – whatever caught his eye.

Av Isaacs reflects

William Kurelek, who had shown up at the gallery in 1959 looking for work as a framer, ended up having a series of exhibitions at the gallery, notwithstanding the fact that the artist's conservative Christian fundamentalism couldn't have been farther from his dealer's left-wing sensibilities. (As Isaacs puts it, today, "I'm from north Winnipeg, remember, where the right wing votes NDP and the left wing votes Communist.")

Broad-mindedness, likewise, characterized the way Isaacs opened the gallery up to artists of all disciplines. Hence the mixed-media evenings organized by composer Udo Kasemets in the late 1960s (one of which was the famous chess game at Ryerson Polytechnic in which Marcel Duchamp and John Cage played an electronically wired-for-sound chessboard), or the poetry nights featuring the likes of Victor Coleman, Charles Olson, or Raymond Souster, or the experimental film series spearheaded by Wieland and Snow, then living in New York.

Art consultant Jeanne Parkin recalls the impact of Snow ("dazzling"), Prent ("You didn't see pickled penises every day in Toronto"), and Wieland ("slightly on the scandalous side") on dear old Rosedale, where dabbling in the restrained British modernism of Barbara Hepworth, Henry Moore, and Ben Nicholson was considered racy. Galleries like Douglas Duncan's Picture Loan Society, the wood-panelled Laing Gallery, or the Roberts Gallery showed historical and traditional Canadian art in a white-gloves-and-silver-platter atmosphere, and the more adventurous dealers like Dorothy Cameron, Carmen Lamanna, and David Mirvish were yet to emerge. "Av always liked strongly expressive work," Parkin remembers. "If it was gutsy, it was great for him."

She also recalls his unwillingness to compromise on his principles. "He would never ever give a discount to a corporate client," she remembers today with amusement. "He would say, 'They've got the money, they can bloody well afford to pay. We should be making them pay more than the asking price!'" This distrust of privilege and authority extended into his many-pronged activism, expressed in his protest of the Canadian Airmen's Memorial on University Avenue (which he thought had been erected in an arrogant breach of public process), or his campaign against the Ontario Censor Board (defending the expressive rights of Vancouver video artist Paul Wong, an artist in whom he had no business interest), or his efforts to highlight the plight of Nicaragua. "Passion," says Parkin, "has guided everything he has done."

His ability to think outside the box and to recognize a great business opportunity when he saw it led Isaacs to the other great adventure of his career, the promotion of Inuit art. Says Terry Ryan, who has run the Inuit co-operative at Cape Dorset since 1960, "Av saw Inuit art as a contemporary art form. He didn't relegate it to the status of ethnographic material."

Isaacs mounted his first exhibition of Inuit art at The Isaacs Gallery in 1967, and since then, when many of the Inuit were still living on the land, Isaacs has made more than eight trips to the Arctic. Today, he still marvels at the formal inventiveness, vivid imagination, and clarity of the Inuit sense of design, and his joy in remembering those early days of discovery is still palpable.

By 1970, when his trade in Inuit art was sufficiently established, he created the Innuit Gallery, the first in Canada exclusively devoted to the sale of Inuit art, and it is this business that has occupied him since he closed The Isaacs Gallery in 1990. His exhibition this spring of the photographs of Richard Harrington, a magnificent and harrowing document by a white photographer of the Inuit caught in their cycles of starvation and migration in the early 1950s, was in many ways a closing testament to the dealer's own complex and deeply felt relationship to the culture of the North, a gesture springing from his deep respect for the endurance of the Inuit people.

Endurance is something Av Isaacs, too, has come to know a little bit about. On the health front, Isaacs's challenges in recent years have been strenuous. (He has survived a quadruple bypass and two knee replacements.) And making a living as an art dealer in Canada was, at times, no bed of roses.

When asked what the secret is to being a successful art dealer, he says there are three magic words: "Persevere! Persevere! Persevere!" But will he miss the business? "I'm 75, for Christ's sake!" he barks. "I've done the same thing for 50 years. I'm starting to bore myself." Asked what prospects he has planned, he says he wants to ride his bike, and he wants to spend six months digging in the York University archives, where his papers are stored. "I want to see if I can find out," he says, "who the hell Av Isaacs was."

Av: The open road

Nobby Kubota, *Voicepiece*. Farewell to the Isaacs/Innuit

Mike Snow and Murray Laufer (from Hayter Street days)

Av Isaacs and long-time staffer Ruby Bronstein

Sarah Milroy, Geraldine Sherman, and Robert Fulford

Gord Rayner and Karen Williamson

Gord Gibson, Carol and Morty Rapp, Pamela Gibson

Av Isaacs and Donnalu Wigmore

Dennis Reid and Ramsay Cook

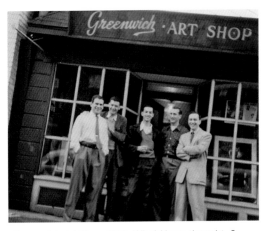

Greenwich Art Shop, 1950. Who'd have thought..?

York University: President Harry Arthurs, Dr. Avrom Isaacs, and Chancellor Oscar Peterson

AV ISAACS

The Fine Art of Surviving as an Artist

June 29, 1992 Toronto art dealer Av Isaacs speaking to arts graduates at York University after he was given an honorary degree.

I am supposed to be here in the role of a wise old codger who has had a great deal of success and is about to inspire all of you with sound and meaningful advice you can take away with you and use throughout your future careers.

I am sure you will be pleased to know this is not going to happen. I was terrible at accepting advice and am therefore not in a very good position to offer it. In any case, what follows is probably a mass of clichés.

The only comfort I can offer you is this. I graduated with a degree in political science and economics and ended up as an art dealer – which is to say, you must not concern yourselves with where you start, as it will provide you with few clues as to where you will end up.

Only in retrospect will you see that there was some obscure direction you were intuitively following. It is very important to realize there are very few times in your life when you will be in a position to pause, take stock, and decide which course you wish to follow. Once you have set a course, it becomes difficult to change it.

Now is certainly one of those rare occasions. There are so many new areas to explore. Sometimes you have to create these opportunities as they do not yet exist. Life is a hell of a lot shorter than you think, so try to focus on the area that will give you the most satisfaction.

Those of you who will be professionally entering the field of fine arts are a rather fortunate group. You will be recession-proof. Recession will be such a normal part of your existence that it becomes an economic condition you take for granted.

For everyone else, it is an abnormal situation to fear and avoid. To carry this thought further in what seems to be a contradiction, it is the artist who is really the patron of the arts, because so few earn what is considered a normal income. Their input into their art is far greater than their return. If the artist included into the cost structure all the time, material, overhead, and profit, as one does in other businesses, he or she would have to raise prices considerably. To put it another way, the consumer of the arts is always getting a bargain.

And now some practical advice for all you innocents who intend to persevere. To make it easier for you to follow, I shall number my points.

Marry a rich father-in-law. This will give you some independence so you can work without any financial pressures.

Remain ignorant of your accounts payable. It is truly amazing how long you can remain in a state of bankruptcy and carry on.

Promise yourself to stick at it, through thick and thin, for at least five years. At the end of that time, you will have lost the ability to do anything else, and you will be stuck with your chosen profession.

Remember: when the other artists get the breaks, it is because they have sold out.

The creative individual never solves the problem in his or her work. It just leads on to the next problem.

In our society, we tend to use the word 'eccentric' as a negative. In the arts, we think of it as a positive. The important artists of the past were all eccentrics, because they could not accept the established rules. Otherwise they could not have been able to reflect the changes

around them. We really must condition ourselves to appreciate those among us who are eccentric or different. Tradition is an anathema to the arts.

To be associated with the arts is to spend your entire life cultivating your instinct or the subconscious. You can use all the intellectual rules you want for assessing a painting, a piece of music, or a play, but in the end it is that unidentifiable cell at the back of your head that will make the final decision.

Like the sun that we cannot afford to do without, I think of galleries and theatres as centres of energy in our personal universe. To seriously diminish these centres would be akin to returning to the ice age. As the government is responsible for our road system, it must realize that art must receive a similarly high priority. We are long past the point where the arts are considered a luxury. It does not take a great deal of knowledge of history to realize that earlier societies are measured by their cultural achievements.

The only art we really can affect is contemporary art. The great centres of culture in the past did not happen by accident. They had a body of patrons and a sympathetic audience. The patrons of today are the business world, governments, and individuals. A supportive and enthusiastic audience will enhance the artists' work.

And a final word of advice – for all of you who intend to go in a direction other than fine arts, that's great. Go out there, make lots of money, and become patrons of the arts. We need you.

The Order of Canada 1998. Presented by former Governor General Ray Hnatyshyn.

PUBLICATIONS FROM THE ISAACS GALLERY

Eyes without a Face. McRobbie/Coughtry. Gallery Editions I. Poems and original lithographs. 1962

Place of Meeting. Souster/Snow. Gallery Editions II. Poems and drawings and original lithographs. 1962

Sketch Book. Tony Urquhart. Gallery Editions III. Drawings and original lithograph. 1962

Michael Snow Retrospective. Catalogue. Art Gallery of Ontario, (Co-Published) 1970.

Limited edition containing plexiglas case with design, 2 magnifiers, 2 photographs, 3 Walking Woman miniature posters, and an original print. 1970

Toronto 20. 20 original prints by 20 artists; edition/100. Signed. (Co-Published) 1969.

High School. Snow. Drawings plus limited edition containing an original print/100 signed. (Co-Published) 1979.

Artists Jazz Band. Double album plus a portfolio of original prints, signed and numbered edition/100. 1979

The Artists Jazz Band (Live at the Edge). Album. (Co-Published).

Inuit Throat and Harp Singing (2 women from Pangnirtung). Canadian Music Heritage Collection. Album, (Co-Published). 1979

The Isaacs Gallery. Toronto Suite. Lumiere Press photography Michael Torosian. Essay by Dennis Reid. (Co-Published). 1989

The Only Paper Today. Publisher Avrom Isaacs

The Isaacs gallery exhibitions

THE ISAACS GALLERY EXHIBITIONS
Compiled by Dennis Reid

1956

**Establishment by Avrom Isaacs
of the Greenwich Gallery
at 736 Bay Street, Toronto**

February 1 - 21
Group exhibition of works by Graham Coughtry, William Ronald, Gerald Scott, Michael Snow, and Robert Varvarande

February 28 - March 30
Exhibition of graphics by Picasso, Chagall, and others

March 2 - April 13
Marcelle Maltais: paintings

April 13 - May 4
Graham Coughtry: paintings and drawings

May 5 - 25
John Gould, Paul Macdonald, Louise Belzile

May 25 - June 15
Robert Varvarande: paintings

September 21 - October
Maxwell Bates: paintings and lithographs

October 13 - November 2:
Michael Snow: paintings, sculptures and drawings

November 3 - November 24
Gerald Scott: paintings and drawings

November 23 - December 14
Fred Ross: paintings and drawings

1957

January 12 - January 25
Tony Urquhart: painting, drawings and prints

January 25 - February 14
Paavo Airola

February 16 - March 8
Walter Yarwood, Ray Mead: paintings and drawings

March 8 - March 28
Graham Coughtry, Gerald Scott, Michael Snow, and Robert Varvarande

March 29 - April 18
Contemporary European etching and lithographs

April 19 - May 9
Miller Brittain: paintings and drawings

September 27 - October 17
Ross Coates, paintings, drawings and prints

October 18 - November 7
Tony Urquhart: paintings, watercolours and drawings

November 8 - November 29
William Ronald: paintings and watercolours

December 2 - January 10, 1958
Group exhibition: Ross Coates, Graham Coughtry, Gerald Gladstone, Betty Mochizuki, John Piper, William Ronald, Gerald Scott, Michael Snow, Mashel Teitelbaum, Tony Urquhart, Robert Varvarande

1958

January 10 - January 31
Gerald Gladstone: paintings and sculptures

January 31 - February 18
Graham Coughtry, Leonard Oesterle, Michael Snow, Tony Urquhart, Robert Varvarande

February 21 - March 13
Mashel Teitelbaum: paintings and photographs

March 14 - April 3
Anne Kahane: sculpture

April 10 - May 1
John Hass: watercolours (Front Gallery)

April 10 - May 1
European graphics (Rear Gallery)

September 13 - October 2
Contemporary Japanese woodblock prints

October 4 - October 23
Michael Snow: paintings and sculpture

May 2 - May 17
Lawrence Galeagno (Front Gallery)

December 13 - January 8, 1959
Group exhibition: Ross Coates, Gerald Gladstone, Tony Urquhart, Mashel Teitelbaum

1959

January 9 - January 29
Richard Gorman: paintings and drawings

January 30 - February 20
Graham Coughtry: paintings and drawings

February 20 - March 12
Gordon Rayner, Joyce Wieland: paintings and drawings

March 13 - April 2
Robert Varvarande: paintings and drawings

April 3 - April 23
Bruno Bobak: watercolours and oils

May 7 - May 28
European graphics

August
Group exhibition: Bruno Bobak, Dennis Burton, Graham Coughtry, Gerald Gladstone, Anne Kahane, Jean-Paul Lemieux, William Ronald, Gerald Scott, Michael Snow, Tony Urquhart, Robert Varvarande

The Greenwich Gallery is re-named The Isaacs Gallery, at 736 Bay Street, Toronto

September 19 - October 8
Tony Urquhart: paintings, watercolours and drawings

October 10 - October 29
Anne Kahane: sculpture, drawings and woodcuts

October 31 - November 19
Gordon Rayner: paintings

November
The Canadian Society of Graphic Art

1960

January 9 - January 28
Gerald Gladstone: sculpture, watercolours, collages and drawings

January 30 - February 11
Georges Rouault: The Miserere Series

February 12 - March 3
Michael Snow: paintings

March 5 - March 24
Group exhibition: Dennis Burton, Graham Coughtry, Richard Gorman, Robert Varvarande (Front Gallery); Gerald Gladstone, Robert Hedrick, Michael Snow, Tony Urquhart (Rear Gallery)

March 26 - April 7
William Kurelek: paintings

April 9 - April 28
Robert Hedrick: paintings and drawings; Gerald Gladstone, William Kurelek, Gordon Rayner (Rear Gallery)

April 30 - May 19
Japanese woodblock prints
Dennis Burton, Robert Hedrick, Tony Urquhart

May 21 - June 9
Graham Coughtry: drawings

September 5 - September 29
Primitive African sculpture

October 1 - October 20
Richard Gorman: paintings and sculpture

October 22 - November 10
Sculpture by Painters: Dennis Burton, Graham Coughtry, Richard Gorman, Robert Hedrick, Robert Markle, Gordon Rayner, Michael Snow, Robert Varvarande

November 12 - December 1
Four New Directions In Graphics: Diane Barr, James Boyd, Richard Gorman, Ted Kranyk (Front Gallery)
Dennis Burton, Gerald Gladstone, John Inglis, Robert Hedrick, Gordon Rayner, Georges Rouault, Michael Snow, Tony Urquhart, Robert Varvarande (Rear Gallery)

December
Dennis Burton - MANIFESTO

1961

January 2 - January 26
Dennis Burton - paintings, objects and drawings

January 26 - February 16
Ross Coates (Front Gallery); Dennis Burton, Richard Gorman, Robert Hedrick, Gordon Rayner, Michael Snow, Tony Urquhart, Robert Varvarande (Rear Gallery)

March 4 - March 23
Michael Snow: paintings

March 25 - April 13
Gerald Gladstone: scuplture

The Isaacs Gallery opens at 832 Yonge Street, Toronto

May 3 - May 9
Opening Exhibition: Dennis Burton, Graham Coughtry, Gerald Gladstone, Richard Gorman, Robert Hedrick, Anne Kahane, William Kurelek, Gordon Rayner, William Ronald, John Ivor Smith, Michael Snow, Tony Urquhart, Robert Varvarande
Pre-Columbian sculpture/Graphics exhibition (to May 30)

May 11- May 31
Gordon Rayner: paintings

May 3 - May 31
Opening exhibition continues, minus Gordon Rayner and Gerald Gladstone (Central Gallery)

June 1 - June 20
Robert Varvarande: paintings and collages

July 4 - July 24
Graphics exhibition
Group exhibition: Paintings: Bruno Bobak, Dennis Burton, Graham Coughtry, Richard Gorman, Robert Hedrick, Anne Kahane, William Kurelek, Kazuo Nakamura, Gordon Rayner, William Ronald, Jack Shadbolt, Gord Smith, Michael Snow, Tony Urquhart, Robert Varvarande, Arthur Villeneuve

July 24 - August 14
Picasso: graphics, 1933-1960

August
Tony Urquhart: watercolours and oils
Group exhibition: Ted Bieler, Dennis Burton, Graham Coughtry, Richard Gorman, Robert Hedrick, Anne Kahane, John Meredith, Gordon Rayner, William Ronald, Gord Smith, Michael Snow, Tony Urquhart, Robert Varvarande, Arthur Villeneuve (Front Gallery)

September 14 - October 30
Primitive African sculpture and contemporary Japanese woodblock prints

September 29 - October 19
Don Jean-Louis: drawings

October 5 - October 25
Robert Hedrick: paintings and sculptures

October 26 - November 14
John Meredith: paintings

Group exhibition: Dennis Burton, Richard Gorman, Robert Hedrick, Anne Kahane, Robert Markle, Gordon Rayner, Michael Snow, Tony Urquhart, Robert Varvarande, Joyce Wieland (Central Gallery)

November 15 - November 28
Arthur Villeneuve: paintings
Group Exhibition: Dennis Burton, Richard Gorman, Robert Hedrick, Robert Markle, John Meredith, Gordon Rayner, John Ivor Smith, Michael Snow, Tony Urquhart, Robert Varvarande, Arthur Villeneuve, Joyce Wieland (Central Gallery)

November 29 - December 20
Graham Coughtry: paintings

December 20, 1961 - January 9, 1962
Dada: Dennis Burton, Arthur Coughtry, Greg Curnoe, Richard Gorman, Gordon Rayner, Michael Snow, Joyce Wieland

Group exhibition: Dennis Burton, Graham Coughtry, Richard Gorman, Robert Hedrick, Anne Kahane, Robert Markle, William Ronald, Michael Snow, Tony Urquhart, Robert Varvarande, Joyce Wieland

1962

January 10 - January 30
Group exhibition: Ted Bieler, Jack Chambers, John Inglis, Robert Markle
Group exhibition: Dennis Burton, Graham Coughtry, Richard Gorman, Robert Hedrick, Anne Kahane, John Meredith, Gordon Rayner, William Ronald, Michael Snow, Robert Varvarande, Joyce Wieland (Central Gallery)

January 31 - February 20
Joyce Wieland
Group exhibition: Ted Bieler, Dennis Burton, Graham Coughtry, Richard Gorman, Robert Hedrick, Anne Kahane, Robert Markle, John Meredith, Gordon Rayner, Michael Snow, Tony Urquhart, Robert Varvarande (Central Gallery)

February 22 - March 1
William Kurelek: Paintings of Farm and Bush Life

Group exhibition: Dennis Burton, Graham Coughtry, Richard Gorman, Robert Hedrick, John Inglis, Anne Kahane, Robert Markle, John Meredith, Gordon Rayner, William Ronald, Gord Smith, Michael Snow, Tony Urquhart, Robert Varvarande, Joyce Wieland (Central Gallery)

March 5 – March 21
Group exhibition: Dennis Burton, Graham Coughtry, Richard Gorman, Robert Markle, John Meredith, Tony Urquhart, Robert Varvarande, Joyce Wieland (Central Gallery)

March 15 - April 3
Michael Snow

March 23 - April 6
Early Chinese scroll painting (Rear Gallery)

April 5 - April 24
Tony Urquhart: oils and collages
Group exhibition: Dennis Burton, Graham Coughtry, Richard Gorman, Robert Hedrick, Anne Kahane, Robert Markle, John Meredith, Gordon Rayner, John Ivor Smith, Michael Snow, Robert Varvarande, Joyce Wieland (Central Gallery)

April 21 - May 10
Morley Markson: photographs

April 26 - May 15
Richard Gorman
Group exhibition: Dennis Burton, Graham Coughtry, Robert Hedrick, Anne Kahane, Robert Markle, John Meredith, Gordon Rayner, William Ronald, John Ivor Smith, Michael Snow, Tony Urquhart, Robert Varvarande, Joyce Wieland (Central Gallery)

June
Group exhibition: Dennis Burton, Graham Coughtry, James Gordaneer, Richard Gorman, Robert Hedrick, John Inglis, Anne Kahane, William Kurelek, Robert Markle, John Meredith, Gordon Rayner, William Rayner, John Ivor Smith, Michael Snow, Tony Urquhart, Robert Varvarande, Joyce Wieland

July
Group exhibition: Ted Bieler, Dennis Burton, Graham Coughtry, James Gordaneer, Richard Gorman, Robert

Hedrick, Anne Kahane, William Kurelek, Robert Markle, John Meredith, Gordon Rayner, William Ronald, Gord Smith, John Ivor Smith, Michael Snow, Tony Urquhart, Robert Varvarande, Joyce Wieland, Arthur Villeneuve

September 13 - September 26
Indian miniatures of the Mughal School (Central Gallery)

Group exhibition: Dennis Burton, Graham Coughtry, Richard Gorman, Robert Hedrick, John Meredith, Gordon Rayner, William Ronald, John Ivor Smith, Michael Snow, Tony Urquhart, Robert Varvarande, Joyce Wieland (Front Gallery)

September 26 - October 16
John Hass

Group exhibition: Dennis Burton, Graham Coughtry, Richard Gorman, Robert Hedrick, Anne Kahane, John Meredith, Gordon Rayner, William Ronald, John Ivor Smith, Michael Snow, Tony Urquhart, Robert Varvarande, Joyce Wieland (Central Gallery)

October 17 - November 6
Anne Kahane: sculpture and graphics
Group exhibition: Dennis Burton, Graham Coughtry, Richard Gorman, John Hass, Robert Hedrick, John Meredith, William Ronald, John Ivor Smith, Michael Snow, Tony Urquhart, Robert Varvarande, Joyce Wieland (Central Gallery)

October 30 - November 13
Christiane Pflug: drawings

November 7 - November 27
Dennis Burton

Group exhibition: Graham Coughtry, Richard Gorman, John Hass, Robert Hedrick, Anne Kahane, John Meredith, Gordon Rayner, William Ronald, John Ivor Smith, Tony Urquhart, Robert Varvarande, Joyce Wieland (Central Gallery)

November 28 - December 18
Robert Varvarande

December 5 - December 19
Kenneth Lochhead: enamel paintings (Central Gallery)

1963

January 9 - January 22
Graham Coughtry, Richard Gorman: graphics

Group exhibition: Dennis Burton, Graham Coughtry, Richard Gorman, John Hass, Kenneth Lochhead, John Meredith, Gordon Rayner, William Ronald, Michael Snow, Tony Urquhart, Robert Varvarande, Joyce Wieland (Central Gallery)

January 25 - February 11
John Meredith
Group exhibition:Dennis Burton, Graham Coughtry, Richard Gorman, Gordon Rayner, William Ronald, John Ivor Smith, Michael Snow, Tony Urquhart, Robert Varvarande, Joyce Wieland (Central Gallery)

February 13 - February 27
Tony Urquhart: watercolours, ikon-collages

Group exhibition: Dennis Burton, Graham Coughtry, Richard Gorman, William Kurelek, Robert Markle, John Meredith, Gordon Rayner, William Ronald, Michael Snow, Tony Urquhart, Robert Varvarande, Joyce Wieland (Front Gallery)

March 1 - March 20
Gordon Rayner

March 11 - March 25
James Boyd: coloured etchings and lithographs (Rear Gallery)

March 21 - April 10
William Ronald

March 28 - April 13
Don Jean-Louis: drawings

April 11 - May 1
Gord Smith: sculpture

April 27 - May 12
Robert Markle: Burlesque

Group exhibition: Dennis Burton, Graham Coughtry, Richard Gorman, Anne Kahane, John Meredith, Gordon Rayner, William Ronald, Gord Smith, John Ivor Smith, Michael Snow, Tony Urquhart, Robert Varvarande, Joyce Wieland

May 14 - May 29
William Kurelek: Experiments in Didactic Art

Group exhibition: Dennis Burton, Graham Coughtry, Anne Kahane, Richard Gorman, Arthur Handy, Robert Markle, John Meredith, Gordon Rayner, William Ronald, John Ivor Smith, Michael Snow, Tony Urquhart, Robert Varvarande, Joyce Wieland

May 31 - June 23
Arthur Handy: ceramic sculptures

June 26 - July 10
Primitive sculptures of New Guinea

September 13 - October 2
Group exhibition: Dennis Burton, Graham Coughtry, Richard Gorman, William Kurelek, Robert Markle, John Meredith, Gordon Rayner, Michael Snow, Tony Urquhart, Joyce Wieland

September 14 - September 28
Mollie Cruickshank: Prairie paintings

October 3 - October 23
Primitive African sculpture (Central Gallery)

October 27 - November 15
Letter Amorosa, 22 Lithographs by Georges Braques

October 30 - November 19
John (Jack) Chambers

November 20 - December 10
Joyce Wieland

November 27 - December 11
18th- and 19th-century Japanese scroll paintings

1964

January 16 - February 3
Walter Redinger: relief sculpture

February 5 - February 24
Richard Gorman: paintings

February 10 - February 22
Norman McLaren: drawings and watercolours

February 22 - March 7
Walter Redinger: relief sculpture/collage paintings

February 22 - March 7
Dennis Burton: oil and collages (Rear Gallery)

February 26 - March 11
Ted Bieler

March 12 - March 30
Anton Van Dalen: paintings

March 26 - April 11
Jan Menses: gouaches

March 31
Group exhibition: Ted Bieler, Dennis Burton, Graham Coughtry, John Chambers, Anton Van Dalen, Richard Gorman, Arthur Handy, Don Jean-Louis, Ann Kahane, William Kurelek, Robert Markle, John Meredith, Gordon Rayner, William Ronald, John Ivor Smith, Michael Snow, Tony Urquhart, Joyce Wieland

April 22 - May 11
Michael Snow

May 15 - June 5
Christiane Pflug: paintings

June
A review of the Fifties (Central Gallery)

September 18 - October 5
William Kurelek: An Immigrant Farms in Canada

October 9 - October 26
Graham Coughtry: Two Figure Series, 1962-64

October 28 - November 16
Gordon Rayner: City Series and Magnetawan Series

November 18 - December 1
Kazuaki Tanahashi: Sumi paintings

December 3 - December 23
Don Jean-Louis

December 8 - December 23
Elves' Art (group exhibition); Robert McTavish: carvings

December 8 - December 23
Folk Carvings by Robert McTavish of Wellington County

1965

January 7 - January 27
James Boyd: embossed etchings; Interim works by Four Artists: Richard Gorman, Robert Markle, Michael Snow, Joyce Wieland

January 29 - February 17
John Meredith

February 19 - March 10
Arthur Handy: sculpture

March 12 - March 31
Polychrome Construction: Dennis Burton, Donald Judd, Gordon Rayner, Michael Snow, David Weinrib, Joyce Wieland

April 1 - April 21
Dennis Burton: paintings

April – May 6
John Ivor Smith

April 22 – May 12
A Folio of Photographs by Michel Lambeth

April 23 - May 12
Anne Kahane: sculptures

May 14 - June 2
Nostalgia Toy: The Athlete's Memorial – Spheroids by Tony Urquhart

May 14 - June 2
Tony Urquhart

October 8 - October 27
Duncan De Kergommeaux: paintings

October 28 - November 17
John (Jack) Chambers: paintings

November 18 - December 8
Les Levine: LXVI (print portfolio)

1966

January 18 - January 31
19th Century Poster Art

February 2 - February 22
Gordon Rayner: paintings

March 2 - March 22
William Kurelek: Glory to Man in the Highest - a Socio-Religious Satire

March 26 - April 11
Graphics

April 6 - April 25
Michael Snow

May 18 - June 8
Eight New Painters and Sculptors in Toronto: Catherine Boudreau, Kelly Clark, Garry Cooke, John Dowds, Gay Humphries, Nobuo Kubota, John MacGregor, Bart Schoales

September 14 - October 3
Primitive Art: African and Oceanic

October 5 - October 24
Archie Miller: sculpture

October 5 - November 27
Dennis Burton: Hart House Exhibit

December 9 - December 22
Graham Coughtry: New Works

October 26 - November 14
Tony Urquhart

November 15 - December 5
Greg Curnoe: new works

December 7 - December 30
Major Eskimo sculpture: Cape Dorset

1967

January 11 - January 30
Jacques Hurtubise

February 10 - February 27
John MacGregor, Bart Schoales

March 1 - March 20
John Meredith

March 22 - April 10
Joyce Wieland: hangings

April 4 - April 18
Greg Curnoe: Time Series

April 11 - May 1
Don Jean-Louis: illuminations

July
Australian aboriginal paintings

September 15 - October 2
5 Vancouver Artists: Iain Baxter, Reg
Holmes, Glenn Lewis, Michael Morris,
Bodo Pfeiffer

September 30 - October 12
Alma Duncan: drawings

October 4 - October 23
John (Jack) Chambers

October 21 & 22
East West Intersect, directed by Udo
Kasemets

November 13 - November 25
Michel Lambeth: nudescapes

November 15 - December 4
Primitive African sculpture

December 9 - December 22
Indian Miniature Painting: XVII-XIX
Centuries

1968

January 10 - January 29
William Kurelek: The Ukrainian Pioneer
Woman in Canada

January 31 - February 19
Eleanor Mackey: paintings

March 6 - March 25
Dennis Burton

March 27 - April 15
Reg Holmes

April 24 - May 6
John Ivor Smith

May 8 - May 27
Arthur Handy

May 31 - June 18
Gordon Rayner: Religious Art Inspired
by the East

October 30 - November 18
John Macgregor

November 19 - December 9
Tony Urquhart: bas relief and sculptures

December 11 - January 6, 1969
Walter Redinger

1969

January 15 - February 3
Michael Snow

February 5 - February 24
Greg Curnoe

February 26 - March 24
Nobuo Kubota: sculpture

March 25 - April 14
Gordon Rayner

April
Don Jean-Louis: The Nature of the
Media is to Expose

May 7 - May 26
Graham Coughtry

May 24 - June 12
Eskimo sculpture from Baker Lake

September 9 - September 22
Don Jean-Louis: The Nature of the
Media, Part II

September 23 - October 13
Reg Holmes

October 15 - November 3
Anne Kahane

November 4 - November 24
John Meredith

November 25 - December 15
Drawings from Cape Dorset

December 11 - December 31
Indian miniatures

1970

January 13 - February 2
Daniel Solomon: paintings

February 4 - February 24
John MacGregor

February 27 - March 14
Gar Smith: Notes on Light, 1969-70

March 18 - April 7
Walter Redinger

April 7 - April 27
Les Levine: Body Control System and
Mimi's Book of Love

April 29 - May 18
Greg Curnoe: collages, 1961 - 1970

May 15 - May 18
Dennis Burton: drawings, 1961 - 1970

May 19 - June 8
John Greer

June
The Innuit Gallery
of Eskimo Art opens

August 29 – September 27
Richard Serra

September 30 - October 19
Dennis Burton: mixed media; Les
Levine: Les Levine Copies Everyone

November 11 - November 30
William Kurelek: Nature, Poor
Stepdame

1971

January 14 - February 2
Nobuo Kubota: paperworks

February 4 - February 22
Five on the Scene Who Should Be
Seen: Ward Estes, Andre Fauteux, Paul
Hutner, Don Norman, Gladys Wozny

February 25 - March 13
Gar Smith: Notes on light, prints and
flags

March 17 - April 5
Greg Curnoe: View of Victoria Hospital
and Wings Over the Atlantic

April 7 - April 26
Gordon Rayner

April 28 - May 17
Tony Urquhart: 10 openings boxes

May 19 - June 7
Daniel Solomon

June 9 - June 29
Embroidery and appliqué cloth
hangings from Gujarat State in India

September 13 - September 25
John Greer: This (One of a Series) And
Other Related Works

September 25 - October 11
Lithographs from the workshop of the
Nova Scotia College of Art and Design

October 13 - November 1
Joyce Wieland: True Patriot Love

November 3 - November 22
John MacGregor

November 23 - December 13
Reg Holmes

1972

January 11 - January 28
Picasso: ceramics

February 19 - March 10
Mark Prent

March 11 - March 24
Gar Smith: Flags

March 25 - April 14
Tony Urquhart

April 6 - April 25
Charles Pachter

April 27 - May 16
Arthur Handy

May 18 - June 6
Robert Markle

September 18 - October 7
Indian miniature painting and Tantric Art

October 10 - October 30
William Kurelek

October 28 - November 13
John Ivor Smith

November 15 - December 5
Dennis Burton

November 6 - November 30
Nobuo Kubota: constructions

1973

January 24 - February 14
Greg Curnoe

February 14 - February 28
John Greer

March 1 - March 21
Gordon Rayner

March 21 - April 10
Graham Coughtry: Water Figure
paintings

April 14 - May 2
Les Levine

May 5 - May 25
Daniel Solomon

May 29 - June 15
Walter Redinger

September 26 - October 17
Five New Artists: Andrew Bodor, Alex
Cameron, Bruce Emilson, Annette
Françoise, Dave Gordon

October 20 - November 2
William Kurelek: A Prairie Boy's Winter

November 3 - November 14
Boats: John Elliot, Leonard Moggy,
Ohotok, Angus Trudeau, Stan
Williamson

November 17 - December 3
John MacGregor

December 5 - December 29
John Meredith

1974

January 12 - January 29
Mark Prent

January 30 - February 19
Gar Smith: letters

February 26 - March 15
Group exhibition: From the Catacombs

March 8 - March 29
Graham Coughtry: Head Arrangements
for the Artists' Jazz Band

March 15 - April 5
Michael Snow

April 1 - April 27
Walter Redinger

May 2 - May 22
Joyce Wieland: works on paper

May 25 - June 14

Arthur Handy

October 19 - November 5
Daniel Solomon

October 26
John Meredith's fifteen-year survey
opens at the Art Gallery of Ontario

November 7 - November 27
William Kurelek: The Happy Canadian

November - December
Artists' Jazz Band Exhibition at the
Musée d'Art Contemporain de Montréal

December 11 - December 28
John MacGregor: graphics

1975

January 11 - February 31
Nobuo Kubota

February 4 - February 21
Greg Curnoe: recent watercolours

February 22 - March 14
John Greer: From Sea to See

March 18 - April 4
Gordon Rayner: Postcards of the Mind

April 7 - April 25
Two New Artists: Paul Harnett, Brian
Porter

April 28 - May 15
Walter Redinger: colour drawings

May 24 - June 13
Graham Coughtry: large "Reclining
Figure Moving" and related works on
paper

September 20 - October 10
Gar Smith: Mantra Masses

October 11 - October 31
Reg Holmes

October 25 - November 8
Ralph Greenhill: Ontario photographs,
1958 -1973

November 1 - November 21
John MacGregor

1976

January 1 - February 4
Michaele Berman: Oceans of Blood

February 6 - February 25
Dennis Burton

February 26 - March 17
Walter Redinger: sculptures, prints and drawings

March 20 - April 7
Greg Curnoe

April - May
William Kurelek: Fields

April 24 - May 14
Richard Prince: constructions

May 22 - June 5
Angus Trudeau: paintings and models of boats

June 19 - July 6
Andrew James Smith: The Papermaker

July 17 - July 31
Pacific Northwest Indian exhibition

September 17 - October 8
Nobuo Kubota

October 9 - October 22
The End of an Era: Tent Rugs from the Oases of Southern Tunisia

October 23 - November 12
John Greer

November 13 - December 3
William Kurelek: The Irish in Canada

December 4 - December 18
Mendelson Joe Paints

1977

January 15 - February 5
Reg Holmes

February 5 - February 26
Gordon Rayner: new collages and paintings

March 8 - March 25
John Meredith

March 19 - April 1
Gar Smith: Black September Journal

April
Dennis Burton: Robert McLaughlin Retrospective (travelling)

April 10 - May 20
Michaele Berman: Carnivore

May 21 - June 10
Arthur Handy

September 17 - October 7
Les Levine: Northern Landscapes

October 8 - October 28
Gheerbrant to Isaacs, Five Montreal

Artists: Pierre Boogaerts, Liljenko Horvat, Jacques Palumbo, Bill Vazan, Roger Vilder

October 15 - October 28
Eldon Garnet: Blurrs

November 1 - November 19
Walter Redinger

November 19 - December 17
John MacGregor

1978

January 14 - February 3
Andrew James Smith: Naked Clothing

February 4 - February 17
Berber Kilims from Southern Tunisia

February 18 - March 10
Greg Curnoe: A Proposed Referendum Question and Five Series

March 11 - March 31
William Kurelek: religious paintings

April 29 - May 19
John Greer: (Trappings) of Progress, Hide and Seek

May 8 - May 28
Six on the Scene Who Should Be Seen: Susan Britton, Mark Gomes, Preben Marcussen, Anne Quigley, Lorne Wagman, George Whiteside

May 20 - June 9
Angus Trudeau

September 23 - October 13
Mark Prent

October 21 - November 10
Reg Holmes

November 11 - December 1
Richard Prince: new constructions and copper pieces

December 2 - December 22
Gar Smith: Earth Stars/Future Markets

1979

January 13 - February 2
Gordon Rayner: Paradise

February 3 - 23
Richard Storms: paintings

February 24 - March 16
Dennis Burton: Do You Read Me?

March 17 - April 6
Five New Artists: Brian Burnett, David Clarkson, Douglas P. McGregor, Judith Schwarz, Caroline Simmons

April 7 - April 27
American Indian Art

April 28 - May 18
Michel Lambeth: photographs

May 19 - June 8
Robert Markle

June 9 - June 29
Mark Gomes: Winter Works

September 14 - October 4
Group exhibition: ceramics from Art's Sake Inc., Zbigniew Blazeje, David Bolduc, Dennis Burton, Dennis Cliff, Graham Coughtry, Joan Van Damme, Robert Hedrick, Ken Lywood, Robert Markle, Ross Mendes, Diane Pugen, Gordon Rayner, Paul Sloggett

October 6 - October 26
John MacGregor: watercolours

October 20 - November 9
Michael Snow

November 10 - November 30
Full-scale watercolour cartoon for carpets

December 1 - December 22
John Greer: Clearly Cloudy

1980

January 12 - February 1
Graham Coughtry

February 2 - February 22
Gar Smith: Photopaintings - Photosynthesis

February 23 - March 21
North American Indian Art & Artifacts

March 22 - April 4
Eldon Garnet: new photo works

March 29 - April 18
William Kurelek: Night Paintings

April 19 - May 9
Walter Redinger

May 10 - May 30
Brian Burnett: paintings

June 7 - June 28
Robert Markle: New looks at the Limelight, works on paper

September 13 - October 3
Les Levine: etchings and video tapes

October 4 - October 24
John Meredith

October 25 - November 14
Mark Gomes: sculpture

November 15 - December 5
Angus Trudeau

December 6 - January 9, 1981
Bizarre Bazaar: group show

1981

January 10 - January 30
Graham Coughtry: Sonata Variations

January 31 - February 20
Gordon Rayner

February 21 - March 13
Joyce Wieland: The Bloom of Matter,
coloured drawings

March 14 - March 27
Jim Cave: linocuts and posters

March 28 - April 17
New Guinea sculpture

April 18 - May 8
John Ivor Smith

May 9 - May 29
Dennis Burton - A selection from 100
drawings

May 30 - June 19
Ed Radford: paintings and drawings

September 12 - October 1
Indian Weavings from the Bolivian
Andes

October 3 - October 23
John Meredith: coloured inks / collages

October 24 - November 13
Mark Prent

November 14 - December 4
Brian Burnett

December 5 - December 24
Early North American Indian Art and
Artifacts

1982

January 16 - February 5
John MacGregor: new paintings

February 6 - February 26
Robert Markle: Zanzibar Series, works
on paper

February 27 - March 19
Indian miniature paintings

April 10 - April 30
Richard Prince: Tables

May 1 - May 21
Stephen Cruise: The Visitor's Book

May 22 - June 11
Gathie Falk: Pieces of Water

June 12 - July 2
Ed Radford: Notes Towards More
Pictures

September 11 - October 1
John Greer: Shot from a Catalogue

October 2 - October 22
Gordon Rayner

October 23 - November 12
Stephen Cruise: drawings 1976-1980

November 13 - December 3
Michael Snow: individual sculpture and
photographic prints

December 4 - December 24
Angus Trudeau: models and paintings

1983

January 15 - February 4
Mark Gomes: Terminal

February 5 - February 25
William Kurelek: Workshop Objects

February 26 - March 18
Graham Coughtry: recent paintings and
lithographs

March 19 - April 14
North American Indian Art: late 19th
and early 20th century

April 16 - May 6
Joyce Wieland: Turkish watercolours,
Nature watercolours, Mythological
paintings

May 7 - May 27
Brian Burnett

May 28 - June 17
Les Levine: new media projects

September 10 - September 30
The Art of New Guinea

October 1 - October 21
Gar Smith

October 22 - November 11
Stephen Cruise: A Space Like This

November 12 - December 2
John Meredith

December 3 - December 24
Dennis Burton: Elves' Art

1984

January 14 - February 3
John MacGregor

February 2 - March 15
Michael Snow: photography, painting,
sculptures

March 17 - April 5
Gordon Rayner: constructed paintings

April 7 - April 26
Ed Radford

April 28 - May 18
John Greer: One of a Number

May
John Meredith: Artist Statement

May 19 - June 8
An Artist's Choice: Three Vancouver
artists - Wendy Hamlin, Gloria Masse,
John Clair Watts

June 16 - July 6
Woven Objects from Many Cultures

September 8 - September 28
David Cheung, Donna Mehalko:
paintings and drawings

September 29 - October 18
Brian Burnett

October 20 - November 8
Mark Prent

November 10 - November 30
Gathie Falk

December 1 - December 21
Posters of the Sandinista Revolution

1985

January 12 - February 1
Stephen Cruise: Israeli Sketch Book

February 2 - February 22
Mark Gomes: common of piscary

March 2 - March 22
Graham Coughtry: Flamencos in
Claremonet & related studies

March 16 - March 29
Ralph Greenhill

March 30 - April 19
Robert Markle: Artist and Model Series,
works on paper

April 20 - May 10
Gar Smith: I give bliss, I give warning,
1975-85

May 18 - June 7
Arnaud Maggs: Dusseldorf photo-
graphs

September 14 - October 4
19th-Century Indian miniature paintings

October 5 - October 25
Mirielle Perron: ceramic installations

October 26 - November 15
Ed Radford

November 16 - December 6
Stephen Cruise

December 7 - January 3, 1986
19th- & 20th-Century Game Boards
from Quebec

1986

January 11 - January 30
Marc Gagné, Michele Karch, Andrew
0-1, Jim Reid

February 1 - February 21
John MacGregor: new sculpture

March 1 - March 21
Gordon Rayner: Constructed Paintings,
Series II

March 22 - April 11
Michael Snow: paintings, sculpture,
works on paper 1959-1960

April 12 - May 2
Brian Burnett: The Vancouver Series,
paintings

May 10 - May 30
Angus Trudeau (1907-1984)

May 31 - June 20
Lorne Wagman: paintings

September 13 - October 3
Mark Prent

**Opening of The Isaacs Gallery Ltd.,
179 John Street, Toronto**

1987

February 13 - March 6
John Meredith

March 7 - March 27
Gathie Falk: Soft Chairs

April 4 - April 24
Stephen Cruise: Models

April 25 - May 15
Joyce Wieland

May 16 - June 5
John Greer: Connected Works

June 6 - June 17
Robert Markle: Traces, works on paper

September 19 - October 9
Ed Radford: Blast Shield, new paintings

October 17 - November 6
Michael Snow: Redifice and other
holograms

November 7 - November 27
Mark Gomes: Face Value

November 28 - December 18
Viktor Tinkl: sculpture

1988

January 16 - February 5
Early North American Indian Art and
Artifacts

February 6 - March 4
John Meredith: thirty years of drawing

March 5 - March 25
Brian Burnett

March 26 - April 15
Lorne Wagman

April 9 - April 29
Tribal Sculpture from West Africa

April 16 - May 13
Gordon Rayner: portraits and portrayals

June - June 24
Tom Burrows: sculpture

September 17 - October 7
Igor Khazanov: paintings

October 15 - November 4
Robert Markle

October 26 – November 4
Ed Radford

November 5 - November 25
Gathie Falk: Support System Series

1989

January 14 - February 10
Viktor Tinkl

February 11 - March 3
Ed Radford

March 4 - March 31
Early North American Indian Art and
Artifacts

April 1 - April 21
William Kurelek: My Father's Barn

April 15 - May 6
Gordon Rayner: Mexican drawings

April 22 - May 12
Stephen Cruise: Turncoat

May 13 - June 2
Michael Torosian: Drawn Out (22 works
on paper from 1959)

June 2 – June 22
Stephen Cruise: on the shelf items

September 15 - October 5
Aboriginal Paintings from the Western
Desert of Australia

September 16 - October 6
John Meredith

October 6 - October 25
Mark Prent

October 7 - October 27
John Ivor Smith

October 27 - November 16
Mark Gomes

October 28 - November 17
Lorne Wagman: new paintings and
sculpture

November 17 - December 7
Ed Radford

November 18 - December 8
Ania Parie: Russian Roulette

December 9 - December 23
Mexican Ex-Voto and Retablos

1990

January 13 - February 3
Walter Redinger: new works on paper

January 19 - February 8
Lorne Wagman

February 3 - February 23
An Interim Report: Tom Burrows,
Robert Markle, Ed Radford, Michael
Snow

February 9 - March 1
Dennis Burton: works from 1962-1990

March 2 - March 22
Igor Khazanov

March 9 - March 22
Michael Torosian: Anatomy,
photographs

April 13 - May 3
Stephen Cruise: Mae Home
Early North American Indian Art and
Artifacts

1991

February 24 - March 16
Gordon Rayner

March 17 - April 7
Gathie Falk: Hedge and Cloud Series

April 14- May 3
Graham Coughtry

May 4 - May 24
Michael Snow: 28 new paintings

May 31 - June 29
Viktor Tinkl

The Isaacs Gallery closes
Exhibitions continue at the Isaacs/Innuit
Gallery

1992

May 23 - 30
One Last Look: a group exhibition from
Isaacs' personal collection

2001

The Isaacs/Innuit Gallery
closes

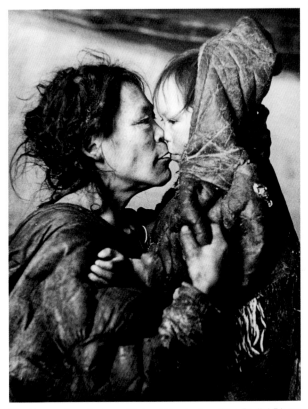

Final Isaacs/Innuit show: Richard Harrington, *The Padlei Diary: 1950 Keenaq and Keepseeyuk*. A profoundly moving chronicle of endurance.

33.6 x 25.8 cm, Gift of Avrom Isaacs, 1994, Acc. 94/478; p. 44
James Reaney, 26.0 x 17.0 cm, Private collection, on loan to the
Art Gallery of Ontario; p. 62 William Kurelek, 33.7 x 25.2 cm,
Gift of Avrom Isaacs, 1994, Acc. 94/470; p. 73 Tanahashi
opening, 33.9 x 26.0 cm, Gift of Avrom Isaacs, 1994, Acc.
94/487; p. 83 Avrom Isaacs, 22.6 x 17.5 cm, Gift of Avrom
Isaacs, 1994, Acc. 94/487; p. 86 Greg Curnoe, 33.3 x 24.5 cm,
Gift of Avrom Isaacs, 1994, Acc. 94/467

page 122 Markle, Robert Nelson (Canadian 1936-1990):
Markelangelo's Front Angel (neon)1979-80, acrylic and neon on
wood, 235.5 x 113.0 x 24 cm, Gift of Robert McLaughlin
Gallery, Oshawa, 2004 © Marlene Markle

page 51 Snow, Michael (Canadian 1929), *Quits* 1960, oil on
wood, plywood, 240.0 x 40.8 x 92.0 cm, Gift of Michael Snow,
© Michael Snow, Acc. 2001/199

Leonard & Bina Ellen Art Gallery, Concordia University:

page 63 Snow, Michael, *Rolled Woman #2* 1961, oil on paper,
72.5 x 48.8 cm, Purchased with the assistance of a Canada
Council Special Purchase Assistance Grant © Michael Snow

**University of Guelph Collection at the Macdonald Stewart
Art Centre:**

page 113 Snow, Michael, *Door* 1979, photograph and wood,
Purchased through the Alma Mater Fund with assistance from
Wintario, 1980, UG980.002, © Michael Snow

National Gallery of Canada:

page 63 Wieland, Joyce, *Cooling Room 11* 1964, metal toy
airplane, cloth, wire and metal, plastic boat, paper collage,
ceramic cups with lipstick, and spoon, mounted in painted
wooden box, 114.4 x 94 x 18.3 cm, Purchased in 1971, ©
National Gallery of Canada

page 139 Wieland, Joyce, *Reason over Passion* 1968, quilted
cotton, 256.5 x 302.3 x 8 cm, Purchased in 1970, © National
Gallery of Canada

The Robert McLaughlin Gallery, Oshawa:

page 71 Burton, Dennis, *Mothers and Daughters* 1966, oil,
acrylic copolymer and graphite on canvas, 152.2 x 152.2 cm,
Purchased in 1976, © Dennis Burton

page 39 Ronald, William, *Central Black* 1955-56, oil on canvas,
214 x 165.7 cm, Gift of Oshawa B'nai B'rith Lodge, 1971, ©
Helen Ronald

page 143 Wieland, Joyce, *Artist on Fire* 1983, oil on canvas,
107.2 x 130.0 cm, Purchased in 1984, © The Robert
McLaughlin Gallery

Textile Museum
of Canada
30YEARS
Celebrating Cloth, Culture and Art

ONTARIO ARTS COUNCIL
CONSEIL DES ARTS DE L'ONTARIO

Canada Council Conseil des Arts
for the Arts du Canada

torontoartscouncil
An arm's length body of the City of Toronto

TORONTO FRIENDS
OF THE VISUAL ARTS

Walter & Duncan
GORDON FOUNDATION